VISUALIZING IRELAND

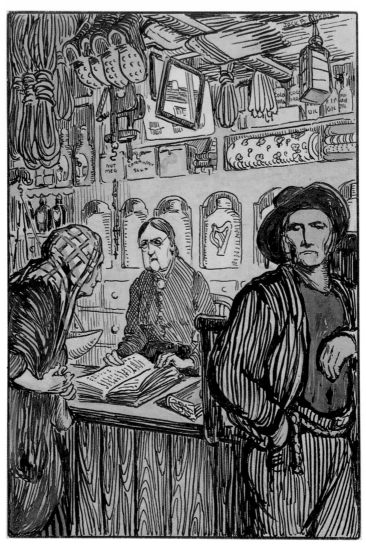

Frontispiece. Jack Butler Yeats (1871–1957), *The Country Shop*, ca. 1912, watercolor over ink on card, 26.6 × 19.5 cm, National Gallery of Ireland no. 3829. (Courtesy of the National Gallery of Ireland)

VISUALIZING IRELAND

National Identity and the Pictorial Tradition

Edited by

ADELE M. DALSIMER

IRISH STUDIES PROGRAM
BOSTON COLLEGE
CHESTNUT HILL, MASSACHUSETTS 02167-3806

IRISH
STUDIES
PROGRAM
BOSTON
COLLEGE

Compilation copyright © 1993 by Adele M. Dalsimer
Introduction copyright © 1993 by Adele M. Dalsimer and Vera Kreilkamp
Preface copyright © 1993 by Adele M. Dalsimer and Nancy Netzer

First published in the United States in 1993 by Faber and Faber, Inc., 50 Cross Street,
Winchester, MA 01890

Library of Congress Cataloging-in-Publication Data

Visualizing Ireland : national identity and the pictorial tradition / edited by Adele Dalsimer.
 p. cm.
 Includes index.
 ISBN 0-571-19813-9
 1. Art, Irish. 2. Nationalism and Art — Ireland. I. Dalsimer, Adele.
N6782.V57 1993
760'. 04499415 — dc20 93-4234
 CIP

Cover design by Don Leeper
Cover art *Molly Macree* by Thomas Alfred Jones, courtesy of the National Gallery of Ireland
Frontispiece *The Country Shop* by Jack Butler Yeats, courtesy of the Natonal Gallery of Ireland

Printed in the United States of America

Contents

Preface

IMPORTING AN EXHIBITION from the National Gallery of Ireland to the Boston College Museum of Art and, at the same time, compiling a complementary volume with authors from both sides of the Atlantic was a challenge. Throughout the dual project, we turned to many experts and friends, whom we would like to thank here.

Former Vice-Consul in Boston and now Secretary of the Cultural Relations Committee of the Republic of Ireland, Geoffrey Keating suggested that an exhibition of Irish watercolors and drawings, shown to great acclaim at the National Gallery in 1991, might be an appropriate inauguration of the new galleries at the college. We are grateful to Raymond Keaveney, Brian P. Kennedy, Adrian Le Harivel, and the trustees of the National Gallery of Ireland for allowing these national treasures to be seen as a group for the first time in North America, and to the Honorables Liam Caniffe, Brian J. Donnelly, Margaret Heckler, Edward M. Kennedy, Thomas P. O'Neill, Jr., former Prime Minister of Ireland Garret Fitzgerald, and Joan Fitzgerald for easing us through various official mazes.

Without the support and help of the administration at Boston College, J. Robert Barth, S.J., Mary Lou Delong, Margaret A. Dwyer, Katharine Hastings, James McGahay, Gary Messinger, William B. Neenan, S.J., Joseph M. Pastore, and Richard Spinello, the exhibition would have been impossible. Philip O'Leary, of the English Department and Irish Studies Program at Boston College, offered encouragement and thoughtful advice from his vast knowledge of Irish culture. A particular expression of grati-

1

tude is due the Friends of Art and Friends of Irish Studies of Boston College, whose enthusiasm for the project was indispensable and constant. Our indefatigable administrative assistants Catherine McLaughlin and Helen Swartz unstintingly nurtured good ideas into realities.

Naomi Rosenberg edited this manuscript with extraordinary discernment; Stephen Vedder of the Boston College Audio-Visual Department helped immeasurably with photographic reproductions. To each, we extend special thanks.

Finally, we are grateful to our fellow contributors for reading and critiquing each other's essays. Such a collaborative spirit enriched our task and immeasurably enhances this book.

Adele M. Dalsimer
Co-Director, Irish Studies Program, Boston College

Nancy Netzer
Director, Boston College Museum of Art

Introduction

Adele M. Dalsimer and Vera Kreilkamp

A N EXHIBITION OF WATERCOLORS and drawings at the National Gallery of Ireland and the Art Museum of Boston College provided the inspiration for *Visualizing Ireland: National Identity and the Pictorial Tradition*. An active Irish Studies Program of historians, literary critics, and art historians at the university fostered an interdisciplinary exploration that rapidly developed into a transatlantic collaboration with scholars from Ireland and America. Just as the exhibition offers a wide-ranging selection from the watercolor holdings of the National Gallery rather than a thematic or ideological presentation, so the editor, in inviting contributions, imposed no uniform viewpoint. The variety of approaches evident in these responses suggests how differently contemporary scholars envision the place of the pictorial tradition within a broader cultural narrative.

Their contributions, nevertheless, indicate how visual materials can be incorporated into our construction of "Irishness" as an ideological concept. Through a multidisciplinary consideration of the nation's pictorial heritage from the seventeenth to the twentieth century, the volume explores the formal dimensions of the watercolors and drawings, and moves beyond aesthetic concerns to the social and political attitudes inherent in the paintings. The collection thus demonstrates how the synchronicities of verbal and visual rhetorics can enrich our assessment of the past.

The essays examine the Irish pictorial tradition that has evolved since the medieval period and attempt to redress its recent neglect in cultural

studies. As Maire de Paor reminds us, visual art that survived from the early modern period was a by-product of the English conquests. For subjects, artists emerging from or working for garrison forces turned to an elite class and its surroundings, or alternatively, to the native Irish world as seen from the perspective of the colonizers. While a significant body of native-Irish music and literature survived after the sixteenth century, a comparably rich tradition is absent in the visual arts—or, as Kevin O'Neill insists, in the visual productions acknowledged as art. Consequently, contemporary cultural historians, seeking the voice of a marginalized people, rather than that of its colonizers, have too often failed to turn to Irish paintings. Because of the imperial sources of post-conquest art, Irish cultural studies ignores material essential to an understanding of the intertwined national identities of the two Irelands in their colonial and post-colonial incarnations. While critics, such as Cheryl Herr, Luke Gibbons, and Richard Kearney, have made significant and even groundbreaking use of the visual arts in important essays, their contributions are the exception rather than the rule.

Visualizing Ireland: National Identity and the Pictorial Tradition focuses on Irish art as a means of accessing the nation's social and political past. Many contributors decode and situate specific paintings in their ideological contexts. They approach the watercolors as texts for interpretation, revealing the tensions of a divided society. Some foreground the silenced presence of the colonized in visual productions that represent the economic and social transactions of an imperial culture. Margaret Mac Curtain's essay illuminates a popular artist's iconography in the idealized genre painting of a peasant girl, *Molly Macree.* She examines the economic and social losses facing women like Molly immediately before and after the Great Famine, and calls for an ideological component in the art historian's study of post-famine genre painting.

Other contributors deploy a variety of verbal narratives to illuminate the tension between surface and context of a painting. Kristin Morrison, juxtaposing Mildred Butler's *Ancient Rubbish* with revelations about Big House life in Molly Keane's Ascendancy fiction, speculates about an encoded political text in a decorative watercolor. Although Butler had no known nationalist sympathies, Morrison implies an ideological complexity in her depiction of gentry life in the uneasy years between the Land Wars and the War of Independence. Challenging formalist analyses of Rose Barton's *Going to the Levée,* Vera Kreilkamp positions the work of yet another gentry artist. She foregrounds the narrative of a Dublin underclass in Barton's painting of an Ascendancy spectacle performed in the city's streets.

Turning to historical accounts and contemporary memoirs and fiction, her essay, like Morrison's, emphasizes alternative narratives in late nineteenth-century Ascendancy art. Thus Mac Curtain, Morrison, and Kreilkamp seek the "meaning" of Irish paintings in a range of discourses that provide verbal contexts for the isolated visual image.

Even as he mounts a vigorous challenge to elitist conceptions of the visual arts by considering iconographic forms from popular culture, Kevin O'Neill also invokes alternative verbal sources to release the native Irish pressure for representation in Ascendancy art. To emphasize, for example, the political implications of William Brocas's early nineteenth-century elision of the political controversy and social activity surrounding the General Post Office in his architectural rendition of that building, O'Neill juxtaposes the print with a contemporary diarist's descriptions of teeming urban life at the GPO. He argues that Brocas's silent architectural forms, which deploy human figures primarily as indicators of scale, like other architectural renditions of Ascendancy monuments, must be read as hegemonic constructs that reveal the silencing of one class by another.

Two contributors explore the negotiations through which mid-nineteenth-century Irish painters reinscribed the nation's historical narrative in their representations of a medieval or contemporary scene. Pamela Berger's analysis of medieval motifs in Daniel Maclise's *The Marriage of Strongbow and Aoife* explains how an artist, painting immediately after the social cataclysm of the famine, transformed Ireland's first great defeat by the English into a celebration of the moral ascendancy of the conquered Irish. Nancy Netzer explores another post-famine painting, but one that considers a contemporary nineteenth-century event: James Mahony's watercolor of Queen Victoria's visit to the Irish Industrial Exhibition in 1853. By decoding Mahony's substitution of Irish for foreign art in his version of the exhibition, Netzer highlights the painting's vision of national recovery. Like other forms of Irish cultural discourse, then, these nineteenth-century watercolors express a persistent desire to reclaim a cultural narrative controlled by imperial forces.

Calling attention to the rich topographical tradition in Irish art, Raymond Gillespie and Maire de Paor describe how the early colonizers' preoccupations with surveying their new territory provided a visible record of a disappearing world. After noting that rural artists were busily employed mapping out their patrons' newly conquered estates, Gillespie demonstrates how the visiting English artist Francis Place's panoramas of late seventeenth-century Dublin reflects a similar process of colonization in urban

life. In Place's cityscape, the prominent positioning of the Thosel, a new merchant exchange and corporation hall, and the squared steeples of Protestant churches signify a simultaneous "civilizing" and "anglicizing" of early modern life in Dublin—in an era when loyal Irishmen were "Christian," city dwellers and the countryside was rife with potentially disloyal "heathens."

In the eighteenth and nineteenth centuries, a growing interest in antiquarianism and Celticism, evident in the work of visiting as well as native artists, incorporated the topographical tradition and laid the groundwork for an emerging cultural nationalism. Jean Archer discusses Francis du Noyer's career as a topographical artist, beginning with his apprenticeship to George Petrie during the National Ordnance Survey in the 1830s. Like de Paor, she indicates how the Ordnance Survey venture, ostensibly an instrument of imperial conquest, became a scholarly and archaeological occupation for artists sympathetic to the native tradition. Du Noyer's subsequent career recording natural phenomena confirms Ireland's increasing participation in new scientific disciplines, particularly geology and paleontology.

Many contributors allude to the pressures exerted by the marketplace and thus to the overdetermination of artistic production by economic forces. James Kelly, Brian P. Kennedy, Alf MacLochlainn, and Adele M. Dalsimer directly address the relationships between painters and their markets. Kelly describes the extent to which finances determined the career of the eighteenth-century artist Francis Wheatley during his self-imposed exile in Ireland to escape his English creditors. Competing for the attention of a very small group of Irish art patrons, Wheatley depicted the political ferment of the late 1770s—and, incidentally, participated in the creation of a new genre of modern historical painting. His best-known work, *A View of College Green with a Meeting of the Volunteers* (not in the exhibition), conveys the resolve of the Irish Volunteer Corps to secure the removal of restrictions binding Irish commerce. But because, according to Kelly, "Wheatley's priority was to make money," the artist avoided reproducing the most radical imagery of the event and inserted the portraits of potential buyers among the leaders of the corps. Kennedy demonstrates how late eighteenth-century landscape artists similarly exploited their subject matter to satisfy market demands. In the interests of the "picturesque" aesthetic, watercolors by John Henry Campbell and Thomas Sautell Roberts offer tranquil images of the Irish countryside. Both avoid alluding to the poverty and degradation of actual rural life and depict the fantasies

of polite society—neatly maintained thatched cottages and a contented peasantry.

Alf MacLochlainn's analysis of the letters of the young Bernard Mulrenin suggests that economic circumstances continued to reinforce colonial allegiances in the early nineteenth-century art world. Exploring the holding of a small file of Mulrenin letters (1825–34) in the John J. Burns Library of Rare Books and Manuscripts at Boston College, MacLochlainn chronicles the social and economic circumstances of an Irish miniaturist's attempts to attract business among army officers, attend exhibitions of his competitors, and respond to the growing threat of photography to his vocation. The essay portrays a rural artist from the west of Ireland remaining loyal to the crown and its servants who were his primary patrons. Thus, on his first visit to Westminster Abbey, when Mulrenin found himself in the company of Daniel O'Connell, he reserved all his admiration and awe for the Gothic monument of an imperial nation rather than for his country's "liberator."

Adele M. Dalsimer's analysis of Jack Yeats's *The Country Shop* explores the relationship between intended audience and artistic production. In her essay we learn that two of the watercolor's three figures emerged from Yeats's 1905 commission with Synge to investigate reports of famine in the west of Ireland for the *Manchester Guardian*. The two figures, depicting the exploitation of a peasant woman by a shopkeeper, reiterate Synge's newspaper reports of peasant victimization by the gombeen class. But a mysterious countryman who dominates the 1912 watercolor reflects an intervening collaboration: Yeats's illustrations for Synge's essays about an idealized peasantry in the 1907 *Aran Islands*. Thus a single visual text contains narratives inherent in Yeats's two previous projects with Synge, one journalistic, the other *belle-lettristique*. Derived from different agendas, written for different audiences, and creating different visions of the western peasantry, the earlier projects reproduce themselves in *The Country Shop*.

Visualizing Ireland: National Identity and the Pictorial Tradition suggests directions and themes for future work. While the pictorial arts in Ireland have not yet been subjected to as ambitious an analysis as, for example, Andrew Hemingway's *Landscape Imagery and Urban Culture in Early Nineteenth-Century Britain*, the contributors' concerns with the economics and sociology of art indicate the need for a similar undertaking. Moreover, Kevin O'Neill's argument for an inclusive definition of art, one that would incorporate the iconography of popular as well as elite culture,

reflects that heightened awareness of class and gender distinctions which is both motive for and consequence of an interdisciplinary approach to culture. The Irish historian Tom Dunne has recently endorsed such an approach, citing "a growing recognition that traditional demarcations in cultural studies are inadequate and restrictive"(1). Dunne challenges his fellow historians to become more responsive to other discourses; *Visualizing Ireland* offers a similar challenge to all those working in the field of Irish studies.

WORKS CITED

Dunne, Tom. "A Polemical Introduction: Literature, Literary Theory, and the Historian." *The Writer as Witness*. Ed. Tom Dunne. Cork: Cork University Press, 1987. 1–9.

Gibbons, Luke. "'A Shadowy Narrator': History, Art and Romantic Nationalism in Ireland 1750–1780." *Ideology and the Historians*. Ed. Ciaran Brady. Dublin: Lilliput Press, 1991. 99–127.

Hemingway, Andrew. *Landscape Imagery and Urban Culture in Early Nineteenth-Century Britain*. Cambridge: Cambridge University Press, 1992.

Herr, Cheryl. "Erotics of Irishness." *Critical Inquiry* 17.3 (1990): 1–34.

Kearney, Richard. *Transitions: Narratives in Modern Irish Culture*. Dublin: Wolfhound Press, 1988. 193–207.

The Real Molly Macree

Margaret MacCurtain

CHARLES BAUDELAIRE, IN a celebrated essay "The Painter of Modern Life," distinguished between "mere trivia dressed up for effect" and the artist's obligation "to have the present in his mind's eye." He commended "those exquisite artists, who, although they have confined themselves to recording what is familiar and pretty, are nonetheless, in their own ways, important historians" (390–435). Thomas Alfred Jones would be astonished today to find that his watercolor of Molly Macree (plate 1), executed in the 1860s, has become a favorite reproduction of purchasers in the National Gallery of Ireland sales department. Furthermore, as a dedicated president of the Royal Hibernian Academy of Arts for twenty-four years (1869–93), he would have expressed satisfaction that one of his own paintings would be such a discreet and steady source of revenue for the cause of art in his native country. Jones would not have demurred when Baudelaire called for an art "based upon the forms, costumes, actions, even facial expressions of his own day." In choosing to exhibit a series of paintings titled *The Irish Colleen* in the second half of the nineteenth century, Jones was attesting to his perception of his own world and, in a subliminal way, challenging the conventional sensibility of his circle. Making an Irish peasant girl the subject of a painting in which the rural landscape became the background contravened the tradition of Irish topographical watercoloring. Jones and artists like Michael Brennan presented the innovation to the Dublin academicians of the period, and if Jones moved on to specialize in painting portraits of his contemporaries—

9

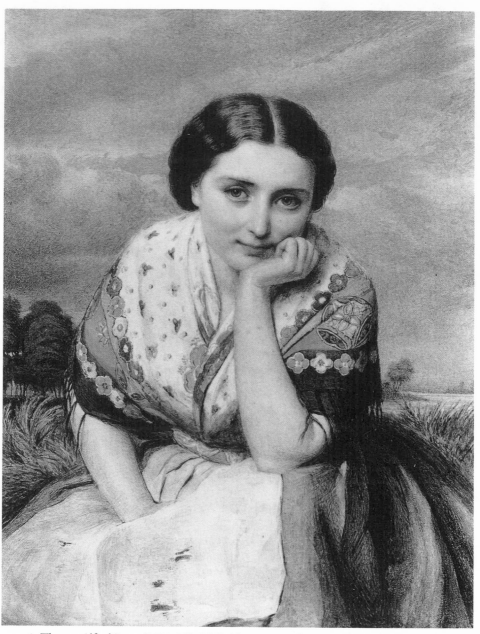

1. Thomas Alfred Jones (1823–93), *Molly Macree,* ca. 1860, watercolor and gouache with gum arabic on paper, 41 × 33.2 cm, National Gallery of Ireland no. 3025. (Courtesy of the National Gallery of Ireland)

and monopolize the field—he returned several times to paint such subjects as *Limerick Lasses* (1872) and *Connemara Girls* (1880), which added to his earlier studies of the 1860s, such as *The Colleen Bawn* (1861), *The Colleen's Toilet* (1864), and *A Limerick Lass* (1865); and, shortly before his death, Jones painted another version of *A Limerick Lass* (1892). Jones gave the genre a place in Irish art that has grown rather than diminished over time (Strickland, 560–65).

On the continent and in Britain, the painting of the rural laborer was a popular subject in nineteenth-century art. Depicting peasant life, the artist could suggest the shifts in sensibility that were taking place around the changing role of the cottier. In literature Honoré de Balzac had turned the French peasant into a loutish fellow and Karl Marx despaired of ever making a revolutionary out of what he fretfully called "the barbarian within society." Nineteenth-century artists saw the peasant as a subject associated with a receding but passionately remembered scene: the haywagon, the communal harvesting of the crops, the patient figures with bowed heads reciting the Angelus—all the romantic evocations of a countryside before the railways swept peasants into the noisome, crowded ghettos and factories of the Industrial Revolution. Even the word "peasant" got lost and was replaced by "the laboring poor," and later still by "working class."

Representations of the peasant woman were an important statement of this shift in sensibility. Professor Linda Nochlin has analyzed the connection between peasant and working woman in nineteenth-century European art, and in her study "Women, Art, and Power" (1988) she examines further aspects of the assimilation of the peasant woman into the rural landscape and, more significantly, into the realm of nature (49–74). Nochlin, referring to paintings as different as Giovanni Segantini's *Two Mothers* and Jean-François Millet's *The Gleaners*, argues that this association of women with nature gave rural poverty an acceptable face and used the farm woman's backbreaking toil to sublimate her destiny and translate it into the sphere of religious piety. Moreover, she cites the idealization of the peasant girl, as depicted in the paintings of Jules Breton, particularly in *The Song of the Lark*. The young peasant girl, invariably striking in form and posture, helped to formulate her gender role in nineteenth-century art, as signifier of earthy eroticism and unconscious sensuality. The representation of "natural mother," Nochlin suggests, was communicated in the juxtaposition of mother and child, cow and calf in *Two Mothers*. Add to this iconography that of peasant woman as symbol of religious devotion, as in Wilhelm Leibl's *Peasant Women in the Church*, and the viewer receives the

image of the elemental, fertile earth mother who conveys overt messages of submissiveness. Thus, like Christian madonna and child paintings, the representation of nineteenth-century peasant woman in art becomes a cliché of a supratemporal, eternal feminine construct. According to Nochlin a biblical setting removed the stooped figures of *The Gleaners*—among the poorest and humblest of rural society—from their stark actuality and placed them in the "suprahistoric context of High Art" (22).

Did Thomas Jones deliberately link the young Irish girl with the emerging image of the Irish Colleen, immortalized by his contemorary, James Lyman Molloy, in the popular lyric "The Kerry Dances"? The archives of the National Gallery of Ireland have a collection of paintings in the Irish Colleen genre. A group of the artistic elite in Ireland communicated upwards what popular culture was mediating in street ballads like "The Kerry Dances" and "The Rose of Tralee." The popular opera of the time, Bendick's *Lily of Killarney* gave Don Bouciault's play, *The Colleen Bawn*, a new lease of life.

> O, the days of the Kerry dancing, O the ring of the piper's tunes
> O for one of those hours of gladness gone alas! like our youth too soon.
> Was there ever a sweeter colleen in the dance than Eily More?
> Or a prouder lad than Thady, as he boldly took the floor?
> "Lads and lasses to your places; up the middle and down again"
> Ah! the merryhearted laughter ringing through the happy glen.
> O, to think of it, O to dream of it, fills my heart with tears.

James Molloy recalled his own boyhood in those nostalgic verses putting aside his memories of the Great Famine (1846–47), the scourge of the generation he had enshrined in that charmed past.[1]

The historian rarely understands completely the sophisticated nuances of a work of art and is always in danger of taking art too literally, believing that an overview of the paintings of a particular artist can expose virtually the entire course of that artist's career. This is a misconception of what art is, which the historian is apt to share with the public in general. Thomas Jones was a prolific portrait painter and the historian can all too easily fall into the trap of interpreting his personal life through those visual texts. Jones is a more complicated artist than he appears. He was a deserted child, his parents unknown. The Archdale family reared him in a large house in fashionable Kildare Place, off St. Stephen's Green, in upper-class Dublin. The Archdales were an influential family, well known for their philanthropy. They supplied the foundling with everything, including his name;

he himself added "Alfred" later. He was educated carefully, entering the Royal Dublin Society's school in 1831, and was sufficiently talented to exhibit a picture, *Vision of the Kings, a subject from Macbeth*, in 1841. In the matriculation register in Trinity College, Dublin, he was entered for 14 October 1842, but he left without taking a degree. He was abroad when the famine struck parts of Ireland. Returning to Dublin, he demonstrated a cosmopolitan training influenced by pre-Raphaelite technique and continental themes. In 1849, once settled in Dublin, he sent two drawings to the Exhibition of the Royal Hibernian Academy, one of which was the study of *Italian Peasants*. He exhibited again in 1851 (subject unknown), and in 1856 he submitted *Daughter of Erin*, which Holl engraved later that year. Thereafter he was a regular exhibitor and in 1860 was elected associate and then, in the same year, a member of the Royal Hibernian Academy. Nine years later he was elected president. Popular and industrious, he was knighted in 1880 by the Lord Lieutenant, the Duke of Marlborough, for his services to the Dublin art world—the first president of the academy, founded in 1823, to receive that honor (Royal Hibernian Academy, x–xxiii).

His oil paintings are numerous, some still hanging in institutions such as the Royal College of Physicians in Dublin, the King's Inns, various banking halls up and down the country, and the Belfast Public Library. Many of the great landowners of Ireland sat for him. Poorly painted, without great artistic merit, his portraits satisfied their subjects. His self-portrait hangs in the Council Room of the Royal Hibernian Academy. Jones was tireless in advancing the interests of the Academy, an indefatigable fundraiser, right through his time of office. Maintenance of the building was not government assisted, save for one instance in 1871 when the Board of Works repaired the roof of the academy building for £400. Jones's commitment to the teaching dimension of the Academy was realistic. He personally donated £1000 towards the construction of a room for the life school in the academy in the late 1870s. During his term as president the academy prospered: Dublin had two art schools and two annual exhibitions (Strickland 560–62). This was a singular achievement for a city whose artistic institutions were established in the post-Union period, after 1801, and much of the credit goes to Thomas Jones's period as president of the Royal Hibernian Academy.

Despite his success as a portrait painter, Jones continued to paint subjects that have proved more permanent as contemporary social commentary. In 1872 he exhibited *The Emigrant's Prayer*, and among the

Conyngham Collection that Christies disposed of in 1908 was *The Emigrant's Departure*, which the Marchioness of Conyngham had acquired. The painting *Molly Macree* dates from the 1860s but its provenance was for nearly eighty years somewhat of a mystery. The artist gave it to M. A. Halligan, and she gave it to the National Gallery of Ireland in 1947. It is not listed as having been exhibited in the 1860s, but the picture belongs unmistakably to the Irish colleen genre, made familiar to Irish viewers by Jones after the fashion of European painting.

Jones's portrait has the brilliant coloring of the pre-Raphaelite movement. It is a finely executed and stylish painting. Every detail is painted in a series of tiny brush strokes. The striking juxtaposition of the clear reds, blues, and greens of the shawl against the stained apron achieves a realism that remains with the viewer as a tantalizing question. Confidently, Jones has placed Molly Macree right up against the picture plane so as to evoke a kind of stage or backdrop. Seeming to lean out of the picture, she lightly props her head on one hand, and behind her, the wind-tossed sky and rain-sodden field bespeak the presence of natural forces greater than human ingenuity. By the 1860s the Irish Colleen and Molly Macree were favored themes of balladeer and musician. Unlike the Colleen Bawn, the Irish Colleen was not associated with tragedy; on the contrary, she was treated as a sweetheart capable of bringing joy to her lover. On one level, Jones treats her allegorically, and the longer one looks at the painting, the more obvious becomes its political statement. As a composition, it is disconcertingly direct, but its iconography expresses what is unrepresentable, disturbing— truths that lurk below the surface of this text of an Irish peasant girl in the years after the Great Famine.

The steep rise in population from a little over four million to eight million recorded in the fifty years before the 1841 census was checked dramatically by the famine years. The shrinkage occurred visibly between 1845 and 1851, when 800,000 died and over a million fled the country. Those statistics represent the poorest rural groups, the cottage dwellers and the tenant laborers. The famine precipitated the decline of the rural laboring man, leaving him in a precarious and landless position with little prospect of marrying. The corresponding rural woman was left with no prospect of advancing her status by marriage or acquiring respect by paid work. Most historians concur that women lost out in the aftermath of the famine. They did, insofar as women with small children, the old, and the feeble always suffer in times of disaster. Long before the famine, however, there was a slump in women's occupations as the cash-paying domestic textile industry

gave place to the centralized shirt-making factories of County Derry and the linen and cotton factories of northeast Ulster around Belfast. The fragile, dual-wage economy of the Irish peasant had been greatly weakened before the famine landed its final blow. Mary Cullen, in an examination of the family budgets of laborers in pre-famine Ireland, has demonstrated the extent to which women contributed to their households and, apart from their direct contribution to farmwork, how they supplemented the family wages by weaving and spinning. Her analysis of the 1835 Poor Inquiry shows conclusively that the women of destitute families in the 1830s were reduced to begging for survival (106–15). As if in anticipation of disaster, the Poor Law Act of 1832 authorized the building of workhouses in 163 zoned districts to deal with the massive wave of poverty and homelessness among families that had relied on the woman's earnings to pay the rent. Between 1841 and 1851, three of every four spinners of wool, linen, and cotton disappeared without trace from the work scene. The new workhouses began to function in the early forties: handsome enough in their stonecut design, totally alien in the Irish countryside, which they dominated. Capable of housing eight hundred inmates, they were planned as short-term shelters for "the deserving destitute." The famine quickly transformed them into refugee compounds, in which the geography of the buildings separated men from women and both from children. Twenty-five percent of all workhouse inmates were able-bodied females over fifteen years of age. Even in the 1860s, twenty years after the famine, the Cork Union recorded that over half the total population of its workhouses was made up of young, as well as aged and infirm, females. After the famine one estimate reckoned that 3.3 percent of the adult female workforce was listed as beggars, brothel-keepers, and prostitutes (Clear 5–14).

The narrative in *Molly Macree* is a silence, the unspoken constituting the discourse underlining almost every individual image of woman in art. The worn apron which partially covers the brown frieze skirt was the uniform of the young Irish woman in the decades after the famine. Reading the painting as a work scene, we see it as a document in which the public informs the private. Domestic service became a major employment pool for young girls after the mid-century. It was an economic necessity and, in a warped way, also an apprenticeship for the burgeoning domesticity that was increasingly defining the position of women. Putting a daughter "in service" was a safe option for parents, in tune with the ideology of Victorian Ireland, which considered housework and care of the farmyard suitable employment for young women. Urban employers hired indoor servants,

preferably young country girls. They became an essential element in the creation of the new bourgeoisie, whose private realm was ordered by the mistress of the house and by the relationship of woman to woman in the tight constraints of domestic bondage. Isolating in its working environment and an impediment to marriage prospects, domestic service provided a precarious sanctuary for the docile. It also allowed more independent young women to leave home and move from domestic service to other kinds of work, an exodus as decisive in its way as emigrating or entering religious life in one of the many new convents in Ireland (Herne 55–60).

Perhaps it renders a disservice to Thomas Jones to take apart a painting of such charming proportions and careful artistic integrity to exercise a kind of historical deconstruction upon a text so plain to read. The shawl is richly patterned in strong focal tones of blue and red against a cream background. It is fringed with a skillful blend of floral arrangements that picks up the differing browns of the skirt and the somber landscape behind. On the left shoulder is an unusual Celtic design, and the shawl is folded into a patterned crimson belt not unlike an Aran Island *crios* (girdle). Is the artist suggesting that a change was taking place in fashion, fashion here meaning "that which is worn," that a new concept of fashionableness had arrived as cheaper manufactured textiles supplanted the hand-knitted shawl? The question begs an investigation of how changes in external dress signaled a new self-consciousness in the wearer, connected with the transition from homemade to manufactured goods. The shift was accompanied by the network of railways bringing the ready-made garments to the expanding shopkeeping middle classes of the country towns. Laying aside the traditional cloak and petticoat was as much related market pressures as it was a gesture of farewell before embarking for another life beyond the island. From the folds and details of Molly Macree's shawl, the eye is drawn to the face above, a face saved from being "pretty-pretty" in the Baudelarian assessment of a poor portrait, by the fine, widespread, grey eyes and the spacious brow over them. The hair, brown and wavy, is drawn back in an oddly mature style for so young a face. The expression is serious, though the mouth is smiling. It is the face of a calm, intelligent girl of perhaps sixteen years of age.

By the 1860s literacy and schooling had become an important goal for Irish girls. The national schools, set up by government orders thirty years previously to provide free education, required voluntary attendance only, yet a perusal of existing roll books reveals that female children were attending school in accelerating numbers from the 1860s onward. The growth

and spread of towns were economic incentives for the building of schools, and convent schools dominated the country towns and the cities in many areas (Fahey 16). Literacy, defined as the ability to read and write English and to be numerate, was the desired objective. In the west and southwest of Ireland, spoken Irish declined and the connection between startlingly high school attendance rates among both sexes and work-related emigration is obvious. Irish girls looked upon emigration as an escape, one sanctioned by their parents. They were, in fact, the first to depart, in clusters of siblings or quite often alone, to regions where spoken and written English were proven qualifications for seeking positions. Literacy was the key to a better life. Schooling replaced powerlessness with a command of one's own destiny, of being able to access a life overseas. Willy-nilly, despite the ugly reality of destitution, life after the famine, from the 1860s onwards, became more diversified than census returns and their rigid classifications indicate.[2] Survival after a harrowing ordeal is always a barometer of a society's will to live, and the strategies that its women develop provide significant clues about the values of that society. Will those who survive want to reconstruct the past and repopulate the landscape? Or will they purposefully set their faces to a future that is unknown, intimidating, but withal emancipatory?

Celibacy, the notion of *"le célibat definitiif"* as developed by the French social historians, emerged as a choice and lifestyle after the famine. It contrasted sharply with the early marriage patterns of the previous hundred years. The Irish population rose from an estimated 4 million in 1780 to 6.8 million in 1821 and 8.2 million by 1841. The most obvious features of that dramatic rise were the early age at which marriage was entered into, the universal popularity of marriage, and the average size of family, generally between ten and fifteen children. After the Famine of 1846–47 (during which nearly one million died), the flow of emigration has been estimated as the chief factor in bringing the population down to 4.4 million by the end of the century. Marriage as an institution in post-famine society became rigid, and for marrying men, the timing was largely determined by succession to land, and by the arrangements around dowry. The distance in age between the late-marrying farmer and his much younger wife perpetuated a structure of strong paternalism. Consolidated by the central position of the widow in family decisions, it in turn postponed the heir's inheritance and eventual marriage. Parental authority wielded significant control over adult children's behavior and desires, achieving within family considerations a precarious balance between marriage and celibacy. A rigid

code of sexual morality imposed uneasy relationships between the unmarried man and woman in both town and country. In a study of marriage in post-famine Ireland, Dr. David Fitzpatrick observes: "For women, the moment of marriage was less tightly tied to their parent's aging process. Nevertheless, the marriage ages of men and women followed quite similar patterns. Parents were reluctant to release one fortune far in advance of receiving another, and encouraged their daughters to remain in service either at home or as hired workers during the years of peak strength following puberty" (119).

Made marriages, the "match," and the payment of dowries gave daughters little maneuverability in that period when claims to land among siblings or compensation for waiving a birthright placed restrictions on the size of a dowry and the appropriate moment of inheritance. The dowry, which formerly was paid in land or animal stock, became a cash settlement capable of being commandeered during family crisis. Fitzpatrick concludes that by the beginning of the twentieth century, restrictive marriage arrangements were well in place: "With the aid of massive emigration, the post-Famine Irish managed to build themselves a drab but functional way of life not too unlike that of their parents" (129). Demographically Ireland became a notably "celibate" society with a high proportion of bachelors and spinsters. In his appendix of those who had never married, among those between ages forty-five and fifty-four, Fitzpatrick does not classify those who remained celibate in the service of the Catholic Church. Between 1851 and 1861 the average age of women entering convents and becoming nuns was 26.2 years. The average amount of a dowry for a choir sister was £500 in the 1860s. For the dowerless girl, religious life offered the role of lay sister whose work and station resembled those of a domestic servant. She was expected to engage in household chores, take charge of the convent farm and garden under supervision of a choir sister, and be content to live without an "active" voice in convent elections for leadership positions. Her story, largely unexplored, had to do with personal autonomy, with security, and with the exercise of informal power in kitchen, farmyard, and laundry. Judging by the numbers who applied for admittance, convent life, either as a choir sister or a lay sister, was an agreeable choice in the 1860s. The census of 1861 shows 68 percent more nuns in Ireland than there had been ten years previously, when there were an estimated 1552 nuns. Entry to convent life, like emigration, continued to rise for women in Ireland throughout the nineteenth century and well into the twentieth (O'Connor 36–42).

Life for working women in the 1860s was drab. Physical desire was muted and death from tuberculosis struck often, sparing neither young nor old. To be an unmarried daughter without dowry affected status within the community. In a patrilineal family dominated by property arrangements, daughters were commodities. Fortunately emigration and the convent provided escape routes that could be negotiated between parents and children. Molly Macree looks out at the viewer from her seated position in a ditch of rain-sodden ferns. Behind her, trees, river, and cornfield are suffused with an atmosphere of bronze-gold light, the sky overhead threatens more flooding. Her posture is composed, even serene. Confidence informs her body and her expression. Her world was far removed from the seventeenth-century aristocratic captivity of Roisin Dubh, idealized in the male-filtered images of the elite poets of eighteenth-century Ireland who wrote in Irish and could not have anticipated that language's decline in Molly's lifetime. She is not a celebratory figure and yet she is a window into that epiphanic world that Yeats created in his invocation of Ireland as Cathleen Ni Houlihan over forty years later. Aodhgan O'Rathaille, the great Gaelic poet of the previous century, would have recognized her "brightness of brightness I saw in a lonely place."[3]

Clearly, Thomas Alfred Jones merits a more detailed study as a painter and as a personality of some weight in Dublin artistic circles. As president of the Royal Hibernian Academy, his judgment was critical in the admittance of new members and in giving fresh directions to the frequent exhibitions. In 1871 the Watercolour Society of Ireland, founded by six women, held its first annual exhibition, providing a respected outlet for the amateur artist. The annual exhibitions of the Royal Hibernian Academy, which showed the works of many foreign artists, throve under his administration. More than 35,000 viewers attended the 1880 exhibition. From 1884 to his death, Jones was professor of painting, an honored position in the academy. In 1991 the editors of the fine catalogue that accompanied the Irish watercolors and drawings exhibition at the National Gallery of Ireland chose *Molly Macree* for its frontispiece.

In the catalogue entry, Adrian Le Harivel places her in the context of a post-famine inconography when "such images of Ireland were understandably popular and part of the received imagery of the countryside" (98). What the historian would now request from the art historian is a study of the ideological in the Irish Colleen genre of that period. Class and gender are quite overt in *Molly Macree* and generally so in representations of the Irish colleen, but as Le Harivel suggests, a further coded message in *Molly*

Macree renders the painting an image of Ireland. After the famine public discussion of Irish nationalism gradually assumed the proportions of a major ideological discourse, communicated at a popular level through broadsheets, ballads, pamphlets, new forms of journalism, and artistic iconography. Ideology finds avenues to express itself in a variety of texts and the visual image is a powerful conveyor of the political text. It is only by the viewer's ability to decode and interpret—as well as respond to—the artist's composition that new modes of recognition surface. Tastes change over decades and the art historian explains what is taking place at a particular time, guiding the public beyond the constraints of present-day fashion to better understand the narrative and the techniques of a painting, as well as the issues that spoke to that society through the artist.

NOTES

1. See reference to James Lyman Molloy in H. R. Diner, *Erin's Daughters in America, Irish Immigrant Women in the Nineteenth Century*. Baltimore and London: Johns Hopkins University Press, 1983. 24.

2. M. E. Daly points out that the census returns are an inadequate representation of the role of women in the economy. The under-recording of women in agriculture and, in the later nineteenth-century returns, the invisibility of dressmakers, washer women, small shopkeepers, and hucksters blur the census figures for women's work. In "Women in the Irish Workforce from Pre-industrial to Modern Times" in *Saothar* (Journal of the Irish Labour History Society), 1981. 74–82.

3. Aodhgan O'Rathaille, eighteenth-century poet, wrote a celebrated poem on the vision woman, a many-layered theme in the *Aisling* (literal meaning "vision") poetry of that period. O'Rathaille's poem, *Gile na Gile, Brightness of Brightness* may be found in several versions. Cf. *An Duanaire, 1600–1900. Poems of the Dispossessed.* Eds. T. Kinsella and S. O. Tuama. Mountrath: Dolmen Press, 1981.

WORKS CITED

Baudelaire, Charles. "The Painter of Modern Life." *Selected Writings on Art and Artists*. Ed. P. E. Charvet. London: Penguin, 1972.

Clear, Caitriona. *Nuns in Nineteenth-Century Ireland*. Washington, D.C.: The Catholic University of America Press, 1987.

Cullen, Mary. "Breadwinners and Providers: Women in the Household Economy of Labouring Families 1835–6." *Women Surviving: Studies in Irish Women's History in the 19th & 20th Centuries*. Ed. Maria Luddy and Cliona Murphy. Dublin: Poolbeg, 1980. 85–116.

Fahey, Tony. "Nuns in the Catholic Church in Ireland." *Girls Don't Do Honours*. Ed. Mary Cullen. Dublin: Web, 1987. 7–30.

Fitzpatrick, David. "Marriage in Post-Famine Ireland." *Marriage in Ireland*. Ed. Art Cosgrove. Dublin: The College Press, 1985. 116–31.

Hearne, Mona. "Life for Domestic Servants in Dublin, 1880–1920." *Women Surviving: Sketches in Irish Women's History in the 19th & 20th Centuries*, 148–70.

Le Harivel, Adrian. "Molly Macree 1860s." *Irish Watercolours and Drawings*. Dublin: National Gallery of Ireland, 1991. The author is grateful to Dr. Brian Kennedy, Assistant Director, National Gallery of Ireland, for suggesting possible sources for details of Thomas Alfred Jones's life.

Nochlin, Linda. "The *Cribleuses de blé*: Courbet, Millet, Breton, Kollwitz and the Image of the Working Woman." *Malerei und Theorie: Das Courbet-Colloquium 1979*. Ed. Klaus Gallwitz and Klaus Herding. Frankfurt: Städtische Galerie im Städelschen Kunstinstitut, 1980. 49–74.

Nochlin, Linda. *Women, Art and Power and Other Essays*. New York: Harper & Row, 1988. In her key essay, "Women, Art and Power," Professor Nochlin refers to her previous work for the Courbet Colloquium and incorporates some of the insights into this essay. 1–35.

O'Connor, Anne V. "The Revolution in Girls' Secondary Education in Ireland, 1860–1910." *Girls Don't Do Honours*. Ed. Mary Cullen. Dublin: Web, 1987. 31–54.

Royal Hibernian Academy of Arts, Vol. 1, A–G. Index of Exhibitors and their works 1826–1979, compiled by A. M. Stewart with a summary history of the R. H. A. by C. de Courcy, x–xxiii. Dublin: Manton Publishing, 1985.

Strickland, Walter G. *A Dictionary of Irish Artists*. Dublin: Irish Academic Press, 1989. Two volumes with an introduction to the reissue of the original 2 vol. work (Dublin and London, 1913) by Theo J. Snoddy, Vol. 1, 560–65.

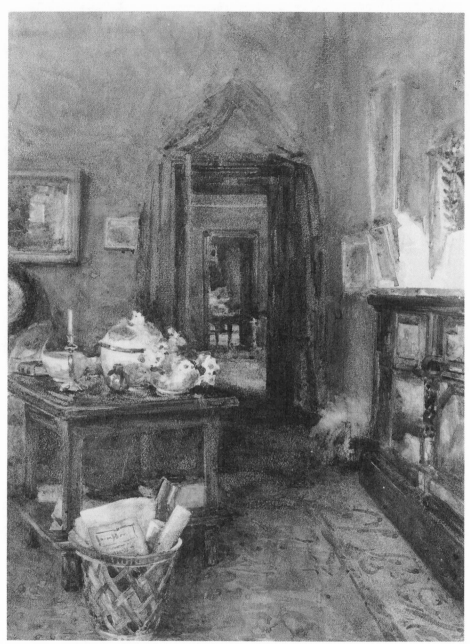

2. Mildred Anne Butler (1858–1941), *Ancient Rubbish, Kilmurry*, watercolor on paper, 36.5 × 26.4 cm, National Gallery of Ireland no. 7955. (Courtesy of the National Gallery of Ireland)

Ancient Rubbish and Interior Spaces: M. A. Butler and M. J. Farrell, Dis-covered

Kristin Morrison

IN HER PAINTING *Ancient Rubbish, Kilmurry* (plate 2), Mildred Anne Butler treats an interior architectural space ambivalently, as indeed do some Irish novelists from the earlier part of this century, especially M. J. Farrell. Here Butler disparages the visual elegance of a comfortable family room, judging it "rubbish" and extending the scope of that disparagement by the word "ancient." Similarly, M. J. Farrell often presents a grand country house as visually admirable even while condemning what has occurred in its rooms over several generations. Both Butler's painting and Farrell's novels show that passage through the interior spaces of these dwellings leads from what is public, open, and available to what is intimate, secret, and in various ways "dark." This essay will explore these images of rooms, their architecture and furnishings, along with the fictional and historical "secrets" rendered by the diverse idioms, writing and painting.

To juxtapose painting and writing, to couple Butler and Farrell, is to suggest neither the influence of one on the other, nor a single source, even though the two women had much in common as daughters of fine country houses in the south of Ireland. Mildred Anne Butler (1858–1941) spent most of her life at her family home, Kilmurry,[1] Thomastown, County Kilkenny, its beautiful garden and surrounding countryside of meadows and lake providing subjects for much of her painting. Mark Bence-Jones, in *Burke's Guide to Country Houses*, refers to Butler as "the eminent water colour painter" and notes that she bequeathed the estate "to her cousin,

23

Mrs. Archer Houblon, the equestrian" (175). Privilege, leisure, and riding were equally familiar to M. J. Farrell, pseudonym for Molly Keane (1904–), who was born in County Kildare to what she describes as "a rather serious Hunting and Fishing and Church-going family" (Farrell, *The Rising Tide*, i). Unlike Butler, whose family fostered her talent, allowing her to study art in London and on the continent, Farrell was given little formal education and initially practiced her art in secret, simply (as she once said) to supplement her dress allowance (Keane, "Molly Keane" 65–78; *The Rising Tide* v). Both women, however, gained international recognition of their work and earned significant money as artists. And both regularly took their subjects from that same landed Anglo-Irish world into which they had been born and in which they spent their long, highly productive lives. Whether they ever met socially despite the forty-six year age difference, whether Butler ever read Farrell's novels or attended one of her plays popular in London's West End, whether Farrell ever saw any of Butler's paintings in a museum or at the home of a friend or perhaps even owns one herself—these are questions for a life of Butler or a life of Farrell still waiting to be written.* But the answers are unnecessary for an essay such as this, which is not focused on biographical connections or artistic influence, but instead uses one art form as catalyst for thinking about another. In the presence of Butler's painting, any reader of twentieth-century Irish fiction must look more closely at Farrell's novels.

Although Mildred Butler preferred landscapes—her favorite subjects were gardens and birds—she often painted such work from "unusual viewpoints, from roof tops, down slopes and so forth . . . [with] broad washes, strong colour, and understanding of sunlight and shadows" (Crookshank 26). Architectural subjects too (such as her luminous study of the Thomastown bridge over the river Nore or her rendering of Kilmurry seen through trees across a lake) lead the viewer toward a space that remains in shadow, unexplored: the arched recesses of the bridge, the interior of the house itself. Even her whimsical and charming study of pigeons flocking to a spilled bag of meal is titled *A Preliminary Investigation*, thus stressing a fas-

* That Butler knew this world of Irish women watercolorists is indicated by a passage describing the morning room of a Big House in one of her later novels: "It was a delightful, careless room, untidy and rather deficient in comfortable chairs. Everything expelled from other places found a haven here, including the only good pictures in the house—a couple of Rose Bartons, bought by Aunt Tossie at a church sale...." (*Loving and Giving*. London: Sphere Books, 1989. pp. 59 f). For discussion of Rose Barton's work, see the essay by Vera Kreilkamp in this volume.

cination with what is hidden and dark. In that work, the fantailed pigeons of dazzling white, occupying the bottom two-thirds of the paper, ignore the spilled golden grain at their feet and approach instead the dark interior of the bag itself.[2] Another painting reverses this perspective and color patterning: a large and strangely disturbing study of three crows, the cause of whose alarmed postures is not apparent until the eye registers the tiny figures of a few boys flying kites at the end of a distant field. The title of the painting urges the viewer to adopt a mock heroic attitude toward the piece, *And Straight Against That Great Array Went Forth the Valiant Three* (from Macaulay's *Lays of Ancient Rome*), but such levity does not offset the ominous mood of the painting, dominated by the huge birds black against the shimmering sky. The viewer is positioned in the "wrong" place, cut off from the human world of the boys in their sunlit field and caught close behind the looming angry birds on their dark and thorny perch. Once again a painting of Butler's suggests something "hidden," but this time with reversed perspective: the boys are unaware they have caused the rooks' distress, but the viewer is "inside" that distress, engulfed by its darkness. In a more typical subject and more conventional structure, Butler renders *The Lilac Phlox, Kilmurry, County Kilkenny* with a great sense of tranquillity, luminescent in classic lilac color and a white-green. But even here the titular flowers occupy only the bottom quadrant of the large paper (36.1 × 54 cm); the viewer's eye is led past the gorgeous border, up the path toward a large, open iron gate with a more highly lit path and border beyond. Butler suggests that what is even more enticing lies deeper into the garden, further than the viewer's eye can see.

This preponderance of outdoor scenes, arresting in their viewpoints and suggestive use of light and dark, makes the rare interior scene all the more interesting, especially when the subject is a room in the beloved house Kilmurry and the title is *Ancient Rubbish*. The most brightly colored and most detailed objects—a basket filled with papers, a table with a candlestick, an empty blue vase, a bowl of anemones, a large covered china tureen, a smaller bowl, a scatter of books—appear in the foreground, placed to one side of the central axis of the vertical composition (36.5 × 26.4 cm). However, none of these objects can compete for attention with the centrally placed doorway, its heavy curtains pulled back to reveal yet another large room, and beyond that, a third. The eye is led through a passageway of rooms, even more commanding because of the pointing arch formed by the curtains. Two elements of the composition are especially remarkable: the farthest room appears to be a mirror image of the first room; and despite

strong pools of light on their floors, the second and third rooms seem progressively darker than the first. The table, its bowl and flowers, the picture on the wall behind in the farthest room are all hazy duplicates of corresponding parts of the first room: they whisper, "This hidden room is like that public room, but darker." Such compositions with corridors of rooms are not unusual in nineteenth- and early twentieth-century painting. Henri Matisse's *Interior, Flowers and Parakeets* (1924)[3] is similar to Butler's *Ancient Rubbish* both in structural layout and color tones, but Matisse's vertical axis leads to a window, through which sky and other buildings are visible. Butler's leads to strict enclosure, a secret.

There are no hints of what that secret might be, aside from the title of the painting itself. Something here constitutes "ancient rubbish." The most obvious candidate is the foreground basket, yet it has a decidedly unrubbishy look, containing carefully rolled scrolls, unrumpled sheets of paper, a pamphlet of some kind with attractive pink cover and lettering that looks invitingly legible. The freshness and the neatness of the basket, indeed of the whole room, belie both "ancient" and "rubbish." What then? The unseen beckons. That far room may hold an answer, but the viewer will never enter it. Forever remote, hidden, obscure, dark, mirroring what is visible in the first room but without its basket; that interior space—with whatever rubbish is there—will remain secret, never seen.

Mildred Butler was entirely "apolitical" in her painting—no maimed cattle, no burnt ricks. That her last painting "of studied nature" (Crookshank 29)—crows fighting over a piece of food in the snow—was titled *Famine* suggests some blindness to the historical and political world around her. Born the same year the Fenians were founded, just a decade after the Great Famine, she lived through years of crop failure in 1878–81 and the 1890s, the Land War and the Plan of Campaign, the 1916 Rising, the Anglo-Irish War, and the Civil War, none of which show in her work. Perhaps because her beloved Kilmurry was not burned down in the many attacks on property during her lifetime, she could continue to paint gardens and birds, and to avoid reckoning, at least publicly, with the darker resonance of the phrase "ancient rubbish." Such a restricted view is, of course, itself a political position. Resolute focus on the beautiful in its genteelly approved manifestations certainly suggests insensitivity to surrounding turbulence and suffering and seems to signal an insistence on the superior values of a gracious and privileged life; an allegiance to the continuance of that life. But however Butler viewed her nation's great events, her painting remains gently private and domestic. Only her odd perspectives,

patterns of dark and light, and unusual interior spaces suggest that there might be serious "rubbish" to contend with, hidden away in recesses of the heart of the past.

After a look at Butler's paintings, with their pathways into remote and hidden regions, a reader of M. J. Farrell's fiction becomes even more aware of the secret spaces there. Her work, too, is full of rooms, some beautiful and comfortable, others hidden away and mysterious. But Farrell lets the secrets show. Nor are politics and history absent.[4]

In one of Farrell's best known earlier novels, *Two Days in Aragon* (1941), architectural spaces render externally the inner lives of her characters as analogues of their larger historical and political context. The two daughters of the house, for example, are epitomized by their bedrooms. Cool, precise Sylvia keeps her river pearls in a quiet room of "whites and greys and near-greens" (234); plump, untidy, emotional Grania chooses cretonne, net, lace, satin fittings with blue birds and masses of pink blossoms, "a dreadful example of girlish taste of the date" (143). Relegation to the old nursery bespeaks the marginal and dependent position of Miss Pidgie, the sisters' spinster aunt.

The most complicated character, Nan, is associated with several rooms. As a secret bastard child of this Big House, born of dalliance between a maid and the young master, she glories in sharing lineage with the family while maintaining the respectful distance of a servant. Reared as the gamekeeper's daughter, Nan is trained as a nurse and given opportunities to escape Aragon, but she chooses instead to serve and to possess it, as the children's nanny, as personal confidant of the infantile Mrs. Fox, as housekeeper for the estate. Her power becomes virtually absolute, directed by her own sense of what she wants: to control Aragon and to preserve its greatness, but to do this as a servant. Thus she keeps to the back stairs, while secretly rejoicing in her blood right to the front staircase. The nursery is her special kingdom, for there she has had total control over children of the Fox family. In a particularly revealing chapter, she sits there sewing, reveling in her thoughts of Aragon and her own identification with it: the linen she works is of the best, stitched with identifying red marks just as Aragon itself is marked "with the blood of her life and the strength of her mind and her body" (106). And when, at the end of the novel, just before she dies, Nan watches Aragon burn (as if her own soul were burning, "For Aragon was her soul"), what first catches her attention is the linen room in flames: "My linen, my pillow cases, my sheets," she cries. "Like all the furnishings of Aragon, they were hers. . . . Hers to keep from sun and moth

and careless hands—most truly hers who could so cherish them, playing
the careful steward to their excellence" (253 f). Through passsages such as
these, Farrell exposes without comment the subtle power of one class over
another, domination in which the servant exults in servitude.

The ghosts Nan feels all about her in Aragon, especially on the night
Hugh Fox acknowledges her as "cousin," include spirits of servants' babies
killed in infancy or aborted during the many generations the Foxes have
lived at Aragon. Nan's own mother had told her "tales of childbeds in far
corners of the big house, and pale heavy-breasted girls dragging themselves
again about their work," tales of Anne Daly, who killed the infants and put
them in the river, or brewed potions for abortion "if a girl went to her in
time with her trouble" (108). Ironically, years later, when Grania fears she
herself is pregnant by a "servant," Nan wants to force her to have an abor-
tion, and muses that "cruelty and pain and tears and death had been com-
mon mates to childbirth at Aragon. The family and the house had kept
their horrid ministers for such times, women like old Anne" (156). Thus
these remote and specialized rooms of the grand house harbor secrets that
touch both classes, masters and servants.

The most secret room in the house, however, is also most revealing: a
hidden chamber of sadistic and guilty pleasure, deep in the basement, cut
off from the rest of the house, unused for several generations but still redo-
lent with "an air of past luxuries" (193). The mirrors, the "contrivances,"
the "delicate ivory-headed cutting ships and other fine and very curious
instruments" according to the narrating voice explain the streak of cruelty
in the Fox family, a streak that manifests itself in Nan, too, and in her son
Foley, Garnia's lover.

All these private vices and venues come together in the central political
action that shapes the plot. Nan's cruelty to a lesser servant boy and Foley's
cruelly selfish dalliance with Grania are the proximate causes of Aragon's
destruction. That mistreated serving boy returns in 1920 as an IRA gun-
man charged with killing some of the British soldiers who frequent
Aragon: burning the house is his own personal act of revenge (184). He
begins by spitting on the drawing room carpet and breaking a china figure
he had admired as a child (237 f). Then he sets fire to the house, destroying
all the rooms, both the elegant and the shameful. As Nan stands bound and
gagged outside, forced to watch, her cruelty and its retribution become
emblems of Anglo-Irish mistreatment of native Irish; the privileged Big
House, Aragon, an emblem of colonized Ireland.

But since M. J. Farrell's view of history is not the simplistic one that

assumes Catholic servants to be "native" and Protestant landowners to be "foreigners," she lodges the ultimate cause of Aragon's destruction within the house itself. Those hidden rooms of cruelty and exploitation are architectural equivalents of secret traits infecting masters and servants alike, those that share the Fox family blood and those that do not.

Aragon is purged of its past by fire. Farrell hints at a happier future, when the house, like the nation, will be rebuilt (255). But though only Nan, among the household members, perishes in the fire, and though all the soldiers, British and IRA, escape death, the final words are less than optimistic. After the horror of Nan's death, the sisters, Grania and Sylvia, sob together and hold hands, united in sympathy for the first time in the narrative. Yet, even now, "Neither told the other what lost love she mourned" (256). Both girls have lost love and innocence (Grania's loss is sexual and emotional; Sylvia's, philosophical and political), but each keeps her painful "secret." Fire has torn open the house of Aragon, but secrets remain.[5]

The persistence of dark and damaging secrets is particularly intriguing in *The Rising Tide* (1937). Throughout this novel two houses are sharply contrasted with each other: the ancestral mansion Garonlea (dark, depressing, austere, traditional, conformist) and the dower house Rathglass (light, modern, pleasure-loving, independent, liberating). M. J. Farrell indicates early that the melancholy shrouding Garonlea haunts its residents (34) and that the loveliness of Rathglass fosters love among those within (81); thus in both cases, the two houses are analogues for the lives they embrace. When Cynthia—strong, successful bride of Rathglass—finally inherits Garonlea, she cuts back "the trees and laurels and rhododendrons [that] had pressed dark and close round the house" (250). By opening up vistas outside and removing the dark wallpaper and cluttering furniture inside, Cynthia triumphs over her deceased mother-in-law, Lady Charlotte, with whom she had had a contest of wills for two decades (268). But the clear contrasts of architectural design and personal style manifest in the two houses and the two women do not themselves indicate the important secret chambers of the novel. Though Lady Charlotte is ponderous and rigid, and Cynthia vital and charming, they are nonetheless very much alike: strong, cruel, manipulative, exacting, utterly convinced of their queenly right to rule. Their differences are those of eras; Lady Charlotte is a woman of the nineteenth century; Cynthia, of the twentieth.

The hidden reason for the "terrifying contrast" (122) between Rathglass and Garonlea is to be found not in their châtelaines, but in a resident of

both houses leading a marginal and dependent life: Diana, Lady Charlotte's youngest daughter, a passionate nonconformist who never marries, serving instead as adoring acolyte to Cynthia. Her normative position in the novel is established by the admiration and the affection of Simon and Susan, Cynthia's children, who from childhood into adulthood (long after they move from fear of their mother to hatred and contempt) continue to seek Diana's company. A discerning visitor from the world outside describes Diana as "altogether truthful and sane" (272).

For Diana, Garonlea was a repressive home, Rathglass a liberating one, not because of architectural closure or openness, darkness or light, but because she has a deeply rooted secret, unknown perhaps even to herself. Without ever stating it directly, Farrell makes clear that Diana is lesbian. Garonlea allows her only the role of traditional femininity; Rathglass permits her to dress, speak, move, ride her horse, and devote her soul as she wishes. The closest the text gets to explicit admission is in its comment about Diana's "spruce little dinner-jacket" and short hair: "Simon helped her to dress like that. Although he was at Cambridge now, he scarcely realised the implications. In 1922 a great many people did not. Especially in Ireland" (213).

What is really interesting here, of course, is that Ireland in 1922 had issues much more critical than closet homosexuality. Aside from two brief references to Ireland "in a state of war" (200) and in a "civil war" (208), Farrell seems unconcerned with contemporaneous political events. But perhaps Diana's personal secret relates to those political events more than the reader first supposes.

Returning to Rathglass after attending a family gathering at Garonlea when her mother dies, Diana perceives her walk from the place of stultifying darkness and depression back to the place of sun and liberty as a movement within herself from sickness to health. But M. J. Farrell uses a strange metaphor to elaborate this experience: "Very slowly she felt the first thin returning tide drawn through her, drawn by her as though she was the moon. It came slowly, curling, falling small waves where sands had dried and bleached again in the sun that afternoon. Sands that had been covered for four years" (154). Oddly, Farrell associates this covering "tide" with Rathglass, and the bleaching sun with Garonlea, a complete reversal of the imagery associated with the two houses throughout the rest of the novel. Yet in this passage, it is clear that the covering tide is salutary while the bleaching light is damaging. Something within Diana, her "sand," needs a barrier, protection. Comforted and restored by her return to this beloved

house and the garden she tends there, Diana breathes the "thrilling animal scent" of lilies, and once again the water image appears: "She thought that forever this scent would haunt her with her present fear and unhappiness. How deeply exciting she should have found it. She could see it all so sharply, but she could not feel it. She could not be quite conscious, she was looking through glass or through water. She went out of her garden and would not go back because she was so afraid" (156). The changing antecedents of the blurred "it," as well as the sexual suggestiveness of the "thrilling animal scent," indicate the extent to which Diana denies her erotic predilections. Her sudden fear is inexplicable because Rathglass has allowed her both unwitting expression of her lesbianism and a respectable cover for it. Garonlea would have forced her into frightened realization by assigning her a traditional role. Farrell indicates, a few pages later, the connection between this particular water image and an ambivalent erotic passion, of whatever sort, when Cynthia's widowed continence is shattered by a new lover. "She felt as if she was sliding between glass and water" (175).

Although titled *The Rising Tide*, this novel rarely mentions tides; thus these three water references stand out, especially when associated with two estates firmly terrestrial. (Even their names reinforce this earthiness, Garonlea meaning place of the shrubbery, and Rathglass, green ring-fort.) The only other two references to tides also pertain to beauty and eros. Transformed for a party by Cynthia and Diana, the drawing room at Garonlea is as "full as a full tide with the river and the garden and the evening" (163); and later Cynthia is described as having been "a queen too long, and the tide of her beauty was too surely on the turn" (206). In context, both metaphors imply that beauty carries an erotic charge and suggest the excitement and danger inherent in eros.

Thus, references to tides are linked to two women, and these women are linked to two houses. Cynthia practices heterosexual eroticism openly and very successfully; Diana sublimates and secretes her homosexual eroticism. When Simon, at his majority, gives the party that destroys Cynthia's power, he invokes the Garonlea of the past, dark and restrictive. A reluctant party game participant, Diana recognizes the danger in the charade in which players delve into the attics of Garonlea for clothes from previous generations. "'If you know Garonlea half as well as I do, you'd know there was danger round every corner and behind every shut door in the house'" (271). Her closeted homosexuality makes Diana especially sensitive to secrets.

During another of the party games, hide-and-seek (the discovery of

what is hidden), Sylvester—a guest who supplies the neutral view of an outsider—remembers Diana's words about danger: "Danger. Behind every shut door in the house . . . and not asleep either. Where so well as in the course of such a game could one see and feel the atmosphere in unused rooms and stuffed, airless attics? The very fact of being fugitive, or seeking, hunting or pursued, lent an antic isolation to such a spying out, such a ghost-smelling as this might be" (275). Finding among the objects in one of these hiding places "two life-size black boys in Saxon porcelain" (277), Sylvester quips to Diana that her grandfather "must have had the strangest fancies." She, of course, misses his meaning and sees the figures simply as expressions of bad taste. But the reader understands both this reference and the function of these passages that describe forays into the attic. They suggest hidden vices, all placed at the center of the party that destroys Cynthia with her light and love, reinstating instead the power of a darkened and restrictive Garonlea. Doors close again on vices, hidden but nonetheless there.

All the fox hunting and ratting that regularly occur throughout the novel also reinforce the sense that hidden evils infest the estate. Yes, these were necessary activities actually pursued, but that realism simply enhances their effect as analogues to the hidden vices suggested by the secret rooms and closed doors. No matter how many rats and foxes are killed (with great orgiastic pleasure), the beasts remain. The earth teems with their tunnels. They cannot be extirpated, nor should they be, for how would these people then occupy themselves?

The secret evils M. J. Farrell codifies within darkness, water, charades, hide-and-seek, fox hunting, and ratting themselves become metaphors for what is most hidden in the novel and, at the same time, most present: its actual historical moment. Throughout the entire novel three brief references to war suffice: all Irish readers in 1937 would have been acutely aware that the action is set against the background of the Anglo-Irish War and the Civil War. They would have been struck immediately with both the truth and the falsity of the following passage: "That horse show was like every other Dublin Horse Show. In spite of the fact that Ireland was at the time in a state of war, the Horse Show was its usual and inevitable social and business success. . . . The whole of Ireland went there" (200). There is no denying the truth of the picture M. J. Farrell then paints of "women in grey flannel coats, . . . busy men in clean breeches, . . . less-busy men in suits and bowler hats, . . . Indian princes in Jodhpurs, . . . old ladies coming to see the flower show, . . . foreign soldiers in Belgian blue and French

grey" (200), but the situational irony in her passing observation that "all Ireland and England that could squeeze into the stewards' box had done so" (204) should trouble even the hastiest of readers. The throng may be diverse, yet harmonious; the horse show may achieve the "usual and inevitable social and business success"; but did Farrell mean to imply that the "whole of Ireland" is really there?

Is Ireland whole? Not with a civil war in progress. But Farrell does not at first name the nature of the war, any more than the festive spectators and participants at the horse show discuss it as they buy and sell. The irony of English, Irish, and Indians (colonizer, ex-colonized, and still-colonized) in amical common endeavor is inescapable though unstated.

The only open reference to the Civil War occurs in the next chapter, buried in discussion of Cynthia's waning love life: "That winter Garonlea was strangely isolated from the near world of neighbors. A civil war was going on in Ireland, much to the inconvenience of social life" (208). Here the irony is not only situational, but also verbal; there is an edge to the narrating voice that combines "civil war" with "inconvenience." But M. J. Farrell declines to develop that irony or touch on it again in the novel. She leaves the political analogy hidden. Whatever parallels exist between history and growing repressiveness at Garonlea, after its brief respite of openness and light, whatever parallels exist between the Irish Free State and Cynthia's failed youth and beauty, or the incestuous self-satisfaction of her now-powerful children—all such political analogies remain hidden, like a secret vice behind a closed door, so much ancient rubbish.

Just as Butler's work prompts the reader to look for secrets couched in Farrell's, Farrell's novels send the viewer back to Butler's paintings with a new eye for political nuances. In *Ancient Rubbish* the duplicate rooms are hung with paintings that can be neither seen nor "read." The most nearly legible item is the sheet of pink paper in the rubbish basket, prominent in the foreground. With it are large flat pieces and a crisply rolled scroll, all of them white and uncrumpled. The top tinted piece suggests a broadside or the cover of a pamphlet or document of some kind, with a heading and decorative detail. Tucked to the side of it, behind the scroll, is something that looks like a book, the whole group neatly fitted into the wicker basket. Discarded these papers may be . . . but rubbish? Hardly.

Anne Crookshank guesses that Butler painted the undated *Ancient Rubbish* in the late 1880s because of the predominance of brownish tones (31); Fionnuala Croke guesses 1901 because of the similarity to another interior scene at Kilmurry painted at that time (42). Whatever its precise date,

period and social class are clearly suggested by the style of late nineteenth-century furnishings in a comfortably informal room. What would a privileged turn-of-the-century Anglo-Irish woman have been likely to discard as ancient rubbish?

The tantalizing near-legibility of the front paper in the basket invites speculation. Clearly this pink pamphlet is not the famous *Yellow Book* of 1890s decadent literature. Could it be sheet music, some popular songs of the day in sentimental mauve? The size of the paper seems wrong. A copy of the Home Rule bill? Daniel O'Connell's speeches? A Pankhurst pamphlet? After several wild surmises, a viewer may decide to examine the "writing" with a magnifying glass, only to find an uncompromising blur, except for two fairly clear capital letters: "F" (or is it "J"?) and "H." Perhaps "H" is for House; perhaps this prominent piece of paper is a broadside poster announcing an auction; or if not the actual poster itself, the handwritten mock-up prepared for the printer, who would set it with its proper heading. Perhaps the executors of an old, declining estate must auction off a farmhouse (F—— H——). The very word "rubbish" adds piquancy to this possibility, since it is etymologically akin to "rubble," and its primary meaning is "waste or refuse material, in early use, esp. such as results from the decay or repair of buildings" (*Shorter Oxford English Dictionary*, 2, 1762). Thus the "ancient" (early) meaning of the word reinforces the notion that the "rubbish" in Butler's basket refers to a decaying estate whose owner hopes to repair some of its buildings with proceeds from the sale of lesser farm houses.[6] If so, once again Mildred Butler has been clever in titling a painting.

That all of this is necessarily *speculation* may be the real point of Butler's tantalizing title. And it is certainly the point of this essay. Both the title and the very composition of the painting provoke unanswerable questions, puzzling the viewer, perhaps on purpose. Where, really, is the rubbish, the rubble? Not here, in this well-appointed and maintained room, whose very wastebasket is a model of decorum; not even in that avenue of rooms beyond, so carefully mirroring the foreground. Burned ricks, maimed cattle, famine and emigration, evictions with their destroyed cottages and hovels—poverty, suffering, and political turmoil are all absent. And yet present as absences. Like M. J. Farrell's assertion that "the whole of Ireland [was] there," Mildred Butler's assertion in her medium also proclaims a patent inaccuracy. The very lack of real rubbish in her painting goads the viewer to look behind the walls of this house, to discover what debris of life is hidden by its gracious and comforting forms.

NOTES

1. Mildred's father, Major Henry Butler, had bought Kilmurry from the children of Thomas Kendal Bushe, Chief Justice of Ireland (known as "the Incorruptible"), whose home it had been.

2. All paintings by Mildred Butler discussed in this essay are in the collection of the National Gallery of Ireland. I am indebted to Ruth Lavelle, Researcher for the National Gallery, for private viewing of these paintings and for her kind help in supplying me with information about Butler.

3. In the Cone Collection, Baltimore Museum of Art, Baltimore, Maryland.

4. M. J. Farrell's family home, unlike Butler's, was burned down during the Anglo-Irish War "as a reprisal for some Black and Tan atrocity. . . . It wasn't a case of personal animosity—we were just unfortunate to be chosen as a target." Keane, "Molly Keane" (74).

5. In later novels, published under her own name (Molly Keane), this same correlation between houses and guilty secrets continues, but usually without political resonance. For example, *Good Behaviour* (1981) parallels *Two Days in Aragon* in many ways but makes almost no use of actual events occurring during its time span (1905–65). Otherwise, similarities between the two novels are striking. *Good Behaviour* also involves an old Protestant family, the fox their emblem, with Catholic servants, living in a large elegant old house in the south of Ireland. There is also a randy master, an important linen cupboard, a runaway horse, and a girl terrified of riding but suppressing her fear. Here, too, rooms harbor secrets, especially bedrooms (the homosexuality of Aroon's brother and her fiancé; the masturbation performed under the sheets by a devoted servant, Rose, on Aroon's paralyzed father; the mysteries of adult sexuality which Aroon, the narrator, cannot fathom either as a child or as an adult). And here, too, the house allows for the hidden exercise of cruelty. The master, or mistress, of the house has power over those dwelling there; every aspect of life is controlled: food, heat, dress allowance, even what animals are on the estate. Having suffered from her mother's parsimony, neglect, and active unkindness in this regard, Aroon gains control when her father wills the estate to her, thus turning tables most ironically (the property had been the mother's dower house, unwittingly signed over to her husband). Now Aroon has taken complete charge of her mother. With exquisite cruelty, she slowly kills her mother with kindness, selling the beloved ancient house, Temple Alice, moving her to a hated "small Gothic folly of a house" (4), and torturing her with rich dainty foods she cannot stomach, until finally she dies in her own vomit. Aroon hides her loathing and guilt even from herself under the guise of love and care. The house itself, and control of it, literally provides a cover for her own nasty secret, which has been generated by all the nasty secrets she suffered from as a child at Temple Alice.

6. For this farmhouse speculation and its etymological sally, I am indebted to my colleague, the historian Kevin O'Neill, who at my request kindly studied the illegible paper in the rubbish basket to determine what documents of the period it might resemble and what associations it generated for him.

WORKS CITED

Bence-Jones, Mark. *Burke's Guide to Country Houses.* Vol. 1: *Ireland.* London: Burke's Peerage Ltd, 1975.

Croke, Fionnuala. *Irish Watercolours and Drawings.* Dublin: National Gallery of Ireland, 1991.

Crookshank, Anne. *Mildred A. Butler.* Dublin: National Gallery of Ireland, 1992.

Farrell, M. J. *The Rising Tide.* Harmondsworth, England: Penguin, 1985.

_____. *Two Days in Aragon.* New York: Viking Penguin, 1986.

Keane, Molly. *Good Behaviour.* New York: E. P. Dutton, 1983.

_____. "Molly Keane." *Portrait of the Artist As a Young Girl.* Ed. John Quinn. London: Methuen, 1987. 65–78.

Shorter Oxford English Dictionary on Historical Principles, rev. 3rd ed. (Oxford: Clarendon Press, 1964), 2, 1762.

Going to the Levée as Ascendancy Spectacle: Alternative Narratives in an Irish Painting

Vera Kreilkamp

The spectacle is not a collection of images, but a social relation among people, mediated by images.

Guy Debord, *Society of the Spectacle*

GOING TO THE LEVÉE (plate 3) depicts a late nineteenth-century colonial spectacle,[1] a performance orchestrated to impress and entertain. Under the gaze of ordinary Dubliners congregating on the street to watch a ritual event in the city's social season, a procession of carriages enters Dublin Castle for the lord lieutenant's annual February reception. Although Rose Barton's watercolor is filled with the contradictory imagery of late nineteenth-century Irish social and political history and evokes the class dynamics implicit in that history, it is most frequently interpreted in formalist terms. Thus, in its critical literature, the painting itself exists as an entertainment and as a celebration of the upper-class ritual which is its subject. It is discussed, for example, as an illustration of the artist's skill in using the techniques of impressionism she had learned in the Paris studio of Henri Gervex. One description notes "the shimmering effect [that] captures perfectly the air of festivity and misty atmosphere of a winter day" (Gillespie, Mooney, and Ryan 40). In *Irish Watercolours and Drawings*, Fionnuala Croke describes the illumination of the watercolor as the effect of afternoon light; the work is "shrouded in a winter mist . . . indicative of the influence of Whistler" on Barton's work. "The overall blue, grey and brown tonality is relieved by the use of yellow highlights and two women's bright red jackets" (22).

Several catalog descriptions of Barton's painting collectively reveal the limitations of traditional formalist criticism—and the unconscious identification of such commentary with an elitist perception of Irish history. In

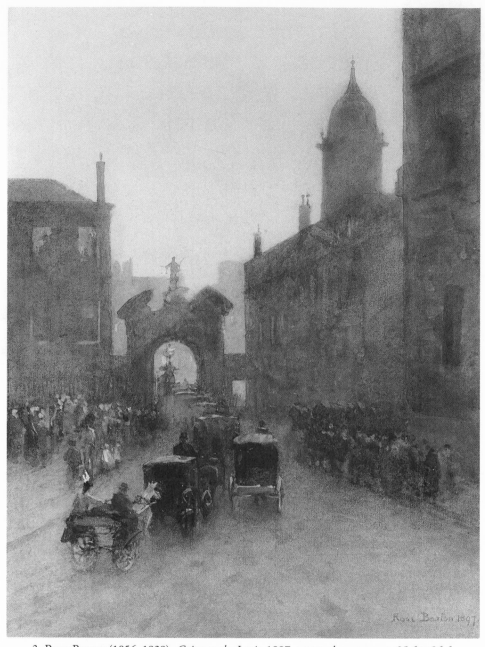

3. Rose Barton (1856–1929), *Going to the Levée,* 1897, watercolor on paper, 35.6 × 26.6 cm, National Gallery of Ireland no. 2989. (Courtesy of the National Gallery of Ireland)

an essay on Barton's work, Rebecca Rowe notes that, in her city scenes, the artist learned to paint "small generalized figures against large forbidding buildings" (13). In another discussion, Rowe describes *Going to the Levée* as a solemn painting, a "carefully balanced composition . . . full of movement and atmosphere," depicting "through the dusky evening haze . . . the anticipation of the waiting crowd and the excitement of the occasion" (*Irish Women Artists* 103). While Rowe identifies "forbidding buildings" as a recurring compositional emblem of Barton's developed style, she fails to mention the particularly "forbidding" resonances the walls and gate of Dublin Castle might have for many city residents. The critic resists connecting her observation about the artist's compositional style with the evident political imagery of this particular painting.

Aside from some errors in fact—the levée was held in the late morning, not the afternoon or evening; the red-clad figures are certainly soldiers, not women—the catalog commentaries accurately describe the surface of Barton's watercolor. It is a solemn portrayal of a major event in Dublin social life, painted for the most part in dark tonalities. But in making further assumptions about the painting's content and effect, the catalog notations are more problematic. Are the crowds framing the carriages really eager and interested? Is the effect of the watercolor truly festive? Absent from all commentary is any mention of the political tensions of late nineteenth-century Ireland or any exploration of the bitter associations the castle had for many Dubliners. *Going to the Levée* is emphatically presented as an aesthetic artifact celebrating an Ascendancy ritual, rather than as an ambivalent interpretation of a declining late Victorian colonized city. The painting's critics do not merely elide the visible historical text; in the innocence of their aesthetic formalism, they are in fact replicating the particular political elitism that, in my view, the painting unconsciously critiques.

In his 1961 memoir of his Anglo-Irish Ascendancy family, Rose Barton's nephew Raymond Brooke praises his aunt's illustrations for her *Familiar London* as "accurate" representations of that changing city. He suggests that her drawings will have enduring value as "historical record" (77). Surprisingly, the affectionate nephew mentions nothing of his aunt's ninety-one grey wash drawings of Dublin in Frances Gerard's *Picturesque Dublin: Old and New* (1898) or of her numerous watercolors of the city. But Brooke's chance remarks about her illustrations for her book about London suggest that Barton's contemporaries and social peers may have valued her work for its chronicling of a familiar world as much as for the formal aesthetic qualities of what Brooke rather awkwardly calls her

"attractive," "first rate" art. In *Familiar London*, an impressionistic guide to the city that she both wrote and illustrated, Rose Barton, however, insists that visual art is more than fashion, or "mere imitation" or photographic reproduction. For her, the true object of art is interpretation (121–22).

Having taken cues from the remarks of both the artist and her nephew, I view *Going to the Levée* as a complex and ambivalent interpretation of a particular historical era. Although Rose Barton belonged to an Anglo-Irish world of privilege, and lived and worked in England for much of her life, the imagery of her watercolor evokes a wider context than her background might suggest; it reveals a colonial city which long defined itself through contradiction and tension. The power of these contradictions in Barton's street scene calls attention to the precariousness of her own class—and the desperation of another.[2]

The carriages driving through the gates of Dublin Castle and under a much reviled statue of Justice represent a layer of society distant from the anonymous crowd of ordinary Dubliners radiating from the central gateway to the Upper Castle Yard. Do not the dark tones of Barton's watercolor, and the faceless, grey anonymity of the citizens lining up in the winter fog to view the passing spectacle suggest more than the artist's fascination with the changing light of a late-morning cityscape and the influence of the impressionist techniques she had learned in Paris?[3] Is Rose Barton depicting, as the usual catalog annotations of her painting imply, the festivity of a traditional Ascendancy social event, or a funereal and valedictory ritual of a beleaguered gentry, which by 1897 had less than a quarter century of such observances left to it?

For some, that Dublin was undoubtedly a festive place. The nineteenth-century imperial city, an urban spectacle of monumental architecture and lavish social forms, appeared to flourish in the wake of an eighteenth-century Ascendancy's prosperity. Barton's painting details the procession of carriages turning up Cork Hill from a Dame Street reportedly "packed from end to end" (Fingall 61) on the day of the lord lieutenant's reception in Dublin Castle. At the 11:30 a.m. levée, in the first week of February, men wishing to pay their respects to the sovereign's representative gathered in the long drawing room overlooking the Upper Castle Yard. Wearing full-dress uniforms, the robes and wigs of the bench and the bar, or black velvet court suits (sometimes rented or borrowed), they were ushered into the Throne Room to bow to the lord lieutenant and the accompanying courtiers clustered around him (Brooke 86–87).

In her recollections of her own presentation season in 1882, the Count-

ess of Fingall explains who rode to the levée in the conveyances appearing in Barton's watercolor. Soldiers, flaunting their dashing red uniforms and their ability to sit "with an air of triumphant nonchalance" with one leg flung over another on the awkward seat, favored the open car. Less interesting than these potential dance partners to sixteen-year-old Daisy Burke, soon to become Countess Fingall, were the occupants of the carriages:

> . . . the staider people: members of the nobility, generals and colonels and country gentlemen, bringing with them into the grey street something of the smell of the country, to which presently they would return with relief. There were Church dignitaries, too, in the carriages, suitably serious; learned professors, faintly dusty from their books, with a distinguished dustiness. (60–61)

Ten years earlier, in 1872, when Rose Barton was similarly introduced to society at a Castle drawing room the day following the levée—and, in fact, since the mid-century famine years—the British empire's "second city" was in acute economic and political distress. Dublin Castle, and, in particular, its triumphant Georgian reconstruction, hovers over and around the carriages in Barton's painting. But the city's anonymous citizens provide a more immediate frame for the procession sweeping up Cork Hill to the ritual inauguration of the winter social season. And these silent figures exert a pressure for representation.

Throughout the nineteenth century, these Dubliners were the most unhealthy, ill-fed, and ill-housed urban dwellers in Europe. Their death rate, the highest in Europe, was said to be comparable to Calcutta's (Kenner viii). Before World War I, Dublin was miserably poor, a city in which poverty was as extreme as in Naples, one Benedictine told Stephen Gwynn: "And in Naples, they have the sun" (214). Such anecdotal impressions are supported by recent historians of the city. Basing their conclusions on corporation records, surveys, revaluation reports, and census data, both Joseph O'Brien and Mary Daly describe post-famine Dublin as a place of increasing filth and poverty, crowded with those working-class and unemployed men and women unable to escape to the rapidly developing middle-class suburbs. Daly emphasizes the difference between Dublin and other urban centers in Great Britain; in an era when a well-paid labor class was evolving elsewhere, the social gulf between the rich and the poor widened in Dublin ("A Tale of Two Cities: 1860–1920" 116).

Moreover, all of Ireland was fast becoming a more visibly military state. Stephen Gwynn estimates that in the nineteenth century the military pres-

ence in Ireland grew from about six thousand to twenty-five thousand British troops (largely Irishmen), as England began using Ireland as a cheap camping and recruiting ground for its military forces (98–99). Compared to the parallel social strata in other parts of Great Britain, the Anglo-Irish were disproportionately represented among the British officer class. Ascendancy youths, raised on their country estates to ride, hunt, and shoot, became good soldiers in the imperial colonies, and the army provided careers for countless younger sons of the Big Houses (McConville 250). Anglo-Irish society welcomed the officers into its circle, and they encouraged the viceregal court and Dublin society to live lavishly, on an English scale.

But the country's growing military presence also revealed the coercive dynamics of colonialism in a century of rising nationalism. Anti-imperial sentiment expressed itself throughout the century—in Daniel O'Connell's pre-famine mass movement for Catholic emancipation; in the cultural nationalism of the Young Irelanders; in the radical Fenianism of the 1860s; in the Land War; and the parliamentary home rule movement under Parnell. Thus the red-jacketed soldiers in Barton's painting,[4] when viewed in the context of Ireland's political history, suggest a locus for political tension in a time of mounting agitation against British domination.

Close to the center of her canvas, Barton places the major entrance gate to Dublin Castle, obscured slightly by mist. From this long-time symbol of the British imperial presence in Ireland, a subject people had been governed, policed, imprisoned, and, on occasion executed, for almost seven centuries. Built within fifty years of the Anglo-Norman conquest in 1169 on the orders of King John, it was erected both as an administrative office of justice and as a fortress to defend the occupying forces from the native Irish. It was located strategically on a ridge, protected by a network of walls and towers, a drawbridge, and a portcullis (Fitzpatrick 96, 100). Subjected to an unsuccessful siege in the rebellion of "Silken Thomas" Fitzgerald in 1534, and the scene of the celebrated imprisonments and escapes of Red Hugh O'Donnell later in the sixteenth century, the Castle became increasingly identified with coercive rule.

Under the reign of Queen Elizabeth I, Dublin Castle was enlarged and repaired to provide a fitting residence for the newly appointed governor of Ireland. Lords lieutenant, however, generally avoided residence in the Castle, which was built on what was considered a damp and unhealthy site. From the late eighteenth century, they lived and entertained in the Viceregal Lodge of Phoenix Park, moving with their courts into the gilded State

Apartments in the Upper Castle Yard for the six- to seven-week winter season, which began with the levée in the first week of February and ended in March with the St. Patrick's Eve ball (Bence-Jones 44).

Described in 1684 by an Ormonde relation as "the worst castle in the worst situation in Christendom" (Craig 5), and much destroyed in an accidental fire that year, Dublin Castle was rebuilt in 1688. Finally, during the feverish architectural activity of the mid-eighteenth century, it became distinctly more Georgian than Elizabethan or medieval in look. The upper yard was totally remodeled and the State Apartments, where the viceroy's levée was held, were reconstructed. Concurrently, one of the original northern gate towers was transformed into what is now the Genealogical Office building; it supports the Bedford Tower and the much praised elegant cupola (or clock tower), hovering in the upper right of Barton's watercolor (Maguire 24). But John Van Nost's statue of Justice, rising above the major arched entrance gate to the upper yard, and visible through the mist in the center of the painting, excited predictable sardonic comment in Dublin, particularly after the Castle's infamous orchestration of union with England in 1800. Facing inward and holding a set of scales that collected so much rainwater they tipped to one side until holes were bored into them, imperial Justice turned her back to the city over which she was to preside (Craig 167).

D. L. Kelleher's dark evocation of Dublin Castle reveals, in fulsome prose, the emotional resonance of that monument for Irish nationalists. While Kelleher wrote in 1918, more than two decades after Rose Barton painted *Going to the Levée*, his linking of Castle officials Cornwallis and Castlereagh with the orgy of bribery leading to the 1800 Act of Union was a common strand in the city's collective memory. In Kelleher's eyes, those nineteenth-century guests who passed through the sinister gate and under the "stone Justice" (it was actually lead) to "trip" to the levée were betraying their country:

> For here above it is a stone Justice with her balance and her blinded eyes, aloof and indifferent to the city's welfare, though the gutter grumbles down on this night when rain and wind issue like snakes out of the bursting sacks of cloud. Aloof and callous, indeed, she is, the most cunning intelligence in that figure of hers thus with her back turned to the street, Justice surely here most literally turning her back these long years upon the people, her balance only for the eyes of the supreme Ambassadors and the Lords Governors imported into the Throne-room from that queen city of shopkeeping on Thames. Though now from her stone eyes she can almost look rebuking

at this final infamy. Over there across the Upper Castle Yard the windows of the state apartments are lighted up and shadows grow and vanish as the two plotters rise and pace the room and re-settle again into their chairs with sharp staccato speech:—

"He wants a bigger bribe?"

"Yes, £5,000 at least."

"Could we not try another way?"

"You mean the woman from Kildare?"

"To give her a title—whose mistress is she?"

Poor Justice! how art thou prostituted now. For these two are Cornwallis and Castlereagh, and the time is December, 1799, and in a month or so the great bribe will have achieved the great betrayal, and the Union of England and Ireland will be complete. So haste thee in, Mistress, and summon thy dancers, O Peer, for now the Levée is prepared and all who sold their country to the gifts of Cornwallis and Castlereagh may trip it featly with their foreign seducers in the routs of Empire in Dublin Castle here. (54–55)

In a more measured analysis of Ascendancy corruption, Maurice Craig notes how the "intimate collegiate" effect of the upper yard becomes the subtle means by which Georgian architecture simultaneously charms the onlooker and reinforces the political imperatives of a coercive imperial regime. After the Levée guests passed from the dirt and din of the city through the gateway and beneath the statue of Justice, they entered a space that reassured through its enclosing order and balance. Craig suggests that, even today, we are persuaded

to forget the evil role of the Castle in Irish affairs. Upper Castle Yard, in particular, evokes to perfection the complacent Hanoverian corruption of that era. It seems to tell us that though every man has his price, the prices are moderate and have all been paid on the nail. Everything is running like well-oiled clockwork, and the clockwork soldiers are changing guard in front of the Bedford Tower. (165–66)

Through such reassurance the architecture discourages us from remembering what we might prefer to forget. Following the Act of Union and Robert Emmet's unsuccessful rebellion in 1803, Dublin Castle functioned as a center for the administration of civil service and surveillance, as well as the setting of the winter social season, rather than as an active military fortress. But Sir Jonah Barrington's report that the Upper Castle Yard was the dumping ground for dead and dying rebel prisoners in the 1798 United Irishmen Rebellion suggests the enduring associations the Castle was to

retain for some—assurdedly those not invited to the levée—throughout the following decades of rising republican aspirations:

> Some dead bodies of insurgents, sabred the night before by Lord Roden's dragoons, were brought in a cart to Dublin, with some prisoners tied together: the carcasses were stretched out in the Castle-yard, where the Viceroy then resided, and in full view of the Secretary's windows: they lay on the pavement as trophies of the first skirmish, during a hot day, cut and gashed in every part, covered with clotted blood and dust, the most frightful spectacle which ever disgraced a royal residence save the seraglio. (216)

And, as if to emphasize its remoteness from the rest of the starving nation during the worst years of the famine, Dublin Castle pursued its social life without interruption; the round of levées, drawing Rooms and balls—another sort of spectacle from that of 1798—continued through 1846–48. *The Freeman's Journal* announced a Castle Drawing Room on February 11, 1847; a local shoe store received and advertised on the same day a shipment of French boots and shoes for the ladies. The chaplain of the Castle's Chapel Royal complained of having to pay poor rates for famine relief, concluding that since the queen was exempted from such rates, so should the occupiers of the state apartments. The Lord Lieutenant, Lord Blessborough, blamed Castle festivities for his dropsy, and during his final illness one member of the court complained that the ladies eagerly awaited his death so the 1847 "gaieties might recommence" (Somerville-Large 246–47). And all this while hundreds of thousands were facing death by starvation and disease.

So we return to the question posed earlier: is Rose Barton's painting *Going to the Levée* celebratory or funereal? Is the artist, in fact, recording the declining rituals of a society which would survive fewer than three more decades or is the watercolor rather a "delightful" rendering of the "prestigious" annual Dublin season that she had observed during her presentation season in 1872 (Butler 155)? Do the gloomy colors of the study, punctuated by the red uniforms of two soldiers, suggest a funereal procession of an increasingly marginalized ruling class into an isolated garrison, or does "the shimmering effect" capture perfectly "the air of festivity and misty atmosphere of a wintery day" (Gillespie, Mooney, Ryan 40)?

To one ruling-class Dubliner, the city's social world at the turn of the century seemed "amazingly gay," its season "brilliant," most certainly not funereal:

For its size Dublin of this period was the most important city in Europe. There was a high pride of race, tradition and culture which has, in all probability, never been surpassed in modern life. There was an amazingly friendly relation between gentry and working class. . . . There was little trade or industry—either you were a gentleman or not. (Dickinson 3)

P.L. Dickinson wrote the above lines in 1929 from London, in his *The Dublin of Yesterday,* after having exiled himself from the Irish Free State and, in his words, its "retrograde" and "pathetic" move backward toward a "Gaelic Hey-Day" and a middle-class society (2). Son of the dean of the Castle's Chapel Royal and, thus, well placed within the ruling class, he reminisced nostalgically about Dublin in the 1880s and 1890s. Dickinson envisioned late nineteenth-century Dublin as rivaling the empire's "first" city, with a social life equal to and a standard of culture higher than that of London, for it excluded "profiteering industrial magnates." While recent historical research emphasizes that the fading wealth and power of nineteenth-century Dublin was caused precisely by its industrial decline (Daly, *Dublin,* 20–49; O'Brien 9–10), Dickinson boasts that his class deliberately excluded those very citizens the city should have cultivated.

Dickinson's description of a triumphant late nineteenth-century Dublin is in striking contrast to the second social narrative visible in Rose Barton's watercolor—the world of the grey bystanders, who pass the late morning watching the procession of carriages to the levée in Dublin Castle. We know the destination of the occupants, and we can speculate that after the levée and the private evening dances which follow it, a few of the lawyers, officers, judges, and landlords will return to their town houses on, for example, Merrion Square or Fitzwilliam Square. Others, residents of Big Houses in the countryside, will disperse to temporary quarters in one of the Dublin hotels, the Shelbourne or Buswell's or Maple's, or to furnished houses they have rented in order to entertain more comfortably during the season (Bence-Jones 46).

The homes of the ordinary Dublin working-class citizens, those grey figures who radiate from the center of Barton's painting, were strikingly different. An investigation of the Royal Commission on Sewerage and Drainage in 1879 revealed that 70 percent of the total inhabitants of Dublin lived in 30 percent of its houses, most in tenements or second- and third-class cottages. Moreover, the commission declared that over two thousand of these structures were unfit for human habitation (O'Brien 126–27). The tenement system, which threatened the public health of the

whole city, had been developing throughout the nineteenth century, with particular acceleration after 1830. By the 1901 census, taken only four years after Rose Barton painted *Going to the Levée*, two thousand more families than in the 1891 survey lived in fourth-class accommodations; one quarter of the city's population lived in single rooms, of which 12,952 (significantly more than half) were occupied by three or more persons (O'Brien 131).

Joseph O'Brien notes that while other cities in Great Britain were renowned for their poverty, none could rival Dublin's "crushing problems" of unemployment, housing, and public health. Even Glasgow, famous for its tenements, approached only 60 percent of Dublin's total for one-room housing (131). The overcrowding, primitive and inadequate sanitary arrangements,[5] filth, lack of ventilation, and general dilapidation of these flats suggest that life on the Dublin streets—spent, on occasion, watching the gentry at their amusements—might have been significantly healthier than life at home. Hugh Kenner notes that such statistics bring new resonance to Leopold Bloom's quip that "the Irishman's house is his coffin"(viii). For nineteenth-century reformers, these overcrowded one-room tenements became emblematic of the moral and physical disease that could spread throughout the city and which could be accounted for only by a pervasive greed.

Although in 1830, Dublin ranked as the second largest city in the British Isles, by the 1890s it was surpassed by Belfast in population and wealth (Daly, "A Tale of Two Cities" 111). Late nineteenth-century Dublin was becoming an economic backwater, a city of festering poverty and urban decline. This Dublin existed far from the glowing center of culture celebrated by Dickinson. Kenner points out that in a century that "mastered the technology of the city, inoculating the citizens, laying water mains and sewer line, paving streets and rationalizing transport, Dublin's lapses from amenities were conspicuous." Although the British preferred to blame Irish fecklessness as the cause, Kenner observes that all historical data suggest the real problem: the grinding poverty of individual Dubliners and thus of the city corporation (ix).

Among those attending the Castle's levées, drawing rooms, and balls, the poverty visible on the streets elicited a variety of reactions. While acknowledging that the slums of Dublin were "most distressing," a "permanent canker" on the city, Dickinson chose not to consider them in his volume on Dublin: "We must let the question of the slums pass; not that they are unimportant—heaven knows that they are not—but they do not

enter into the scheme of this book"(8). Thus, the alien world of the poor is
excised from his vision of a glorious city rivaling London for cultural and
social ascendancy. In the concluding chapter of *Dublin of Yesterday*, Dick-
inson returns briefly to Dublin's failure to eliminate its slums. After de-
ploring the "class of people that drift or are born into the lowest of our
modern social environments," he suggests that those "born in original gin"
would be best dealt with through sterilization (176).

In *Seventy Years Young*, Countess Fingall recalls her girlhood responses
to the distraction of Dublin's poverty with a greater self-consciousness.
The early portions of her memoir describe an upper-class childhood in
Connemara and her presentation at the Castle when she was sixteen. She
suggests that the participants of the Dublin social season chose, quite liter-
ally, not to see and not to hear the world surrounding their festivities. Rec-
ollecting a party on a wet winter night in the Castle Yard quarters of her
future husband, the state steward, she remarks how the windows of the
room where the young women finished primping before the ball over-
looked an "appalling slum." She describes the ease with which the young
guests chose to shut out the depressing tableau situated immediately
beneath them:

> But the windows are curtained, and one need not lift the curtains and the
> wailing voice of the weary child only comes faintly through the glass. There
> is the dance music to drown it. We run downstairs in a hurry. It draws us.
> We cannot lose even one second of that ecstasy of waltzing. (66)

While Countess Fingall's decision to ignore the slums occurred from
within a fortress whose walls had divided two societies for almost seven
hundred years, new barriers provided psychological rather than military
protection. In the nineteenth century, for example, Queen Victoria is said
to have ordered Castle officials to erect a castellated stone wall to hide the
backs of the Stephen Street slums from the royal bed chambers in the State
Apartments (MacLoughlin 154). Now, the very sight of the city's poverty
had become an aggression.

But Barton's watercolor is situated on the street, just before the lord
lieutenant's guests disappear within the walled fortress which shields them
from city life. The eye of the viewer is drawn along with the carriages,
toward the statue of Justice and the well-lit upper yard by the othogonals
created by the roof and cornices on the building to the right of the gateway,
as well as by the line of the carriage route toward the unclear shape within

the gateway.[6] The imagery and composition of the painting invites us to speculate about the relationship between two disparate societies.

Literary texts provide ample narratives of encounters between the gentry and the street people. Many upper-class recollections indicate an astonishing certainty about the affectionate and benign interest of the spectators, even a sense of pride in the level of entertainment the rich provided them. In her history of the Shelbourne Hotel, the Anglo-Irish novelist Elizabeth Bowen proudly describes the departure of hotel guests bound for a Castle ball or drawing-room as "one of the spectacles of Dublin, a drama played to an audience of old timers, critical, but well mannered" (112). Watching the "actors in this drama" seated in plain view on the hotel staircase as they awaited their carriages, the Dublin crowd, according to Bowen, became "connoisseurs: each equipage drew an inspecting glance; the profiles inside its windows were closely scanned" (112).

Bowen insists that the the upper classes conducted their public lives "with the approval of the surrounding city." Her nostalgic portrayal of the Dublin street people becomes, if her account is to be trusted, a powerful dramatization then of their false consciousness. Bowen perceived the social ritual of the Shelbourne guests as an obligatory act, a far different kind of drama performed by the Ascendancy than that "spectacle" of dying bodies that Barrington tells us the Castle-led dragoons deposited in the Upper Castle Yard. The performance of the Shelbourne guests before the spectators on the street is an act of ruling class hegemony rather than coercion— a spectacle designed to distract and entertain, rather than to terrify:

> it was more than a decoration; it stood for something. Ireland esteems pleasure and likes pomp: all she asks in return, from those who enjoy, is that they should comport themselves in a worthy manner. Several of the older Shelbourne servants have told me that . . . they were among those children in the forefront of the onlooking crowds: it came about that a high idea of the Shelbourne so instilled itself into their infant minds that they wished when they should be old enough, to work there. "I became drawn to the place," exclaimed one of them, by simply looking at it. (113)

Rose Barton's nephew Raymond Brooke writes with similar conviction of the good will and pleasure of the "Shawlies" who filled the streets on the evening of the Castle drawing room presentation to look. As lines of carriages waited for entrance to the Upper Castle Yard, their windows opened for ventilation, spectators "walked along gazing into the carriages and making comments—often of refreshing candor—about the occupants."

Brooke interprets the onlookers' comments—that his mother was "plain," that his aunt had "bulgy eyes"—as spirited banter (87). Like Bowen, Brooke was convinced of the benevolence of ordinary Dubliners, despite their enormous poverty. Nevertheless, he reveals the anxiety that lay beneath the cheerful optimism of his narrative of class relations when he suggests some surprise at their forbearance: "The extraordinary thing was that there never appeared to be any police about . . . and there must have been many thousands of pounds of diamonds in the carriages along the strings" (88).

A few commentators are less sanguine than Bowen and Brooke. In her *Picturesque Dublin*, illustrated by Rose Barton's drawings, Frances Gerard remarks that the "motley throng in the side-walks indulge their pungent wit, not unmixed with sarcasm, *at the expense of the individual as he goes by*" (23, my italics). But she also asserts that although the comments of the crowd are "pointed" with personal allusions, they are taken in good humor by the occupants of the carriages.

George Moore's novel *A Drama in Muslin*, written in 1886, provides a very different perspective of class relations in late nineteenth-century Dublin. It expresses the conviction that the social order in Ireland was in the midst of upheaval, that the parasitic life of the landlord was doomed in a country where each Big House was "surrounded by a hundred small ones, all working to keep it in sloth and luxury" (68). Writing about the 1882 Castle season, held in the midst of the Land War, Moore undermines—even demolishes—the vision of an affectionate give and take between gentry and spectators. His description of a line of carriages waiting in a storm to enter Dublin Castle for a drawing room presentation reconfigures Brooke or Bowen's recollection of the gentry's social performance. Moore depicts the poverty of the spectators and emphasizes their threat to the upper-class Dubliners they observe through closed carriage windows. He suggests that each class is on display, "revealing" itself to the other—and that the act of looking is no longer benign:

> Never were poverty and wealth brought into plainer proximity. In the broad glare of the carriage lights the shape of every feature, even the colour of the eyes, every glance, every detail of dress, every stain of misery were revealed to the silken exquisites who, a little frightened, strove to hide themselves within the scented shadows of their broughrams; and in like manner, the bloom on every aristocratic cheek, the glitter of every diamond, the richness of every plume were visible to the avid eyes of those who stood without in the wet and the cold. (171)

The fervor of the hungry spectators and the fear of the performers become the controlling dynamics in Moore's narrative. Instead of describing a mutual affection between two classes, Moore depicts a gentry uneasy in its role as spectacle. The carriage occupants hide from onlookers eager to consume, rather than emulate, admire, or serve them (by aspiring, as Bowen imagines, to employment in the Shelbourne Hotel). The mother of two debutantes being presented at the Castle drawing room voices the anxiety of her class before such proletarian menace: "I wish they would not look so . . . one would think they were a lot of hungry children looking into a sweetmeat shop. The police ought really to prevent it" (171).

In *A Drama in Muslin*, Moore illustrates the failure of the nineteenth-century Irish gentry to achieve hegemony. During a period of overt class violence in the country, within a year of the passage of the 1881 Coercion Act and during the jailing of nationalist leaders Charles Stewart Parnell and Michael Davitt, the lord lieutenant's guests cringe behind their closed carriage windows to escape the gaze of the Dubliners who have, in turn, become a spectacle for them. Alice Barton, the intelligent young woman whose rejection of Ascendancy values frames Moore's fictional narrative, remembers an earlier "Spinsters' Ball" in Galway, when the assassination of a great landlord was announced. There, peasants stood in the cold and dark and stared in at the windows, and, it seemed to her, transformed a social festivity into something "sinister" (87). Now, driving to Dublin Castle for her presentation, she again "thought of the Galway ball, with the terrible faces looking in at the window" (171).

In light of the steady loss of the gentry's economic and political position in late nineteenth and early twentieth-century Ireland, Moore's narrative of class relations appears far more prescient than Bowen's. Thus, *A Drama in Muslin* encourages the viewer of Barton's *Going to the Levée* to reject an interpretation of the painting as celebratory, or as a festive Ascendancy spectacle. While Moore does not depict the levée itself, the great set piece of his novel is a Castle drawing room, a comparable social event of the winter season. The actual moment of the debutante's presentation, when the lord lieutenant bestows a kiss on her cheek, is compared to "a lingering survival of the terrible Droit de Seigneur," as if to emphasize the coercive dynamics of the colonial social ritual itself (175). Moore envisioned the Castle event a great muslin market, a battle for existence, a barbaric, "distorted and unreal . . . spectacle" (182) where desperate young women struggle violently with each other for precedence. Musing, Alice Barton envisions herself as living in a kind of seraglio: " . . . she realized how men

have bought women, imprisoned women, kept women as a sort of common property" (101). Moore's imagery in the presentation scene recalls Jonah Barrington's shocked response to a very different event in 1798. Barrington compared the spectacle of slaughtered bodies in the Upper Castle Yard to the shame of a royal seraglio—as if anticipating Moore's recognition of the continuing violence perpetrated in the imperial fortress a century later.

Moore's judgment of his own class and bitter prediction of the fate of an empire, symbolized by the lord lieutenant, emerges throughout his descriptions of the drawing room evening. The vice-regal procession, made up of the lord lieutenant and his entourage, as well as the "band of underlings who swarm about this mock court like flies about a choice pile of excrement" (181), becomes surreal funeral, rather than festivity, a spectacle turned into sepulchre:

> And with all the gravity of a funeral the *cortège* passes between the ranks of the women: their naked shoulders are the mourners, their skirts are cerecloths that enwrap this poor ghost of royalty: criminal-like, its living ears filled with the dirges the skies are ringing, it passes down the long room, returning to its gruesome throne, a throne that is an open bier, a throne is even now its eternal sepulchre of shame. (181–82)

Moore's vision of a winter social event at Dublin Castle—a levée, a drawing room, or a Castle ball—offers a dark perspective, indeed, of the class narratives that Rose Barton's watercolor reveals and invites us to interpret. Recently the painting was chosen as the cover illustration of an edition of *A Drama in Muslin*.[7] Seeing the two works thus juxtaposed, I am encouraged to read *Going to the Levée* as Rose Barton's funereal depiction of a social class and of an empire.

NOTES

1. *Ox. Eng. Dict.*'s first definition of "spectacle" is relevant: "A specially prepared or arranged display of a more or less public nature (esp. on a large scale), forming an impressive or interesting show or entertainment for those viewing it." But a second meaning of the word suggests the political implications of the painting which this essay seeks to explore: "A person or thing exhibited to, or set before the public gaze as an object either (a) of curiosity or contempt, or (b) of marvel or admiration."

2. While Barton generally chose upper-class locales for her street scenes in *Picturesque Dublin Old and New* (St. Patrick's Cathedral, Trinity College, College Green, King William's Statue, Stephen's Green, the Rotunda, Merrion Square, etc.), she occasionally

ventured into less familiar territory (Patrick Street, the Huguenot houses in Weavers' Square, narrow lanes branching off from the Quays). Her earliest datable painting, *St. Patrick's Close, Dublin* of 1881 (Ulster Museum, Belfast), depicts a street market and fore-grounds working-class figures. While Rowe describes this apprentice work as lacking con-vincing perspective and filled with "fussy detail" (13), the lively painting indicates Barton's familiarity with the faceless Dubliners she relegated to the misty background of *Going to the Levée*.

3. In *Familiar London*, Barton confesses her love of fog: " . . . in a fog that is fairly thick, yet not dense enough to stop the traffic, it is wonderful to see the shrouded forms looking gigantic as they come toward you. The scene is weird, ghastly, almost silent" (5). Her choice, in the 1897 watercolor, to place the procession of carriages to the levée in such a "weird, ghastly" fog suggests an interpretative decision about a "festive" event.

4. Barton's illustration, *Going to the Levée up Cork Hill* (plate 4) in *Picturesque Dublin Old and New* (1898), is taken from a grey wash drawing of the same scene as the 1897 watercolor. The more clearly articulated drawing of the 1898 illustration indicates that both the left figure in the open car and the tall figure with a hat among the onlookers stand-ing to the left of the procession of carriages are uniformed British soldiers, not women. In addition, Frances Gerard's text for *Picturesque Dublin* refers to "the jarvey upon which lounge a couple of officers in resplendent uniform" (23), and the Countess of Fingall's memoir recounts how uniformed soldiers would drive to the February levée in outside cars.

5. In a 1914 housing inquiry, the corporation admitted that almost one-fifth of the city's tenements with twenty or more inhabitants were provided with but one water closet (O'Brien 135).

6. A comparison of Barton's two versions of the same scene reveals that in the 1897 watercolor, the indeterminate shape *within* the well-lit interior courtyard—a vague, blurred white image suggesting a fountain—is probably a gate lantern which, in the more articulat-ed 1898 illustration, is placed on a stone column of a metal fence *outside* the walls of the Castle Yard. Plans of the Castle indicate no interior structure between the gateway and the state apartments across the yard (Maguire 11).

7. The 1981 edition published by Colin Smythe.

WORKS CITED

Barrington, Jonah. *The Rise and Fall of the Irish Nation*. Dublin: Duffy, 1843.

Barton, Rose. *Familiar London*. London: Adam and Charles Black, 1904.

Bence-Jones, Mark. *Twilight of the Ascendancy*. London: Constable, 1987.

Bowen, Elizabeth. *The Shelbourne*. London: Harrap, 1951.

Brooke, Raymond. *The Brimming River*. Dublin: Allen Figgis, 1961.

Butler, Patricia. *Three Hundred Years of Irish Watercolours and Drawings*. London: Weiden-feld and Nicolson, 1990.

Craig, Maurice. *Dublin 1660–1860*. Dublin: Hodges, Figgis, 1952.

Croke, Fionnuala. *Irish Watercolours and Drawings*. Dublin: National Gallery of Dublin, 1991.

Daly, Mary. *Dublin—The Deposed Capital: A Social and Economic History 1860–1914.* Cork: Cork University Press, 1984.

———. "A Tale of Two Cities: 1860-1920." *Dublin Through the Ages.* Ed. Art Cosgrove. Dublin: College Press, 1988. 113–32.

Dickinson, P. L. *The Dublin of Yesterday.* London: Methuen, 1929.

Fingall, Elizabeth, Countess of. *Seventy Years Young.* 1937. Dublin: Lilliput, 1991.

Fitzpatrick, Samuel A. Ossorry. *Dublin: A Historical and Topographical Account of the City.* New York: Dutton, 1907.

Gerard, Frances. *Picturesque Dublin Old and New* (with Ninety-one Illustrations by Rose Barton). London: Hutchinson, 1898.

Gillespie, Frances, Mooney, Kim-Mai, and Ryan, Wanda. *Fifty Irish Drawings and Water-colours.* Dublin: National Gallery of Ireland, 1986.

Gwynn, Stephen. *Dublin Old and New.* New York: Macmillan, 1938.

Irish Women Artists. Dublin: National Gallery of Ireland, 1987.

Kelleher, D. L. *The Glamour of Dublin.* 1918. Dublin: Talbot Press, 1920.

Kenner, Hugh. Foreword. *"Dear, Dirty Dublin": A City in Distress, 1899–1916.* Ed. Joseph O'Brien. Berkeley: University of California Press, 1982. vii–x.

MacLoughlin, Adrian. *A Guide to Historic Dublin.* Dublin: Gill and Macmillan, 1979.

Maguire, J. P. *Dublin Castle: Historical Background and Guide.* Dublin: Stationary Office, n.d.

McConville, Michael. *Ascendancy to Oblivion: The Story of the Anglo-Irish.* London: Quartet, 1986.

Moore, George. *A Drama in Muslin.* 1886. Gerrards Cross, Buckinghamshire: Colin Smythe, 1981.

O'Brien, Joseph. *"Dear, Dirty Dublin": A City in Distress, 1899–1916.* Berkeley: University of California Press, 1982.

Rowe, Rebecca. "The Paintings of Rose Barton." *Rose Barton R. W. S. (1856–1929): Exhibition of Watercolours and Drawings.* Cork: Crawford Municipal Art Gallery, 1987. 12–16.

Somerville-Large, Peter. *Dublin: The First Thousand Years.* Belfast: Appletree, 1979.

"Spectacle." *The Compact Edition of the Oxford English Dictionary.* 2 vols. Oxford: Clarendon Press, 1971.

Looking at the Pictures:
Art and Artfulness in
Colonial Ireland

Kevin O'Neill

HISTORIANS OF IRELAND have been reluctant to incorporate visual evidence into their documentary catalogue. The normal defense is that, unlike historians of fourteenth-century Italy or the seventeenth-century Netherlands, we have little such evidence with which to work. This is only partly true. Ireland did miss the quattrocento Renaissance and its aftermath, but there is a large and important body of visual evidence available for Ireland since 1700.

There are two issues here: one aesthetic, the other evidentiary. The history of the fine arts in Ireland, as elsewhere, has been left either to the very few interested intellectual historians and iconographers, or to the art historians. This is unfortunate because it has left a major area of human expression largely unexplored by social historians, which in turn means that social historians have not yet made an adequate contribution to our understanding of the meaning of art itself. Visual art, perhaps more than any other form of artistic expression, functions on multiple levels. And while aesthetic criticism of the formalist school provides one avenue for exploring artistic meaning, it often obscures the ways in which art functions as a form of ideological and political iteration.

This essay is a preliminary investigation into the relationship between literary and visual forms of cultural and political expression. This is a difficult task. Because we lack a vocabulary to deal with popular forms of visual expression, we could easily be limited by the language of elite discourse and its attendant ideology. This would be unfortunate, as the major social and

political transformations in Irish society which produced the defining
moments of revolution in 1798, Union in 1800, and Catholic emancipa-
tion in 1829 occurred within a popular culture that was both illerate and in
the process of a dramatic linguistic transformation. Oral and visual forms
of representation were the major vehicles of the social and cultural articula-
tion that led to these critical moments of self-definition.[1] The exploration
of oral popular culture is under way, but the use of visual forms of commu-
nication is still at a very elementary stage. Given the great difficulty in
locating popular visual material and the still greater problem of integrating
it into as yet undefined popular mentality, this essay attempts a slightly dif-
ferent and much easier task: an examination of several visual and literary
sources drawn from elite culture in a process of critical interpolation which
will hopefully enhance the depth of our understanding of creativity, poli-
tics, and the past.

 Much of Irish art in the modern era attempts to define, and thereby fix,
the idea of the "Nation." In this, it paralleled most Irish elite intellectual
activity but was at odds with an energetic popular culture which deployed a
"plastic" or "organic" idea of both the community and the nation. Those
outside this popular culture often denied that it had any "intellectual histo-
ry" worthy of study, preferring to see it as "unchanging," "traditional," or
"atavistic." Much of this hostility to popular culture stems from its local
versus "national" orientation. Urban intellectuals in the modern era from
Voltaire to Marx and beyond have argued that no progress is possible until
the "rural idiots" who reside outside of polite culture can be reformed via
education into an imitation of the rational and national urban individual.
Of course Irish popular culture, like all peasant culture, *did* function pri-
marily at a local level, but it is simplistic to conclude that a local center
entailed either stasis, isolation, or inferiority.

 The urban elite view of popular culture, which saw "rustics" as at best
rough clay, or at worst irremediable primitives, was confirmed by juxtapos-
ing rural culture produced by communal enterprise with its own ideologi-
cally constructed notion of the individual artist interacting with "culture"
without mediation by a collective community. The resulting paradigm
defined a folk art of "replication" and an elite art of "creation." Clearly, in a
culture defined by "schools" of "style" and "genre," this was illogical; but
the illusion that the "fine" artists functioned as individuals, bringing cre-
ativity and control to their product, while the "folk" artists merely repeated
a static and simplistic cultural refrain, has managed to marginalize popular
artistic endeavor, often to the point where it disappears from elite con-

sciousness altogether, and to cloud the social reality of the work produced by elite artists.

This elite–folk dichotomy is also unsatisfactory because it is increasingly evident that, despite its inherent localism, rural society elaborated "national" motifs such as "Irish," "Catholic," and "Protestant" which became the critical discriminators within "local" cultural dynamics. Such motifs can be found in folk literature from at least the 1780s, and in the emerging organization of agrarian secret societies from a still earlier date. By the mid-nineteenth century, such forms of "national" popular culture were commonplace, often formed by a process of co-option in which new identities associated with the national struggle were folded into older forms of folk expression. For example, Wexford folk drama traditionally employed as its major characters saints Patrick, Andrew, and George as personifiers of their respective countries. By the mid-nineteenth century they were joined by the contemporary Irish national hero and antihero, Daniel O'Connell, and the Duke of Wellington (Gailey 17–35). Their inclusion represented a much more complicated retooling of these plays than a simple "updating" might require. The O'Connell figure not only represented Ireland as Patrick had always done, but functioned as a spokesperson for new notions of national politics predicated on modern notions of religious and ethnic identities.

It is difficult, given the very local nature of these artistic expressions, to document similar developments of local rural national thinking. But the more overtly political ideology of agrarian society was largely displayed through the actions of their agrarian secret societies. Based on local and regional class, factional, and cultural interests, these were complex organizations that sought to project an alternative system of law and justice into the rural community. Their actions are not difficult to understand: attacks upon bailiffs, land grabbers, tithe proctors, and landlords and their property were part of the "small arms fire" of a land war which was to last throughout the nineteenth century.[2] Their actions against merchants, wealthy farmers, and, occasionally, the clergy represent a fairly sophisticated class war. Yet we still do not know a great deal about their ideology or how it meshed with those of others who wished to alter society radically (Donnelly and Clark; Beames). For example, their frequent adoption of women's clothing as a "disguise," or their symbolic claim to be acting in the interest of a woman, are difficult to interpret through reference to other aspects of Irish society. Any effort to present them as a "nationalist" force is clearly over-simplistic; yet there is little doubt that both the Whiteboys and

the Defenders of the eighteenth century had developed notions of group identity that reached far beyond the boundaries of their local communities. They were also adept at using visual cues and symbols to validate their political actions. Whatever the ultimate source or meaning of their political transvestism, it indicates a dramatic and dynamic sense of their ability to negotiate complex structures of gender and hierarchical meaning via a process of theatrical visualization. The fact that elite contemporaries, and their historical descendants, have difficulty in understanding the codes and meanings inherent in these visualizations should make us wary of attempts to dismiss their significance. Those who have tried to dismiss them have done so because these activities are at variance with the elite notions of nationalism against which they have been compared. Such comparisons, based on logocentric assumptions of questionable validity, may be useful in understanding the failure of elite and popular forms of resistance to forge effective links in the revolutionary period, but they do not negate the reality of an emerging ideology of Catholic peasant collectivism.

Obviously the art represented in the National Gallery of Ireland is overwhelmingly produced by and for the elite. Like most "high" culture, a wider popular audience was denied access to it by barriers of class, caste, and education. And yet, unlike the writings of the great Anglo-Irish literary figures from Swift to Yeats, these pictures were not totally inaccessible to the populace. The pictures contain conventions, nuances, and ideologies that, as part of an encoded discourse, would likely escape the understanding of the uninitiated. One might not understand the allusions, classical allegories, or conventions of a painting, but by its nature, visual representation requires no formal preparation for initial engagement, enjoyment, or analysis; and on a different level, the uninitiated may have been well placed to intuit the unintended and perhaps unknown meanings that artists may have supplied.

Of course, this is largely an academic argument. Prior to the twentieth century, few (other than servants in Big Houses) would ever have seen a painting. But perhaps we should not dismiss these servants from our consideration too quickly. Many young rural Irish women received a semi-formal "education" from their "mistresses" in the care and running of a "proper" household. In addition to the more tedious aspects of household management, these young women were often given instruction in the proper respect for and care of fine furniture, and, of course, fine art. Did women in such situations gain an appreciation for the finery for which they cared? Did they carry away such ideas when they left to marry? By the early

days of the nineteenth century, many middle-class reformers believed such cultural transmission was possible; and they sought to further promote popular literacy, via the Kildare Place Society's publications, many of which provided cheap illustrations, woodcuts, as an important attraction to the newly and partially literate audience (Daly and Dickson).

The development of cheap prints in the eighteenth century had already dramatically increased access to visual art. Several of the watercolors in the National Library collection in Dublin were created with the print market in mind, and often these artists had their widest exposure via this medium. While the poorest probably remained outside even this avenue of artistic consumption until later in the nineteenth century, we should not underestimate the increasing use of visual symbols and cues in the realm of popular culture and society during this era. During the rebellion of 1798, both French and Irish symbols were used by peasant forces to provide a visual proclamation of the ideas of equality and nationalism, and—on a more practical level—to provide visual identity for troops without uniforms. Again, the gender distinctions drawn by elite society did not function here; women as well as men participated in this process of visualizing their community by decking themselves with green ribbons when they marched off with their pikes (National Library of Ireland ms. 9322). Daniel O'Connell's political movements helped to establish certain icons of "Irishness," which served to link the imagery of popular religious art with national themes. The round tower, wolfhound, Celtic cross, harp, and shamrock were all deployed on banners and other meeting paraphernalia, and Father Matthew's temperance movement made a similar use of banners, publications and, most of all, printed pledge cards which through visual representation connected religious, social, and class concepts (Malcolm).

Yet, however large or small this popular artistic consumption, it remained distinct from contemporary fine art, and we are very unlikely to find technical, stylistic, or intellectual links between the two. The pictures represented in this exhibition are fairly limited in what they can reveal about the lives of the majority of Irish people. Because the creators of these works were nearly all members of a social elite, we may be unable to move beyond fairly elementary observations about the lives and mentalities of those of humbler origins. These paintings will not help us to gain an understanding of even the more overt political arguments and actions of the poor, for these were very rarely the subject of elite interest.

Despite the many limitations, however, we are not restricted to observing only the elite in these paintings. On an empirical level we can, with

proper caution, learn a fair amount about Irish material life throughout
the modern period. Occasionally these images are our only record of cer-
tain aspects of architecture, dress, technology, food ways, and other aspects
of daily life. More frequently, they provide a visual analog to scant written
evidence. This lack of information should, in itself, be enough to warrant
the efforts of social and material historians in seeking out visual representa-
tions whenever possible. But we can learn much through the careful scruti-
ny of these visual sources. Several of the essays in this volume explore the
latent meaning in particular works through a process of "close seeing."
Using this process we may come closer to understanding the nebulous
process through which popular culture and elite culture both critiqued and
influenced each other.

We can gain a sense of the artist's "selectivity" operating just beyond the
viewer's field of vision, as well as the potential for revivifying these images,
by juxtaposing several of the views of Dublin so popular in the eighteenth
and early nineteenth centuries, and well represented in this exhibition,
with contemporary written accounts of the same scenes. We are fortu-
nate to have "word pictures" left by an Irish writer, Mary Shackleton-
Leadbeater, which connect directly with scenes represented in works by
Francis Wheatley, William Brocas, and Michael Angelo Hayes. Mary
Shackleton-Leadbeater was a poet and annalist who has given us one of the
fullest transcripts of day-to-day life both in her small Kildare village of Bal-
litoreand in the metropolis. She was the child of one of Ireland's great
Quaker schoolmasters,³ and a correspondent of Burke, Edgeworth,
Crabbe, and most of the Irish educators of her day. In addition to her best-
known creation, the *Annals of Ballitore*, she published several works for the
Kildare Place Society which were intended to serve as practical guides to
rural industry, husbandry, and housekeeping. She also submitted numer-
ous pieces under pseudonyms to Dublin periodicals. Among her literary
papers she has left a short manuscript, obviously part of a series, entitled "A
City Landscape."⁴ In it she describes a walking journey which she fre-
quently took. As a member of the Society of Friends, she often came to
Dublin to attend quarterly or yearly meetings and stayed with friends or
relatives on Earl Street, a convenient location close to both the Cork Street
and Eustace Street Friends' meeting houses. After 1800 she was also the
postmistress for her village of Ballitore, and hence she frequently walked
from Earl Street to the General Post Office via Dame Street, College
Green, Westmoreland Street, Carlisle Bridge, and Sackville Street.

Her manuscript is undated, but multiple references indicate the years

1824–26.[5] Her depiction of the scene in front of the GPO allows us to compare the scene she describes with several others which visual artists have offered. Hers is remarkably different from a contemporary print offered by William Brocas in his print *New Post Office* (plate 4). Whereas Brocas provides Sackville Street with a few pedestrians and three carriages, all rather static—even the horses appear frozen in motion—Shackleton-Leadbeater's literary description vibrates with activity:

> Having a letter to post in the Post Office . . . I am very sure that I paid my usual homage to the noble architecture of the Bank, and perhaps gave a patriotic sigh to the memory of the Parliament, "*which they took away from us.*"
>
> . . . I had not time to reflect upon the contrast when my ears were stunned by the cries of "O'Connell's speech"—"Sir Harcourt Lee's letter"—"Dr. Curtis against the Archbishop"—"The Archbishop against Dr. Curtis"—"Dr. Doyle's address to the Ribbon-men, selling for three pence this day"—and a number of other political speeches, and letters, and proclamations—Some men strutted up and down with great placards attached to their persons — others with the utmost earnestness handed me, and every other passenger little bills or notes doubtless containing information of the highest importance—little boys wore penny[?] advertisements round their hats, or stood clothed in printed sheets, so that all the front of the post Office was crowned with these papers & the air rang with their contents—Who would think of dying amidst so much life? . . . The newest airs & the sweetest melodies filled one shop window, which was also decorated with musical instruments of various descriptions.

This urban landscape differs markedly from that presented by Brocas, whose work is representative of architectural illustrators of the era 1750 to 1850. His drawing not only silences the cacophony of the shouts and music represented by Shackleton-Leadbeater, but by raising the perspective to a spot well above street level, also removes his viewer from the immediacy of the sights, sounds, and motion within the streetscape. Through this process he obscures the synergy which existed between the architectural and human inhabitants of the space, and shifts the viewers' focus away from the people who possessed the street through their presence, and towards the people who built and owned the street's substance and form. Through this process of erasure, the representation iterates and supports the power relationships between ascendancy and populace which underlay the political dynamic of the era.

As Leadbeater-Shackleton demonstrates, the human presence in these

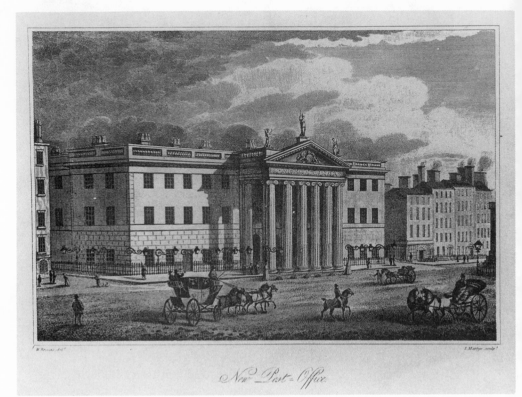

New Post-Office.

4. Samuel Frederick Brocas (1792–1847), *The New Post Office*, ca. 1820, engraving on paper, 20.2 × 13.75 cm. (Courtesy of Kevin O'Neill Collection.)

streets was clearly political as well as visceral. Yet, like most Quakers, she was normally extremely careful not to reveal any political opinions in her public writing, lest she be thought to be engaging in partisan debate. But here, her adoption of a persona partially liberates her and allows her to provide at least a qualified nationalist statement on the suppression of the Irish Parliament. The qualification represented by her uncertainty regarding her patriotic sigh, which she "perhaps gave . . . to the memory of the Parliament," is more reductive than it may at first appear. For while her persona is "very sure" of her/his homage to the architectural integrity of the former Parliament building, he/she can only offer a "perhaps" to confirm her/his performance of the patriotic emotion. And even then, the words used to make the patriotic statement are words, and perhaps sentiments, borrowed from another. This subversion of the patriotic text might merely be a liter-

ary device to provide the light tone of banter and mock seriousness which characterized her pseudonymous periodical writing; but it also represents a more complex reflection of the author's deep anxiety when faced with partisan politics in a violently sectarian world. She had witnessed firsthand the summary execution of innocent neighbors by British forces during the rebellion of 1798, and while she sympathized with her Catholic neighbors' political grievances, she dreaded the high cost of even the most selfless patriotic bravery. Her rhetorical question, "Who would think of dying amidst so much life?" ironically reflects her ambivalence towards nationalism: while she sympathized with the sense of justice and liberation contained within the developing Catholic nationalist message, she rejected the martyrdom already beginning to be associated with the leaders of the 1798 and 1803 rebellions.

Perhaps with intentional irony, it is precisely this sectarian politics that she documents so vividly in her cataloguing of the polemical pamphlets and speeches being hawked outside the GPO. Sir Harcourt Lee was a Church of Ireland clergyman who wrote several pamphlets supporting the Protestant Ascendancy's privileged position and attacking Daniel O'Connell and the movement for Catholic emancipation. Dr. Patrick Curtis was the Catholic bishop of Armagh and primate of all Ireland. (Catholic bishops were forbidden by law from using ecclesiastical titles, and by default used the less powerful academic honorifics.) Dr. James Doyle, bishop of Kildare and Leiglin, was one of the more literary of the Catholic bishops, a key supporter of O'Connell, and an important spokesperson for the Catholic community in many areas. By contrast, Brocas's image completely silences all notion of the political controversy that swirled about the GPO in his day. His stolid building, with its limited human presence, elides all evidence of business or political activity. In this sense at least, his was the more artificial of the two representations: for the GPO was in fact the communications center of Ireland and served not only as the headquarters of the postal service, but as the site of a number of government offices, such as the meteorological office, and as the starting point for the long-distance and local coaches that provided the only public forms of transport of the time. The silencing of the function of this building—in favor of its form—represents a common motif of this genre.

Of course, these architectural artists generally strove for geometric, not social, reality. And the popularity of this type of image suggests most viewers were willing to forgive, and even applaud, the artist for excluding the human element from their streetscapes. As a formalist critic might note,

these scenes are "architectural views," not "urban scenes," and like the rural landscapes of the same era, are not concerned with the "reality" of the image they present. Their purpose was the depiction of the grandeur and value of the great buildings created by the wealth of official Dublin. These were icons of civic pride and elite dominance. Evidence of poverty and strife, or reminders of recent violence and disorder, were clearly not in the artist's best commercial interests.

Still, we should not lose sight of the political significance of this preference for buildings over citizens, since the stress of form over function was a clear sign of the development of fine art as a vehicle for expressing and even celebrating the dominance of the Ascendancy. We can get some idea of just how far artists were prepared to go in the pursuit of this expression by comparing Brocas's GPO and its Sackville Street neighbours with those presented in W. H. Bartlett's "Sackville Street" (plate 5). In the latter view, even the architectural reality of the buildings and streetscape is sacrificed in pursuit of the atmosphere of grandeur. In this representation, the height of all the buildings is exaggerated and Nelson's pillar is moved towards the foreground and elongated. Bartlett "extends" the GPO by adding several additional courses of stone above the top windows and elongating the bottom windows. Yet the proportion of the street to the buildings is maintained. The effect is indeed striking; the buildings enhanced in this way seem to tower over the diminished humans who populate the street. Clearly, in some instances at least, these drawings are more than they appear!

Yet, despite this artistic distortion, Bartlett does provide an interesting array of human characters by placing his viewer upon the new Carlisle Bridge and deploying a diverse group of figures who span the immediate foreground. Ironically, it is the more accurate architectural artists like Brocas, interested in maintaining scale, who use human figures primarily as a scaling device for buildings. His figures have an odd parroted air, as if created by a modern digital graphics program which generates synchronic figures in order to fill space. Not all of the architectural artists represented in this collection were so parsimonious in populating their spaces. For instance, Michael Angelo Hayes in his post-famine watercolor of Sackville Street (plate 6), provides a much more lively depiction of traffic on this major thoroughfare. Not only can we sense the commercial nature of the street, with shoppers and carters, we can also see an important improvement for the city's more humble travelers, the arrival of the omnibus—in this case the number 2 from Portabello. Yet even with this greater human presence, we might still wonder if the scene hasn't been neutralized by the

Sackville Street, Dublin

5. William H. Bartlett (1809–54) *Sackville Street, Dublin,* ca. 1820, engraving on paper, 18 × 12 cm. (Courtesy of Kevin O'Neill Collection)

artist. The painting was completed circa 1853, just two years after emigration caused by the Great Famine had peaked, and long before any real recovery began. Dublin had received many famine refugees. In 1851 Dublin had its highest proportion of nonresidents ever, 39 percent of its residents were born elsewhere—a jump from 27 percent in 1841 (D'Arcy 99). The refugees were not easily absorbed into a city which already had some of the worst slums in Europe. Some of the worst of these were only a short walk from the GPO. Sackville Street and its surroundings were a likely place for rich and poor to meet. In Hayes's watercolor, the very poor are notable only by their absence.

We are fortunate, however, to have in this exhibition the work of an artisit whose streetscapes are populated with humans who function as more than calibration marks for an architect's ruler. The English painter, Francis

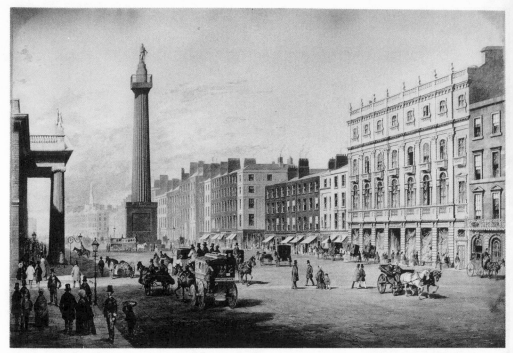

6. Michael Angelo Hayes (1820–77), *Sackville Street, Dublin*, ca. 1853, watercolor over pencil with gum arabic and white highlights on paper, 54.5 × 77.6 cm, National Gallery of Ireland no. 2980. (Courtesy of the National Gallery of Ireland)

Wheatley, in his *Entry of the Speaker into the Irish House of Commons, 1782*, offers an image of the less fortunate folk of Dublin (plate 7). Wheatley's figures, especially the barefooted women, provide a sense of the great disparity between these grand buildings and the impoverished lives of those who passed them but rarely entered them. Yet even here the human scene is static, with the speaker's gait frozen into a odd prance. There is no evidence of a crowd nor of a procession. Such tranquillity would be odd at any time in this central hub of the south city, but given that the painting commemorates a ceremonial entry of the Speaker of the Irish House of Commons in the fateful year of 1782, it is truly remarkable. The quiet, casual scene composed of small groups of the elite in polite conversation, of poor women selling their wares, talking, one nursing an infant, others ignoring their playing children, is more suggestive of life in a small village than in the heart of a nation's capital. This quiet atmosphere is even more strange considering that Wheatley, as James Kelly notes in his essay, was

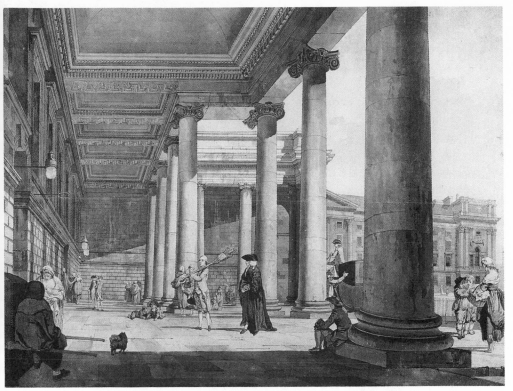

7. Francis Wheatley (1747–1801), *The Entry of the Speaker into the Irish House of Commons,* 1782, watercolor over ink on paper, 49.7 × 63.8 cm, National Gallery of Ireland no. 2930. (Courtesy of the National Gallery of Ireland)

responsible for one of the great "action" paintings of the era, *Dublin Volunteers on College Green,* a painting which took as its locus this same urban crossroads.

Again, we can gain an alternative view of this streetscape by referring to Mary Shackleton-Leadbeater, who recorded several impressions of this area of the city. Interestingly the description most contemporary with Wheatley's painting is unusually direct in its reference to the less desirable aspects of Georgian Dublin. Whereas in her published work Shackleton-Leadbeater adopted the indirect and casual tone noted above, her diary provides access to her private and more revealing impressions. Like the paintings of Wheatley, Brocas, and Hayes, her public "landscape" was composed by an educated person for an audience made up of different social and cultural backgrounds. It too was the product of editing: more

unpleasant aspects of the urban scene were removed—aspects of which she was only too aware. As a Quaker, she was frequently the target of hostile interest in the streets, being spit upon, verbally ridiculed, and threatened. The following passage from her diary describes her walk with a friend to Dame Street in 1778 on one of her early visits to the city. Dame Street begins (or ends, depending upon whether one is a modern or early-modern Dubliner) at College Green. It is from the Dame Street end of the Parliament's portico that Wheatley captures his scene in *The Entry of the Speaker into the Irish House of Commons, 1782*. Shackleton-Leadbeater's account provides a sense of the density and variety of human activity in this neighborhood on a far less important day than that chosen by Wheatley:

> We were . . . frightened with a drunken man who pursued Bell for a pin.
> We passed along with difficulty to Dame Street through crowds of people. I was surprised to see a very genteel chaise with a Black behind it, with an orange ribbon in his hat, hissed after as it drove along, but Nancy told me the Women who were in it were Ladies of the town, I saw them afterwards as I stood at the window with pity & horror, they were painted I suppose . . . My head ached prodigiously with the noise of coaches & the bustle to which I was so unused! (National Library of Ireland ms. 9304)

It is difficult to imagine a representation more dramatically different from that offered by Wheatley. Instead of tranquillity, order, and space, we have fear, aggravation, and disorder.

It would be too bold a leap to conclude that because Mary Shackleton's description was composed solely for herself—and is thus a less "censored" representation—it represents a more "realistic" account than Wheatley's. But we can, with a fair amount of confidence, suggest that her scene conveys important information about these streets which is absent from Wheatley's representation. Indeed, the juxtaposition of the two images suggests that Wheatley's population is deployed for allegorical purposes. Our written image contains threatening elements of alcoholic and sexual tension. Wheatley, however, has domesticated the portico of the Parliament building; the small dog, playing children, resting men, and most importantly the woman with an infant at her breast all signify aspects of intimate family life collected in this entryway to the nation's great hall of deliberation.

The arrangement of these figures also has a "class" dimension. All of the figures in the foreground—between the viewer and the Speaker—are of very humble social rank: a barefoot woman selling fruit to two children, a

sedan-chair carrier resting on the shafts of his chair, another man sitting on the base of one of the great columns (perhaps the chair man?) and the nursing woman and infant. None of these people belong within the walls of this great edifice. The middle ground is held by the Speaker and ser- jeant-at-arms, the coachmen who have likely just delivered the Speaker, and another domestic group composed of several barefoot women and children. Only in the distance do we see men of the gentlemanly sort who might be about to join the Speaker within the House.

Any attempt to provide a clear "interpretation" of Wheatley's inten- tions here would require heroic assumptions. It might also be a fruitless task, for as Luke Gibbons has recently noted in a discussion of colonial Ire- land, "it was not always possible to clearly distinguish what was factual and what was allegorical" (Gibbons 366). What we can say about this particu- lar painting is that the viewer is located at ground level, on the Portico itself, and apparently within the group composed of humble folks. This perspective is unusual for a drawing of this type and suggests that Wheatley wants us to be aware of the social differences on display in the portico. He has also quite consciously domesticated this space by placing women and children at the center of this political place identified, at least in our under- standing, as a male space.

Was he creating an allegorical connection between the location of domestic tranquillity and the establishment of an autonomous "Home" Parliament in Dublin? Or was he claiming a patriarchal significance for the Speaker? He certainly deploys gender in traditional patriarchal terms, with women as nurturers, rather than the targets of the male sexual aggression apparent in Shackleton-Leadbeater's diary image. But what is the woman doing in the doorway to the Parliament? Why is she holding the man's hand? Is this simply a greeting, or could she be a "woman of the town"? Would Wheatley dare to suggest such a violation of the Parliament's digni- ty? Is the group in which she stands balanced by that in which the nursing woman is placed in the foreground? Or are we being entertained by a paro- dy of the aristocratic family groupings with which Wheatley earned much of his livelihood?[6] Perhaps his inclusion of the more humble folk of Dublin is meant to undercut the pretensions of the Ascendancy nabobs, of the ascendancy, an interpretation supported by the odd gait of the speaker and the apparent general lack of interest in his arrival at the Parliament.

We cannot push any of these interpretations very far, and perhaps merely by suggesting them we resemble Diderot, who "could see a hundred brilliant things in a work, but not the things that actually happened to be

there." But hopefully by raising these issues, I have provided some small sense of the possibilities for exploring art with a more common lens than is usually focused upon it.

NOTES

1. Luke Gibbons has presented important explorations of these issues in: "A Shadowy Narrator: History, Art and Romantic Nationalism in Ireland" in *Ideology and the Historians*. Ed. Ciaran Brady. Dublin: Lilliput Press, 1991. pp. 99–127.

2. See James Scott's *Weapons of the Weak* for a discussion of the complexities of peasant resistance. These Irish actions represent a much more violent and provocative form of resistance than Scott envisions with this term, but given the high level of violence in Irish political life and the long tradition of subversive peasant violence, it is seems an appropriate misuse of his concept.

3. Richard Shackleton was a schoolmate and lifelong friend and correspondent of Edmund Burke.

4. I have not yet been able to determine if this was eventually published.

5. The textual evidence implies a date of at least 1823–24, Mary died in 1826.

6. See James Kelly's essay on Francis Wheatley in this volume.

WORKS CITED

Beames, Michael R. *Peasants and Power: The Whiteboy Movements and Their Control in Pre-famine Ireland*. New York: St. Martin's Press, 1983.

Daly, Mary and Dickson, David. *The Origins of Popular Literacy in Ireland: Language and Education Development 1700–1920*. Dublin: Anna Livia, 1990.

D'Arcy, Fergus. "An Age of Distress and Reform: 1800-1860." *Dublin Through the Ages*. Ed. Art Cosgrove. Dublin: College Press, 1988.

Donnelly, James and Clark, Samuel. *Irish Peasants: Violence and Political Unrest 1780–1914*. Madison: University of Wisconsin Press, 1983.

Gailey, Alan. *Irish Folk Drama*. Cork: Mercier Press, 1969.

Gibbons, Luke. "A Shadowy Narrator: History, Art and Romantic Nationalism in Ireland." *Ideology and the Historians*. Ed. Ciaran Brady. Dublin: Lilliput Press, 1991. 99–127.

Malcolm, Elizabeth. *Ireland Sober, Ireland Free: Drink and Temperance in Nineteenth-Century Ireland*. Syracuse: Syracuse University Press, 1986.

Scott, James. *Weapons of the Weak: Everyday Forms of Peasant Resistance*. New Haven: Yale University Press, 1985.

Shackleton-Leadbeater, Mary. Manuscripts in the National Library of Ireland, Dublin. ms 9304, ms 8910(5).

The Historical, the Sacred, the Romantic: Medieval Texts into Irish Watercolors

Pamela Berger

S EVERAL WATERCOLORS in the exhibit depict events from the Middle Ages. This essay will discuss three of those: Daniel Maclise's *The Marriage of Strongbow and Aoife* (plate 8), c. 1854; Michael Healy's *St. Patrick Lighting the Paschal Fire on the Hill of Slane* (plate 9), c. 1914; and Frederic William Burton's *The Meeting on the Turret Stairs* (plate 10), 1864. Derived from a variety of medieval contexts, secular, religious, mythological, folkloric, and sometimes a combination of those elements, each conveys the artist's personal vision, but also imparts a perspective of its time. Maclise's watercolor must be considered in the spirit of the burgeoning cultural nationalism in the mid-nineteenth century. Healy's work reveals the Christianizing of pagan Celtic figures. Burton's painting depicts a Scandinavian legend involving a medieval English prince whose sword is adorned with a triskele, the most powerful symbol of the ancient Celtic past. By incorporating so prominently Celtic motifs and imagery, these watercolors reflect a nation striving to see its Celtic legacy as part of a glorious past awaiting revival.

Maclise's watercolor depicts a crucial moment in Ireland's political history, the marriage of the Norman Richard FitzGilbert (of the Clare family), known as Strongbow, and Aoife, daughter of Diarmait McMurrough, King of Leinster. The nuptials took place in the wake of Strongbow's victory at Waterford. The most comprehensive account of the marriage and the events surrounding it is found in the *Expugnatio Hibernica*, written by Giraldus Cambrensis in the 1180s. Giraldus knew some of the participants

8. Daniel Maclise (1806–70), *The Marriage of Strongbow and Aoife,* ca. 1854, watercolor on paper, 51.2 × 80.2 cm, National Gallery of Ireland no. 6315. (Courtesy of the National Gallery of Ireland)

9. Michael Healy (1873–1941), *Saint Patrick Lighting the Paschal Fire on the Hill of Slane,* ca. 1914, watercolor over ink and pencil on paper, 27.2 × 28 cm, National Gallery of Ireland no. 18.363. (Courtesy of the National Gallery of Ireland)

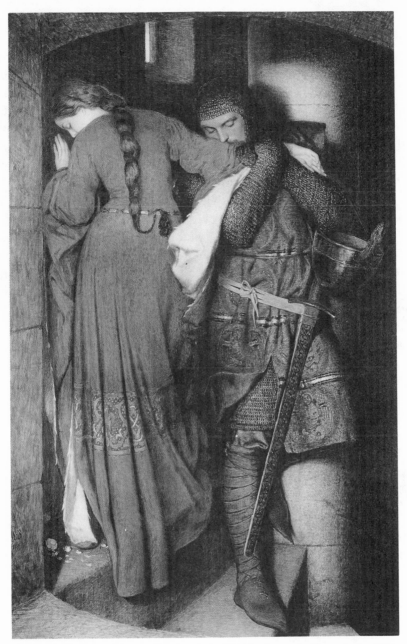

10. Frederic William Burton (1816–1900), *The Meeting on the Turret Stairs,* 1864, watercolor on paper, 95.5 × 60.8 cm, National Gallery of Ireland no. 2358. (Courtesy of the National Gallery of Ireland)

and had traveled in Ireland. He tells us that Diarmait Mac Murchada had lost the kingship of Ireland to Ruaidri, Prince of Connacht (I, 25–55; V, 5), and fled to England seeking help from King Henry II. Henry proffered him his "most intimate grace and favor," and promised that "any person from within [Henry's] wide dominions [who] wishes to help in restoring [Diarmait]" would have "our goodwill and permission to do this" (I, 55–60). With this letter, Diarmait was able to secure the aid of Strongbow, who agreed to help him in exchange for the hand of the deposed king's eldest daughter in marriage, together with the succession to his kingdom (II, 5–10).

Strongbow arrived in Ireland with his army in August 1170. In the ensuing battle "the invaders eagerly effected an entry . . . into the city [of Waterford], and won a most bloody victory, large numbers of the citizens being slaughtered in the streets. . . . A garrison was assigned to the city, and there too Diarmait's daughter Eva [Aoife] was lawfully wed to the earl" (XVI, 20–32). These events became the subject of Maclise's painting. Strongbow later offered his gains in Ireland to Henry II, who then became ruler of the land, exercised his power through viceroys, and gave Leinster back to Strongbow.

Giraldus also tells us that the English bishops and clergy, as well as the English king, stood behind the invasion, which occurred during the papacy of Hadrian IV, the only Englishman ever to become pope. Giraldus copied into his text a document he asserts to be a bull granted by Hadrian at John of Salisbury's request.[1] The text, *Laudabiliter et satis*, was allegedly composed by Hadrian IV's curial writers, though the actual document has vanished. It is addressed to King Henry II from Pope Hadrian:

> In right praiseworthy fashion, and to good purpose, your Majesty is considering how to spread abroad the glorious name of Christ on earth, and thus store up for yourself in heaven the reward of eternal bliss, while striving . . . to enlarge the boundaries of the church, [and] to reveal the truth of the Christian faith to peoples still untaught and barbarous . . . That Ireland, and indeed all islands . . . belong to the jurisdiction of blessed Peter and the holy Roman church is a fact beyond doubt . . . You have indeed indicated to us . . . that you wish to enter this island of Ireland, to make that people obedient to the laws, and to root out from there the weeds of vices, that you are willing to pay to St. Peter the annual tax of one penny from each [ecclesiatical] household, and to preserve the rights of the churches of that land intact and unimpaired. We therefore support your pious and praiseworthy

intention ... [to] ... enter that island ... checking the descent into wicked-
ness, correcting morals and implanting virtues. (V, 25–50)

According to continental feudal law, Strongbow's actions were sound.
The political chaos in Ireland enabled the Norman army to gain a
foothold. Furthermore, succession was a concern only of the royal family
and its supporters, and Diarmait's offering of his daughter's hand to
Strongbow was not foreign to Irish custom (Flanagan 83, 90). Henry II's
acceptance of the land was within feudal law, as was his rule through
viceroys. Since the seventeenth century, however, Irish scholars have railed
against Giraldus's perspective in *Expugnatio Hibernica*.[2] They consider this
account prejudiced, since Giraldus was of the family of the invading Nor-
mans. He describes the Irish as *barbarus* and the Normans' influence as civ-
ilizing. Furthermore, he readily asserts the English King Henry's moral and
legal rights to possess Ireland (II, 6; II, 33). The invasion had little immedi-
ate effect on the Gaelic-speaking population, but it has had a special reso-
nance for the Irish. Since this event connected Ireland to the British
monarchy for nearly eight centuries (Sheehy 6–15; Flanagan 79); Irish his-
torians have long viewed it as a flagrantly unjust Norman–English invasion
of their land. They cite Irish law, according to which it was not at all clear
that a man could acquire a kingdom by right of a woman. Under the Gael-
ic system of the twelfth century, the island, which, in the twelfth century,
consisted of ninety-seven small kingdoms grouped into provinces,
belonged to various extended families. Membership in one of these fami-
lies entitled an individual to use land. By conveying land to an outsider,
Diarmait deprived his sons and brothers of their rights to succession, and,
most egregious of all, from the Irish standpoint, initiated the long struggle
against absentee rulers (Sheehy 12).

Maclise's watercolor supports the Irish view. The painting presents
Strongbow's victory as a tragic defeat for the Irish, who vainly fought to
preserve their traditional way of life. The poignancy of that defeat is
expressed through composition, iconographic detail, color, and gestures.
The triadic forces of subjugation, Strongbow, the bishop, and Diarmait,
form the dramatic center, encompassing the female pawn, Aoife. The bish-
op dominates the scene in his wide-sleeved, red dalmatique, matching
miter, and white stole with blue crosses. He holds a book and raises his
other hand to heaven. The laurel-wreathed Strongbow, with one hand on a
massive sword and the other holding the fingers of Aoife, his prize, wears a
garment prominently displaying a white cross on a blue field. His military

garb contrasts with Aoife's white tunic, which highlights her status as a virgin. Her cloak, however, garners our attention. It is rich yellow, the color of Irish gold, its embroidery of geometric, curvilinear interlace recalling the filigree of the escutcheon on the Ardagh Chalice now in the National Museum, Dublin. Diarmait, whose expression suggests that he is not only a traitor but also a cynic, wears a long cloak of purple and gold, royal colors since Roman imperial times, when purple was used only by the highest aristocrats and the emperor's family. The red of Diarmait's tunic may allude to his status as a traitor.

One of the most prominent figures to catch our eye is the woman to the lower left of the central grouping. Her hands are thrown up and her head is flung back in the traditional mourning gesture. Her garment has been pulled away, exposing her breasts. With the dead child across her knees, she seems the victim of the cruelest violence, a symbol of the fate of her people. The powers of church and state behind her ignore her cry of woe.

In the early nineteenth century antiquarians and scholars undertook the study of the recently uncovered artifacts and treasures of the Bronze Age and early Christian period. Coins and inscriptions were studied, and archaeological investigations were begun. This happened on the heels of Edward Bunting's first transcriptions of traditional Irish music in the late eigthteenth century, and was contemporaneous with the philological studies that placed the Irish language in its Indo-European context. *The Marriage of Strongbow and Aoife* reflects Maclise's keen interest in these activities. The bard dominates the lower left side. The only figure in green, his hunched shoulders and bowed head convey his interior lament. His harp is no doubt modeled after the so-called harp of Brian Boru discovered a century earlier and now in Trinity College, Dublin. Such iconographic details enhance the scene. But Maclise's interest was not just that of an antiquarian; architecture and artifacts have a didactic role, and are always in the service of the emotional content of the scene.

The most eye-catching object is the cross on the ground in the center of the picture. It is literally a stepping stone for Strongbow, illuminating the whole tableau before us. A bell lies among the ruins, positioned just above the figure of the bishop. Bells were among the most sacred relics in the Middle Ages. Their pleasing tonality awoke potent responses and the bells themselves were considered miracle working. The unadorned staff of the crozier, held by the monk behind Diarmait, further reveals Maclise's acute attention to detail. The crozier marks the monk as one of the "invading" ecclesiastics, its sinuous crook distinctly continental in type. Maclise no

doubt knew that Irish models, such as the Lismore Crozier, discovered in 1814 and now in the National Museum, Dublin, are typified by the simple perpendicular drop.

The banners that were intended to be the emblems of a triumphant people rest in the dust. The banner motif that remains visible, the almond-eyed serpent's head, is typical of the medieval Scandinavian Urnes style, which, by the twelfth century, had penetrated Ireland. Its sinuous lines can be seen in the handle of the Shrine of St. Patrick's Bell now in the National Museum of Ireland. But Maclise, working in the 1850s, was most likely unaware of the ultimate Scandinavian origins of the design.

The Irish warriors are depicted as a varied lot. One has a circular tatoo on his breast. Another, no doubt one of the wealthier defeated chieftans, wears a finely wrought cream garment embroidered in gold. Others are wearing animal skins or coats of mail. Their haggard appearances suggest rough but fiercely independent men, set upon by colonizers and put down only after stupendous struggle. By placing them in the forefront, Maclise has invited our identification with the defeated Irish, whom we see in greater detail than the Normans in the background.

The bottom edge of the picture is adorned with mistletoe. Its shiny green leaves and white berries strewn in a seemingly haphazard way are interspersed with a few leaves of red oak. These two plants are given prominence because of their mythic allusions. According to ancient texts, the Druids, priests of the Celts, used golden sickles to cut mistletoe from oak trees, and gave it to people as healing plants or as charms (Cunliffe 108–10). Though casually placed in the composition, this leafy decor has a resonance, especially for the modern viewer, since twentieth-century archaeological investigation has revealed that mistletoe is one of the oldest Celtic motifs, dating from an early phase of La Tène art in the fifth century B.C.

The writing on the slab at lower right displays the graceful curving reminiscent of letter forms in the Book of Kells (Miller 358–59). This type of lettering, developed from the seventh century on in Ireland, spread to its monastic foundations on the continent and played an important role in the preservation of learning. Used by the teachers and scribes in Charlemagne's court, eventually it became the basis for what we recognize as modern lower case hand (Miller 361–62). A typeface inspired by this cursive majuscule was created in 1840, and used for specifically "Irish" works.

The architectural structures and their placement in the composition have particular symbolic value. At the top, near the center, is the round

tower, a motif that was adopted by romantic nationalists of the nineteenth century as a symbol of Ireland. More than one hundred still survive in various states of preservation. The base and doorway of the tower in Maclise's watercolor are clouded by the smoke of battle. This is consonant with the belief that they were used as a refuge, as well as a bell tower. The Viking invasion, which began in the late eighth century, had forced the Irish to build stone fortifications to which they could flee in time of attack. The door, here seemingly placed at ground level, would, in actuality, be higher, to thwart attempts to force it open. When the invaders had battered down the doors, they would start fires on the lower floors. Windows at the top of the tower produced a powerful draft, and the furnace-like effect was tragic for those who had sought asylum within. The stone walls in the background are anachronistic. Circular earthworks and wooden palisades with an artificial mound in the middle were the norm before Strongbow invaded. It was not until after the invasion that certain Irish sites were protected by stone walls (as at Trim, begun in the 1220s).

These iconographic details are organized into a composition defined by the strong central axis formed by the bishop and the dark, shaded side of the tower. The upper half of the picture has strong diagonals created by the lines of the hills and of the people pouring out of the city of Waterford. Those diagonals are mirrored in the arrangement and gestures of the figures in the middle register; in the lower third of the composition, the dominant diagonals are defined by the spears of the Irish in the right foreground and the white and yellow garbed prisoners on the left. Within those dominant diagonal lines are smaller triangles that set off the bard on the left and the cream-tuniced warrior on the right.

The iconographic details, as well as the composition, reveal how strongly Maclise's perspective supports the Irish view. Each actor's expression and gesture are theatrically rendered. Diarmait's cynical "noble victim" demeanor contrasts with the self-satisfied look of Strongbow. The bowing Celts in the foreground are treated in the canonical manner that goes back to Roman art, in which the conquered "barbarians" bow at the feet of the symbols of imperial victory. But in this work, the Normans in the background signify evil, whereas the "barbarians" in the foreground signify the positive and the heroic. A final detail implies that the defeat was temporary and that the crumbling buildings and wounded people would rise from the ashes; on the horizon is a rainbow, a symbol of hope.

Maclise painted this work in the early 1850s just after the famine, when the dispirited population could not even consider issues of nationalism,

despite the Young Irelanders' attempt to ignite a revolt. Nevertheless, the political aspect of Maclise's watercolor should be seen in the context of long-enduring Irish struggle against the English, a struggle which grappled for cultural roots in a glorious, but benighted, past. Some scholars see this "simmering" Celticism as part of a continuous strain of cultural consciousness (Reynolds 383–88). In addition to the Macpherson "translations" in the 1760s, there was the founding of the Royal Irish Academy in 1785; the translation of poems in Irish by Samuel Ferguson in the 1830s; the cultural nationalism of the Young Irelanders in the 1840s; the Bunting collections of Irish music; and Zeuss's *Grammatica Celtica* in 1853. Maclise's watercolor, with its iconographic detail, can be seen as part of this unbroken tradition, a part of the "Celtic twilight," which prepared for the Celtic Renaissance at the end of the century. Though completed before W.B. Yeats, George Russell, Douglas Hyde, and others fully articulated their ideals, Maclise's work makes clear that he was a forerunner of those neo-Celtic visionaries. Even during Maclise's day the French and the English saw the Celtic people as spiritual, impractical, and poetic, in contrast to the materialistic, excessively rational Saxons (McCone 22). *The Marriage of Strongbow and Aoife* displays Maclise's power to poeticize and further mythologize the romantic, impractical Celts.

Maclise has been connected with the Nazarene painters who worked in Italy, near Rome. Their mission was to recreate patriotic, Christian art, and they were particularly oriented toward the art of the Middle Ages. In these respects Maclise follows in their footsteps, but his loyalty was to a benighted Irish past (Ammann, Schindler). Like Maclise, the Nazarene painters highlighted details with a strong linearity. Their paintings echo the pure sense of color and the stable geometric compositions that characterize Maclise's, and they, too, sought not only to convey an authentic sense of history, but also to probe the emotional currents implicit in their themes.

Maclise purposefully fashioned a tableau meant to set forth, in a formal heraldic manner, the events surrounding Diarmait, Strongbow, and Aoife. In his watercolor, a traitorous king has allowed a foreign power to invade illegally and, through marriage, to create an alliance to start a new dynasty; the Norman invasion has become an analogue for oppressed Ireland. Recent scholarship has pointed out that the vast majority of twelfth-century Irish barely noticed the conquest of Strongbow and the subsequent occupation, and that they did not succumb to the invader's culture (Collins). Indeed, the very opposite occurred. The Normans (and presum-

ably the Welsh and Flemings who accompanied them) became assimilated. And many of those who fought against the English in the seventeenth century were Strongbow's descendants, who, during the early days of the Reformation, remained loyal to Rome. They paid the price by being dispossessed of their land, and by the time of the famine, most were "ordinary" Irish Catholics, indistinguishable from their Gaelic neighbors. Maclise used these twelfth-century Normans to "stand for" the English. For Maclise, those invaders, representing an English king and an English pope, foreshadowed the later, tragic invasion by the British. In this way, Maclise contributed to the mythologizing of history, and helped create a new "fiction," pertinent to his own time.

Michael Healey takes for his subject matter a still more ancient event, one that had roots in pre-Christian, pagan mythology: *St. Patrick Lighting the Paschal Fire on the Hill of Slane.* This watercolor, executed as a study for a work in stained glass, celebrates the triumph of St. Patrick, who, despite a pagan king's prohibition, lit a paschal fire, thereby instituting the first Irish Easter. Patrick, in full bishop's regalia of miter, stole, dalmatique, and alb, raises a crosier surmounted by a Celtic cross. Standing on a hill, he is surrounded by tongues of flames which form a mandorla around his form. The angel to his left holds the martyr's palm of victory, and the angel to his right, an open book with indistinct writing. The Druid poet, Dubthach maccu Lugair, kneels at the base of his crozier; Ercc mac Dego, a member of the pagan nobility of the court of Loegaire mac Neill, a high king in pre-Christian Ireland, faces the bard.

The event behind this hieratic image is first recounted by Patrick's seventh-century Latin biographers, Muirchu and Tirechan. Elaborated down through the centuries, the story became one of the most well-known episodes of the Irish folkloric tradition.[3] The king of Tara, Loegaire mac Neill, surrounded by his nobles and men of art, his enchanters, augurs, and magicians—"*incantatores, aruspices, magi*"—was celebrating an early-spring pagan religious festival. Loegaire had proclaimed that only he could light the celebratory fire at that festival (Bieler 190). While the people of the court were awaiting the king's fire, Patrick, on the hill of Slane, lit a fire. Loegaire gathered the men of his court to ask who would commit such an abominable wickedness. The nobles and elders answered that they did not know, but that if the fire were not put out that very night, it would overcome all other fires and never die, and that he who lit it would triumph over them.

When it was discovered that Patrick had lit the fire, he was summoned

to the palace. The magicians warned the people not to rise as Patrick came near, " . . . for whosoever rises up at the approach of this fellow will afterwards believe in him and worship him." But as Patrick approached, "only one, helped by the Lord, who willed not to obey the words of the magicians, rose up. This was Ercc, the son of Daig, whose relics are now venerated in the city called Slane. And Patrick blessed him and he believed in the everlasting God." The following day, when Patrick and five companions came again to the Loegaire's feasting hall, "no one of them rose up at his approach, save one only, and that was Dubthach-maccu-Lugair, an excellent poet. . . ."

Perhaps King Loegaire's court was participating in Beltane, the pagan fire-lighting festival commemorating the coming of the warm season. This was an ancient Celtic (or possibly pre-Celtic) celebration (Danaher 218–22). In pre-Christian times the year was divided into four seasons: Imbolc, February 1; Beltane, May 1; Lunasa, August 1; and Samhain, November 1. All but Imbolc were associated with bonfires, probably a vestige of more ancient "signal" fires that proclaimed the arrival of the new season. Beltane was counted as the first day of the warm season (ushering in the light half of the year), and it is recorded in the Calendar of Coligny, a document written in bronze in the Celtic language and dating from the first century B.C. (Cunliffe 110). Calendrical reckonings, however, were imprecise, and the later notion of "months" was not yet part of the system, so the Beltane festivities might have occurred when Easter would have been celebrated.

We see from Muirchu's account that Ercc mac Dego and Dubthach maccu Lugair resisted King Loegaire and, at different times, rose to show Patrick their respect, thus becoming the first two to acknowledge the new faith. Later in the Middle Ages, Ercc was regarded as the one who became Patrick's judge and is identified as the founder of the monastery called Slane (McCone 90). The role of Dubthach was likewise transformed. A tradition developed that he not only bore witness to the new faith, but also became a vessel of the holy spirit. His persona was likened to that of John the Baptist, a member of the old religion and precursor to the new, and he slowly became the model for the medieval *filid*.

We discover more about Dubthach from the *Senchus Mar*, a compilation of vernacular Irish law written in the eighth century. By this time, Dubthach's status was elevated from the accepting Druidic priest to the "chief poet of the island of Ireland" (McCone 96). He was described as Patrick's companion and when the saint spoke in assembly, was called

upon to "show the judgement and all the poetry of Ireland" (McCone 96).
As a righteous prophet, the Holy Spirit could speak through him just as it
had spoken through the Old Testament prophets. Thus, as two figures
who formed the link between the old and the new, Ercc mac Dego and
Dubthach maccu Lugair became part of the collective memory of Ireland.
In Healy's design, the poet with his scroll and the henchman with his spear
kneel at the feet of the glowing figure of Patrick, doing obeisance and hon-
oring the religion that was to survive theirs.

Michael Healy was one of the more talented of the stained-glass artists
working in Ireland in the early twentieth century. The craft, particularly as
it was practiced for churches, was an outgrowth of the coalescence between
the literary–political movements of the late nineteenth century and the
Arts and Crafts movement, which sought to reestablish handcrafts in reac-
tion to the mass production of the Industrial Revolution (Sheehy 262).
This work demonstrates that the merging of the ideology of the Celtic
Revival with that of the Arts and Crafts movement provided encourage-
ment for a churchman like Healy to include "heroic" Celtic figures in a
stained-glass church window, thus incorporating images of the pagan
Celtic past into his Christian iconography. Healy has even taken the step of
placing Ercc mac Dego and Dubthach maccu Lugair in the position usual-
ly reserved for such figures as the Virgin or St. John, that of intercessors.

The final watercolor we will treat is based on the Danish ballad "Hella-
lyle and Hildebrand." The song was translated into English and appeared
in 1855 in *Fraser's Magazine*. A decade later, Frederick William Burton
translated it again—into a painting, *The Meeting on the Turret Stairs*.
Unlike the medieval Latin texts that inspired the historical and/or mytho-
logical traditions that informed the iconography of the two works already
discussed, the seeds of *The Meeting on the Turret Stairs* lie in a work collect-
ed perhaps only a hundred years earlier and published in the voluminous
compendium of Danish folk songs, the *Danske Viser*.

Songs and ballads collected by eighteenth- and nineteenth-century
folklorists are now recognized as the rich repository of family, tribal, or
communal "history." Originally sung or recited, the ballads were orally
transmitted, preserved by memory rather than by written record. The
meter and rhymes served as mnemonic devices, as did certain formulaic
expressions particular to the language.[4]

"Hellalyle and Hildebrand" is a "spinning song," told by Hellalyle, a
high-born slave to an unidentified queen. Though such ballads have no
known "author," the perspective and voice of this song is that of a woman,

the very person whose story it is. The ballad is framed by verses which set the scene in a bower where Hellalyle is embroidering but is so "lost in woe" that she lets her needle go astray. The Queen comes to see what is amiss, and thereupon hears Hellalyle's tale:

> My father was lord of the land by his sword,
> And knights of renown were the slaves at his board.
>
> My father gave me a glorious guard:
> Twelve noble knights were my watch and ward.
>
> Eleven daily served me well,
> But oh, I loved the last—I fell.
>
> My true-love's name was Hildebrand,
> And he was Prince of Engelland.
>
> Scarce came to my bower that knight so bold,
> When all was to my father told.
>
> Oh if you heard my father's shout—
> "Champions! On with your armour stout!
>
> "See that your swords and shields be right,
> Hildebrand, he is a lord of might."
>
> They stood at the door with spear and shield:
> "Up, Lord Hildebrand! Out and yield!"
>
> He kissed me then mine eyes above:
> "Say never my name, thou darling love."

Burton illustrates the tragic moment of farewell after Hellalyle and Hildebrand have consummated their forbidden love, a love that is sure to lead to death for the two young people. The wrenching verses portray the conflict between loyalty to a lover and to one's blood ties:

> Out of the door Lord Hildebrand sprang;
> Around his head the sword he swang.
>
> In gore they soon were lying there,
> My seven brothers with golden hair.
>
> My youngest brother was battling near,
> And O in my heart I held him dear.
>
> And so I screamed, "Lord Hildebrand,
> For God's dear love now hold thy hand!

> "O let him live—my youngest brother,
> He'll bear the tidings to my mother."

Hellalyle's plea to Hildebrand to save the life of her brother, who was rushing to kill him, meant certain death to her lover. In obediance to her will, Hildebrand did not raise his hand against this "youngest brother," and died as a result. Then Hellalyle's brother, whose life she had saved, bound her by the hair and hung her from the heels of his "frantic mare." Then he tore over stones, through boughs, and over ice-rivers. Her mother, witnessing their arrival at the castle, "stood in misery." The brother built a tower and inside it he laid Hellalyle nearly naked on "horrible thorns."

> My brother wished me in the grave,
> My mother would sell me for a slave.
>
> And soon they sold me for a bell:
> In Mary's tower they hung it well.
>
> The bell rang out, and rang again:
> My mother's bosom brast in twain.

Such is the story Hellalyle tells to the Queen, into whose household she has come as a slave in exchange for the bell. Bells were considered objects of great wonder in the medieval world, and presumably this bell had the magic power to break the mother's heart in two, thereby relieving her of the wretched misery of her life, bereft of all but one of the eight children she had borne. As Hellalyle completes this tale of sorrow, "dead she fell before the Queen."

Burton renders the lovers' parting with a restrained pathos that is consonant with the Pre-Raphaelite tradition of representing worthy subjects bearing a deep strain of moral dignity. The setting, in the picturesque staircase of the castle, as well as the detailed rendering of the objects and garments, are in accord with the romantic medievalism that was becoming a stylistic trend in the mid-nineteenth century. The text of the ballad indicates that, as Hellalyle sings her tale, she was "bending over the broidery frame / And where the red gold ought to shine / She broiders there wi' the silken twine. / And where the silken twine should be, / She lays the golden broiderie." These words surely inspired the glistening red-gold colors Burton chose for Hildebrand's tunic. Within the medallions embroidered on the garment are fantastic creatures, contorted in Romanesque fashion so that their shapes conform to the curving contours of the circle. Two of the

creatures, with human faces, dragon tails, and wings, are examples of the zoanthropomorphs occasionally glimpsed in northern European medieval art.[5] Hildebrand's coat of mail is a kind frequently seen in medieval representations of knights (for example, the jamb statue of Saint Theodore on the south transept portal at Chartres Cathedral), and his helmet, with the descending cheek-guard in the form of an animal's head, is also commonly depicted.

It is the scabbard of the sword, however, that is most tellingly rendered, as a precious work in black niello and gold. It is adorned with one of the most powerful images of the Celtic repertoire, the ancient "three-legged" triskele, found in some of the earliest continental Celtic art, as well as in the books of Durrow and Kells. The triskele, long associated with potent magic, seems to be moving continuously around a single, central point.[6] Burton probably knew that the triskele was used to decorate military armor, since a shield boss found at Llyn Cerrig in Anglesey in Wales is adorned with a triskele. This would also have been a fitting motif for a scabbard, since the triskele, like the "Celtic Head," may have been an apotropaic sign, protecting its wearers against evil. In fact, the artist positioned this object so that it forms the main diagonal element of the composition. The striking gold and black coloring and the clarity of the articulation of the triskele suggest that Burton wanted to highlight this "Celtic" aspect of Hildebrand's sheath. In Burton's imagination, perhaps, this Prince of England was ultimately of Celtic stock.

In contrast to the decidedly Celtic motif on the scabbard, the decor of Hellalyle's garment is specifically Scandinavian. The band of decoration on her robe recalls the loose interlaces on works of early Scandinavian art. Floor length, with long-flowing sleeves and belted at the hips, the robe is of the fashion worn by the royal women sculpted on the west facade of Chartres. The ashlar masonry of the turret, where the lovers stand, with the stairs splaying round the central supporting pier, is typical of numerous tower stairwells of the late Middle Ages.

Presenting the figures' emotions with an immediacy worthy of a modern "close-up," Burton shows us only the back of Hellalyle; her left hand and forehead pressed against the cold stone, her anguish and resignation only partially seen. Though Hildebrand faces us, his mouth is hidden and his eyes, closed. The lovers' gestures and bodies bespeak their impending tragedy. Hildebrand's pose is hesitant; his head is bowed as his lips touch her skin. The graceful line created by her white palm and the fur lining of her cloak draws our eye to her forearm locked between his hands and lips.

All is restrained, subdued in this last moment, as the light sifts over them and creates soft shadows. Their advocate, Burton invests the lovers with supreme dignity, obedient as they are to a higher law, one above those acknowledged by society.

Each of these three artists sought to create a work that would be meaningful in his own day, but each work has a contemporary resonance. Maclise's work delivers to today's viewer a message that links the violent dominance of the invader with sexual dominance through the portrayal of the violated, bare-breasted woman juxtaposed with the marriage/rape of Princess Aoife, both analogues for the betrayal/rape of the nation. The heraldic St. Patrick image evokes for the modern audience the idea of syncretism, the incorporating of what was sacred for the old into the new, thereby creating a sustainable, long-lasting religious culture. Burton directs our attention to the plight of aristocratic women who "belonged to" the father or the brother, and were kept as breeders to preserve property rights for the next generation. Though each artist's view of the past was necessarily shaped by his own time, he sifted and transformed his sources to create a pictorial rendering that would touch his own audience, but that would, in fact, be universal and timeless.

NOTES

1. Sheehy 8. John of Salisbury reports that "It was at my request that he [the Pope] granted to the illustrious king of England, Henry, the hereditary possession of Ireland . . . for all islands are reputed to belong by long-established right to the Church at Rome, to which they were granted by Constantine, who established and endowed it."

2. Another source entitled "The Song of Dermot and the Earl," a kind of *chanson de jeste*, was first published in 1892, well after Maclise's time.

3. Bieler 190 f. See also the English translations of the Muirchu text in Brian de Breffny, 45–47, and in Alice-Boyd Proudfoot, 43–45.

4. Alfred B. Lord, *The Singer of Tales*, Cambridge, Mass.: 1960; reprint, New York, 1965, 4. For a discussion of the abuses of the oral-formulaic theory, see Ruth Finnegan, *Oral Poetry*, Cambridge, Mass., 1977, 69–72.

5. We see an example in the zoanthropomorphic renderings in the Book of Kells (folio 1, recto), where the four Evangelists, in their symbolic forms of calf, lion, eagle, and man, also display a hoof, paw, or claw, as well as a human hand.

6. Embodying the notion of triplism, the concept of the Three is often alluded to in Early Irish literature. The three mother goddesses of war, Morrigan, Macha, and Bodb, together are called the Morrigna or the Great Queens; the goddess Brigit also has three aspects. In Celto-Gaulish Burgundy, the triadic reliefs of the Three Mother Goddesses are an aspect of the same idea.

WORKS CITED

Ammann, Gert, ed. *Klassizisten-Nazarener*. Innsbruck: Tiroler Landesmuseum Ferdinandeum, 1982.

Bieler, Ludwig. *Studies on the Life and Legend of St. Patrick*. London: Variorum Reprints, 1986.

Collins, Kevin. *The Cultural Conquest of Ireland*. Dublin: Mercier Press, 1990.

Cunliffe, Barry. *The Celtic World*. New York: McGraw-Hill, 1979.

Danaher, Kevin. "Irish Folk Tradition and the Celtic Calendar," *The Celtic Consciousness*. Ed. Robert O'Driscoll. New York: George Braziller, 1981.

Flanagan, Marie Therese. *Irish Society, Anglo-Norman Settlers, Angevin Kingship*. Oxford: Clarendon Press, 1989.

Giraldus Cambrensis. *Expugnatio Hibernica: The Conquest of Ireland*. Ed. A. S. Scott and F. X. Martin. Dublin: Royal Irish Academy, 1978.

Lucas, A. T. *Treasures of Ireland*. Dublin: Gill and Macmillan, 1973.

Miller, Liam, and Musick, Pat. "The Celtic Continuum, From Penstroke to Print," *The Celtic Consciousness*. Ed. Robert O'Driscoll, New York: George Braziller, 1981.

Moody, T. W. *The Course of Irish History*. Cork: Mercier Press, 1984.

O'Driscoll, Robert. "The Aesthetic and Intellectual Foundations of the Celtic Literary Revival in Ireland," *The Celtic Consciousness*. Ed. Robert O'Driscoll. New York: George Braziller, 1981.

Reynolds, Lorna. "The Irish Literary Revival: Preparation and Personalities," *The Celtic Consciousnes*. Ed. Robert O'Driscoll. New York: George Braziller, 1981.

Schindler, Herbert. *Nazarener*. Regensburg: F. Pustet, 1982.

Sheehy, Jeanne. *Irish Art and Architecture*. London: Thames and Hudson, 1978.

Sheehy, Maurice. *When the Normans Came to Ireland*. Cork and Dublin: Mercier Press, 1975.

Wilson, David M., and Klindt-Jensen, Ole. *Viking Art*. Ithaca: Cornell University Press, 1966. Pl. LXXX.

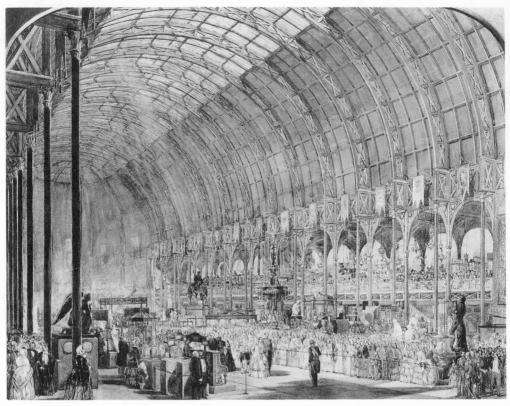

11. James Mahony (1810–79), *The First Visit by Queen Victoria and Prince Albert to the Irish Industrial Exhibition, Dublin,* ca. 1853, watercolor on paper, 60.1 × 73.3 cm, National Gallery of Ireland no. 2453. (Courtesy of the National Gallery of Ireland)

Picturing an Exhibition:
James Mahony's Watercolors
of the Irish Industrial
Exhibition of 1853

Nancy Netzer

A N UAIR IS dorcha sé an uair roimh breacadh an Iae" (the darkest
hour is the hour before the dawn). So reads the inscription around
the relief medallion of William Dargan in the upper right corner
of James Mahony's watercolor (plate 12) illustrating Queen Victoria and
Prince Albert's visit to the Irish Industrial Exhibition in Dublin on August
31, 1853. These words, as will be shown below, unveil the social outlook of
an elite (comprising industrialists, intelligentsia, and others well connected
to Britain) that inspired all three of Mahony's images of the exhibition. In
addition to visually chronicling an historic event, these watercolors reflect
prevailing aspects of an influential, if minority, culture of their time.

Held in temporary quarters on the six-and-a-half acres between Mer-
rion Square and Kildare Street—on the grounds of Leinster House (the
then premises of the Royal Dublin Society)—the exhibition was to mark
"the commencement of a new era in the history of Ireland . . . when indus-
try and public order, with their inseparable companions, happiness and
wealth, shed their abundant blessings over this portion of her Majesty's
dominions" (Sproule 14). William Dargan (1799–1867) proposed and
underwrote the ambitious project, which took place from May 12 to Octo-
ber 31, 1853. One of the richest men in Ireland, Dargan, an industrialist,
had built most of Ireland's railway system.

In 1852, when William Dargan suggested to the Royal Dublin Society
that it expand the scope of its Triennial Exhibition of Manufactures
planned for the following year, Ireland was "just recovering from the

effects of a degree of prostration almost unparalleled in history" (Sproule v). The previous year, Dargan had attended the Great Exhibition of the Works of Industry of All Nations in London, which had inaugurated the concept of a universal exposition focusing on innovation, industrial progress, and the intellectual improvement of society. Housed in the Crystal Palace, a temporary glass and steel construction in Hyde Park, the London exhibits included industrial machinery, raw materials, tools, textiles, musical instruments, and furniture from all over Europe. Although Ireland mounted an "eminently creditable" showing, "some districts were greatly wanting in responding to the call" (Sproule 4). After the Great Famine, the government of Ireland sought to convince both its people and the crown that it was taking steps to improve the country's economy and to build its industrial base. Dargan intended just such a demonstration "of the great industrial force which Ireland could bring forward" (Kane 1). The Irish exhibition showed the world, and most particularly fellow subjects in Great Britain, that, despite its recent reversals, Ireland had "abundant means for industrial employment" and that the Irish people could "carry out industrial pursuits, if properly directed" (Kane 2). Given this self-deprecating view on the part of the Irish nationals supporting the exhibition, the Queen and Prince Albert's promised support early in the planning stage, seemed a strong omen. "A great demonstration had been made calculated materially to improve the condition of the country; and it was especially gratifying on such an occasion to find the royal sympathies so thoroughly enlisted in its favour" (Sproule 15). Especially significant was the Queen honoring a leading Irish industrialist like Dargan. "In the private visit of Her Majesty to the founder of the exhibition—the first that has been paid by a British Sovereign to a Commoner in modern times—the people saw a recognition of the dignity of Labour, an acknowledgment of the importance of well-applied persistent Industry, which could not fail to be attended by beneficial effects in a country in which it had been the fashion for a spurious and affected gentility to sneer at such pursuits" (Sproule 15).

Such, in brief, is the setting, as seen by its organizers, for the Dublin Exhibition that James Mahony (1810–79) depicts. An associate of the Royal Hibernian Academy known for his renderings of panoramic scenes in Ireland, Spain, France, and Italy, Mahony had just returned from five years of traveling on the continent when he undertook the recording of Victoria and Albert's visits on four successive mornings during the eighteenth week of the exhibition. The watercolors form a complicated sym-

bolic apparatus that reinforces the overriding message of the exhibition. The illustrations are not accurate in every detail; rather, Mahony's use of artistic license enhances the viewer's understanding of their meaning. The message of the watercolors may be decoded by careful analysis of their content and by comparisons with contemporary descriptions of the Exhibition. Such an examination reveals their value not only for explicating the cultural role of the Dublin Exhibition of 1853, but also for clarifying the aspirations those who organized and supported the exhibition had for Ireland just after the famine.

The first of the watercolors in the chronology (plate 11) depicts the State reception, which took place shortly after ten o'clock on the morning of August 30. Upon entering the exhibition building, the Queen and Prince, shown in the watercolor with their two sons, Alfred and Arthur, and a royal suite behind, were conducted along the left side of the Great Centre Hall. They were led to a dais (not shown) where they were received by the executive committee of the exhibition and the Corporation of the City of Dublin, probably the group of officially dressed men in the lower right corner (Sproule 15–16). In the absence of written descriptions of the central event, one may reasonably surmise that the man receiving the royal procession, seen from behind in the center, is the Earl of Saint Germans, Lord Lieutenant of Ireland. During this first royal visit, William Dargan was formally presented to the Queen, who congratulated his "disinterested patriotism" (Sproule 16). Dargan, therefore, may be the figure in formal attire facing the viewer in the foreground on the left, waiting to be presented.

The oblique angle Mahony chose for this large watercolor captures the vastness and grandeur of the main hall, which, at the time, was regarded as the most magnificent space ever erected:

> The feelings produced on entering the Centre Hall were those of amazement and delight. The noble proportions of the Building, the apparently countless succession of arches presented on either side, the vistas between them, which conveyed an idea of almost unlimited extent. . . . On entering the door almost the first object that attracted attention of the visitor was Marochetti's equestrian statue of the Queen, placed in the center of the Hall; and ranged along either side were massive works of statuary, the colossal statue of Mr. Dargan, by Jones, occupying a prominent position on the right-hand side, near the upper end of the Hall. (Sproule 13)

The Temple of Industry, as it was called, was designed by John Benson, a native of Sligo. Its Centre Hall measured 425 feet long, 100 feet wide,

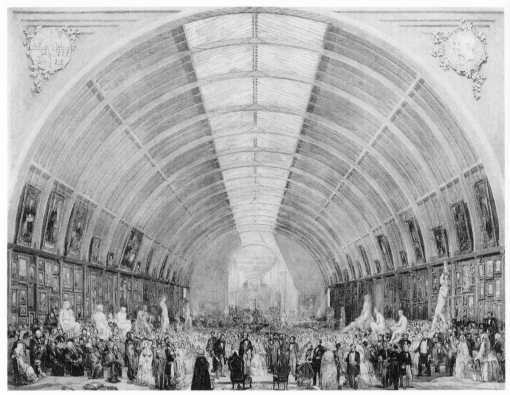

12. James Mahony (1810–79), *The Visit by Queen Victoria and Prince Albert to the Fine Art Hall of the Irish Industrial Exhibition, Dublin,* ca. 1853, watercolor on paper, 62.8 × 81 cm, National Gallery of Ireland no. 7009. (Courtesy of the National Gallery of Ireland)

and 105 feet high. Galleries lined either side, and the roof was constructed of semicircular arches placed 25 feet apart and made of wood, a material never before used for this purpose. Mahony takes great care to honor the private initiative responsible for the exhibition by detailing the circular heraldic devices and banners (above and in the spandrels of the arcade, respectively) of the various participating countries, guilds, corporations, and personages. Indeed, the design of his second watercolor (plate 12), seen through such an arch, bears circular devices in the upper corners representing the arms of Dublin, on the left, and Dargan, on the right. It pays visual homage and reinforces the message of the decoration on the arches of the Centre Hall.

In the center of the room, Mahony shows, unobstructed, the large

equestrian statue of Queen Victoria by the French sculptor Baron Charles Marochetti. It is the most symbolically significant sculpture by virtue of its subject and is indicative of the organizers' allegiance to Britain. Mahony depicts only some of the large sculptures that lined the hall on either side. The group of three reclining and seated female nudes at the right are probably the *Three Graces* by the English sculptor Edward-Hodges Bailey, which was considered one of the finest contemporary works in the Centre Hall. The standing nude figure to the left of the equestrian statue is probably a copy of the ancient Greek *Venus* that belonged to the Medici (now in the Uffizi in Florence), the most celebrated of the nineteen ancient sculptures acquired in Italy in the late eighteenth century by the Earl of Bristol, Bishop of Derry, and, at the time, belonged to Sir Hervey Bruce. On the opposite side may be the copy after the Hellenistic Greek *Crouching Venus* by the contemporary Roman sculptor Giacomo Vanelli, and in the left foreground is probably one of the two colossal *Praying Angels* in zinc after an original by the German artist Gustav Blaeser (Sproule 429–32). Representing a microcosm of the 455 sculptures spanning classical to modern times recorded as having been on loan from several European countries, Mahony's selection expresses the international and chronological breadth of the exhibition. In light of the nation's pride in the scope of the show, Mahony's omission of the large, prominently placed statue of Dargan by an Irish sculptor working in London, John E. Jones, does not seem odd. The likeness would have distracted the viewer from the message implicit in the selection of sculptures and, furthermore, its symbolic import would have been superfluous, as Dargan himself is shown in the foreground.

One commentator noted that "the building itself was perhaps the most successful novelty exhibited, both in Art and Manufacture" and that visitors "were struck by the richness and splendour of the Building more almost than by any of the objects that it contained" (Sproule 37). Devoting over 80 percent of the space to articulation of the building, Mahony has chosen a perspective for this illustration that graphically affirms the observation. On this first royal visit, the great Centre Hall was packed with spectators "crowded into every corner and perched on every conceiveable thing—fountains, statues, vases, looms, & etc." (*Exhibition Expositor and Advertiser* XVIII, 2). Indeed, season ticket sales soared to their highest level in anticipation of the royal visit (Sproule 21). Again, the picture captures the essence of the written description and, most important, conveys visually that the Queen recognized the exhibition as the epitomization of Ire-

land's post-famine progress and the degree to which the Irish supporting the exhibition welcomed that recognition.

On the occasion represented in this watercolor, the Corporation of the City of Dublin addressed the Queen, speaking of her visit as "additional proof of [her] solicitude to promote the interest and prosperity of [her] Irish subjects" (Sproule 17). Moreover, the *Exhibition Expositor* described Victoria and Albert's visits to the exhibition and especially their call on Dargan at home "as amongst the most important incidents in its history, and as deserving of a permanent record in the annals of this country" (XVIII, 1). The arrival of the Queen and her consort symbolized for all the world that England acknowledged Ireland's potential, a giant step in light of the country's recent economic history. Thus has Mahony recorded the event that for some, at least, signified the regeneration of Ireland.

The second watercolor (plate 12) depicts the second royal visit to the exhibition, the next morning. Victoria and Albert stand on a dais in the center; their sons, dressed in kilts, stand in front and to their right. Although in the first picture Mahony illustrated the crowds as he saw them, here he appears to have invented them, probably even the members of the Royal Hibernian Academy, whom he honors by positioning in the left foreground. As this visit took place early in the morning, before the public was admitted, only the exhibitors were in the building to explain their displays. The scene represented may well conflate events from the previous day. Members of the welcoming party hold scrolls, presumably the addresses presented by the Queen, Prince Albert, the executive committee, and the Corporation on the dais in the Centre Hall during the initial reception (Sproule 16–18).

As on the two subsequent visits, the Queen and Prince are said to have "minutely inspected [the exhibition's] contents, going regularly through the several departments" (Sproule 18). The exhibition was divided into four sections, raw materials, machinery, manufactures, and fine arts, each displayed in separate halls within the building. Mahony's artful decision to record the visit to the Fine Arts Hall, however, may be explained only in part by the royal party's having spent more than an hour there that day (*The Times* 6) and by his desire to celebrate his profession and fellow artists. A clue to the larger meaning of his choice resides in the perception that the particular genius of Ireland (like that of France) was "the ideal rather than the actual, the spiritual rather than the material, the abstract rather than the concrete" (*Journal of Social Progress* 4); that the Irish therefore were more innately artistic than the English, who are characterized

repeatedly as "mechanical, practical, and materialistic" (*Journal of Social Progress* 4–5). The fine arts had been excluded from London's industrial exhibition of 1851 in the Crystal Palace (although they were included in a smaller exhibition in Cork in 1852). Despite much debate, the Dublin committee argued for their inclusion: "In truth it is difficult, when once we have emerged from the rudest and most elementary state of society, to deny that the Fine Arts are themselves utilitarian . . . the study of Sculpture and Painting is essential to perfection in the ornamentation of almost everything in ordinary use" (Sproule 10). The inclusion of the fine arts, like Mahony's decision to depict the royal visit to the Fine Arts Hall, then, stands as a metaphor for the emergence of Ireland from a depressed past, able to realize the potential of its unique, artistic genius.

Details of the representation of the Fine Arts Hall reinforce this message. This construction, a grand space (albeit considerably smaller than the Centre Hall), measured 325 feet long, 40 feet wide, and 38 feet high. Mahony captures its scale and grandeur this time from a central viewpoint in front of the royal couple. The morning light, pouring through frosted glass in the center of the vaulted roof, was, as Mahony shows, adequate and not excessive. Contemporary paintings by British and Irish artists hung on one wall, and by German, French, and Belgian artists on the other. The watercolor shows larger portraits fitted in the lower part of the vault. Principal among them, but not identifiable in this rendering, were Franz Xaver Winterhalter's full-length portraits of Victoria and Albert, lent by the queen from Windsor Castle. Smaller paintings of various subjects were crowded one above the other against a cloth of "a deep heavy shade of muddy marone," which was thought to obscure the colors of the paintings (*Exhibition Expositor* II, 5). In this regard, Mahony's choice of pink for the material significantly improves the effect and appeal of the gallery.

Among the sculptures shown on either side of the hall are two of the three considered the finest and "most remarkable" contemporary works in the exhibition (Sproule 426). Mahony depicts the two by Irish artists, omitting the third, the *Seated Victory* by the Prussian sculptor, Christian Rauch. Moving the two Irish works from their actual placements in the Centre Hall, he imagines them here in positions of prominence on either side of the fountain in the center. On the left is *Eve*, by Patrick MacDowell, previously exhibited to wide acclaim at the Royal Academy in London and the London Exhibition of 1851; on the right is the *Drunken Faun* by John Hogan. These works were thought to show that modern, and more specifically Irish, art might "justly hope to rival the glories of the past"

(Sproule 423–26). Two other identifiable works by Irish sculptors are on the left: the nearest, *Hibernia with a Bust of Lord Cloncurry*, also by Hogan, and considered "his finest perfect work in marble," suitable to "adorn the Hall of an Irish National Gallery"; and farther back, the *Boys Wrestling* by John Lalor, "a careful composition presenting . . . regular and graceful outlines from every point of view" (Sproule 428). Another Irish work, the nearest on the right, not recorded as having been in the exhibition and therefore probably placed here by Mahony, is the large marble of a *Youth at the Stream* by John Foley. The majority of sculptures on the right, however, appear to be copies after the Greek, like the Hellenistic *Seated Boxer*. Their absence from the catalogue of the exhibition (Sproule 429–32) suggests that Mahony may have invented and placed them here to show the finest contemporary Irish sculptures in the company of the most celebrated works of antiquity. Indeed, sculpture was the only department of the exhibition in which the Irish were thought to "honestly claim pre-eminence" (Sproule 422), a claim Mahony has taken great liberty to confirm.

The third watercolor (plate 13) represents the fourth and final visit of the Queen and her Prince to the exhibition on the morning of September 2. Here, Mahony returns to the Centre Hall, this time viewing it from the front and only slightly to the left. Again, the structure of the building, its streaming light and lofty proportions figure prominently, emphasizing the scope of the achievement. Victoria and Albert lead a procession with their sons immediately behind. A small group of formally dressed gentlemen, probably members of the exhibition's executive committee, stand ready to receive them. As in the previous watercolor, the crowds of onlookers at the sides and in the galleries are exaggerated. Once again, several sculptures stand out in the Centre Hall (i.e., Marochetti's *Equestrian Statue of Victoria*, immediately in front of the first fountain, Bailey's *Three Graces*, and, on the left, the two colossal *Praying Angels* after Blaeser). In this watercolor an Irish medieval high cross (eclipsing a cross of Anglo-Saxon type further back) sits in full view at the left front of the hall, symbolizing the period during which Ireland was in the forefront of artistic development. It signifies that the promise of Ireland's future lay in the illustrious past of the Irish people. Mahony relies primarily on one image to visualize this point, thereby relegating it to a subplot. His purpose, indeed the prevailing purpose of the exhibition, signified by the emphasis on contemporary Irish art in the second watercolor and on the building in all three, is that Ireland was fully able to adapt and prosper in the evolving industrialized world.

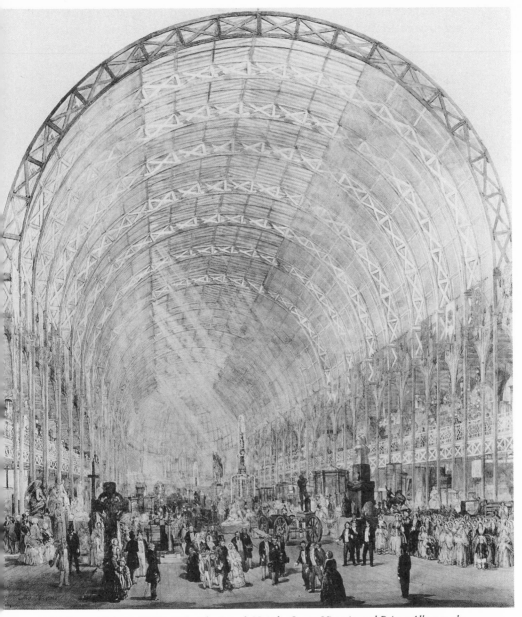

13. James Mahony (1810–79), *The Fourth Visit by Queen Victoria and Prince Albert to the Irish Industrial Exhibition, Dublin*, ca. 1853, watercolor on paper, 72.8 × 65.6 cm, National Gallery of Ireland no. 2452. (Courtesy of the National Gallery of Ireland)

The exhibition was thought to have succeeded on several counts: it accelerated Ireland's recovery, it acquainted the world with the country's resources, it reinforced the value of indigenous and productive industry, and it prompted the founding of the National Gallery of Ireland (Sproule 20–21). Mahony brilliantly depicts the exhibition's success in conveying to the world the arrival of the dawn after Ireland's darkest hours. These watercolors symbolize optimism and the promise of Ireland. They bespeak the eventful history and the contemporaneous struggle of one nation to regain the respect of its fellow subjects of the crown across the channel.

The executive committee of the Irish Industrial Exhibition of 1853 argued that the fine arts "contribute to the pages of history as well as the scribe or printer. The former perpetuates and diffuses the forms and characters of historical persons and events . . . as the latter cannot do" (Sproule 10). William Dargan and James Mahony were alike in the grandeur of their objectives: one to demonstrate the achievement and even greater potential of Ireland; the other to record and dramatize that achievement. As the exhibition foretold a new age of industry and art, so the industrialist and artist foretold of better days for Ireland.

WORKS CITED

Bence-Jones, Mark. "Ireland's Great Exhibition," *Country Life* (15 Mar., 1973): 666–68.

Exhibition Expositor and Advertiser, 24 vols. Dublin, (1853): II, XVIII.

Kane, Robert. "On the Uses of Industrial Exhibitions," *Journal of Industrial Progress* (Jan. 1854): 1–6.

"On the Establishment of a National Gallery of Art in Dublin, and on the means of establishing Permanent Exhibitions of Art in Provincial Cities generally," *Journal of Social Progress* 1 (1854): 1–11.

Sproule, J., ed. *The Irish Industrial Exhibition of 1853: A Detailed Catalogue of Its Contents*. Dublin, 1854.

The Times (2 Sept. 1853): 6.

Describing Dublin:
Francis Place's Visit, 1698–99

Raymond Gillespie

T HE FEATURE of Irish society in the seventeenth century that struck visitors to the country was its poverty. While a near economic miracle occurred in the years after 1603, and especially after 1660, Ireland remained a poor, marginal society in comparison to most of Europe. Visitors commented on the underdeveloped landscape and its sparse population. James Verdon, rector of Market Deerham in Norfolk, traveling from Dublin to Drogheda in 1699 observed that there were "no houses or people to be seen in ten miles riding." He also noted that "in cities and great towns as they call them, though I saw none bigger than Market Deerham nor none so good except Dublin, the people are civilized and do like christians but in the country they are barbarous in all points."[1]

The pall of such poverty and limited urbanization spread over many areas of Irish society, including its cultural life. Low population limited the demand for land and hence landlords commanded a rental income lower than in most other parts of the British Isles. There was correspondingly less money to spare for artistic patronage. Settler landlords, most of whom had risen from humble origins, spent such cash as was available on building large houses and erecting large-scale funeral monuments as public manifestations of their new-found status. Heraldic drawings, prepared in designing such monuments, still survive (Loeber, *Sculptured Monuments* 267–93). Patronage for writers was also negligible. Dublin, as the capital of Ireland and the center of its cultural life, had little to offer as a status imprint on published work. As a result most seventeenth-century Irish manuscripts

were published in London, leaving the Dublin presses idle for most of the century. As James Verdon remarked, "They have, moreover, a printing house which, I must own, is no great glory for them because they seldom print anything but news and tickets for funerals."[2]

Similarly, activity in the visual arts was limited in seventeenth-century Ireland. Artists produced and collectors collected for practical reasons rather than to indulge aesthetic tastes. Only the very wealthy, such as the Duke of Ormond, could indulge their aesthetic taste. When Richard Boyle, the Earl of Cork, paid a French lymner £12 in 1621 for miniatures of himself and members of his family, his motive was practical. The portraits of his children were sent to potential spouses (Grossart 2:30).[3] Most settlers' investments in painting stopped with portraits of themselves or, in a suitably idealized form, of their ancestors. It was only at the end of the century that interests grew wider. The busiest visual artists of the seventeenth century were map makers. They drafted high quality surveys that helped settlers manage their newly acquired estates (Andrews 52–102). The state also employed such men to draw maps of the countryside, the land-owning arrangements of which were constantly changing, and to make surveys of and recommendations for its defense. Nicholas Pynnar, an early seventeenth-century surveyor general, produced fine drawings of Irish fortifications although he lacked skill in conveying perspective. It was Thomas Phillips who, in 1684, prepared a series of watercolors that provide the first real topographical views of Irish towns and forts.

Few artists within Ireland produced views of their surrounding landscape but several visitors, as part of their wider travels, recorded their impressions of Ireland in their sketchbooks. Most, however, preferred to capture their Irish experience in the written word. It was not until 1681 that Thomas Dineley, a Southampton lawyer who had already visited France and the Low Countries, illustrated his description of his travels in Ireland with sketches, as he had with his European tours. Dineley, like most travelers to Ireland, had come with a purpose: to gratify his passion for funeral monuments, scores of which he had already recorded in England and Europe. His Irish notebook contains carefully executed sketches of such monuments in the principal Dublin churches, but he also found time to document the architecture of some public buildings, including the new merchant exchange hall, the Thosel. As he toured the country, he made rough sketches of the houses belonging to the principal families and of the towns of Limerick, Ennis, Kinsale, and Youghal, but in the main, he restricted himself to tombs (National Library of Ireland ms. 392).

Almost twenty years passed before another artistically inclined tourist visited Ireland: Francis Place, touring along the east coast of the country in 1698 and 1699. His interests were rather less specific than Dineley's. Born in 1647 at Dinsdale in County Durham, Francis Place was the sixth and last child of a lawyer father (Tyler). He had entered his father's old Inn of Court, Gray's Inn, to train as a lawyer in 1665 but his leaning was not toward law but toward art. He spent most of his life traveling, sketching, illustrating, and working with ceramics, a career made possible by a private income after his father died in 1680. While at Gray's Inn he met the Prague artist Wencesaus Hollar, who had first come to England in the 1630s under the patronage of the Earl of Arundel. Hollar's work had a significant influence on Place. The basic feature of Hollar's work was realism, drawn from Renaissance rationalism, and not surprisingly his main interest was in landscape. He produced a vast and historically reliable record of the land and people of seventeenth-century Europe: his engravings attempting to depict the realism of life. Of particular importance are his urban landscapes. His parallel views of London before and after the Great Fire of 1666, together with the ground plans of the areas destroyed, are especially valuable. Place followed his master with a series of drawings documenting York in 1675, capturing the city with views from a circular pattern of vantage points, a technique he also used on his Irish tour. New scientific ideas, advocated by the Royal Society and elsewhere, which relied on careful observation and recording, encouraged Place to emulate Hollar's realism. He illustrated scientific works for the Royal Society and provided illustrations for the York Virtuosi, a scientific and antiquarian society.

What prompted Francis Place to visit Ireland in 1698 is unclear. He had already traveled extensively in France and England in the 1680s after his father's death. Perhaps antiquarian curiosity launched the journey; he certainly made notes on the history of the country from Sir John Temple's history of the Irish rebellion in 1641, one of the most reprinted books of the day, which he pasted into one of his sketchbooks. He may have seen an opening in the market for a series of engravings of the British Isles. Most of his original drawings would have met the requirements of such a proposal and he visited Wales in 1699–1700 and Scotland in 1701. He may also have come to visit relatives.

Whatever his motive, Francis Place arrived at Drogheda in 1698 and journeyed south to Dublin. In 1699 he traveled to Waterford on the south coast by way of Castledermot and Kilkenny. Like Dineley before him, he sketched some castles and small scenes along his route, but his panoramic

views of Drogheda, Dublin, and Waterford are of particular significance.[4] As he had in York, he selected a number of prominent sites that gave him a wide view of the town. He probably used a camera obscura and the outline was penciled in lightly (Loeber, "Unpublished View" 15). In some of the partly unfinished drawings, such as the view of Dublin from the north, the light penciling is all that remains in some parts of the drawing. On others the drawing has been inked over and on some a wash applied. Given what is known of Wencesaus Hollar's influence and Place's careful execution of other topographical sketches, we may suppose his Irish drawings to be an accurate record of the Irish urban landscape at the end of the seventeenth century. Where his drawings can be checked by reference to contemporary documents, this proves that is indeed the case. Place's drawings constitute a vital source for reconstructing the social landscape of Ireland's three main towns, particularly Dublin, at the end of the seventeenth century. This essay attempts to expand Place's moment of expression into a panorama of Dublin in the late 1690s.

Place's sketches of Drogheda and Waterford show towns that appear still largely medieval. Waterford is depicted as a town still enclosed within medieval walls and dominated by its thirteenth-century defensive towers, of which Reginald's Tower on the river is the most prominent. It was only in the early years of the eighteenth century that Waterford lost its predominantly medieval appearance. William Van der Hagen's 1736 view of the city, composed from almost the same vantage point Place had used, illustrates the change: considerable rebuilding along the waterfront and eastwards along the river and the construction of a pedimented exchange on the waterfront (Crookshank and Glin 57). The churches in Place's sketch are small, dominated by the medieval cathedral of Christ Church with the dissolved Franciscan friary to the left and the thirteenth-century Dominican friary to the right. Similarly in his view of Drogheda from the southwest, the medieval St. Lawrence's gate is prominent. In another sketch, he recorded the remains of St. Mary's Abbey in the town.

Place's series of Dublin views, by contrast, show a more modern city. Almost no medieval fabric can be seen, except for a part of the castle in his view from the north. During the seventeenth century Dublin spread dramatically beyond its medieval core, which lay on the south side of the river. It expanded across the river to the north and south, beyond the medieval walls. Place recorded the dramatic effects of this development on the landscape by featuring in his drawings the new bridges that connected the

developing north side of the city with the older city on the south bank of the river, and connected the city with the wider world. He chose the substantial four-arched bridge at Donnybrook as his vantage point for his easterly view of the city. Likewise, from the standpoint of the house called the Phoenix, west of the city, he gave prominence to the seven-arched sixteenth-century bridge across the Liffey at Chapelizod, which had been repaired at a cost of £20 in 1694. Within the city, the Essex, Ormond, and Arran bridges had been built after 1660. Originally constructed of wood, Ormond Bridge was rebuilt in stone in 1684 and Essex Bridge was rebuilt in 1688. In 1693 a new wooden bridge was built at Parkgate, at the extreme west of the city, costing £48 (Representative Church Body P328/7/1). From this bridge Place drew *Dublin from the Wooden Bridge* (plate 14), which shows at its center Arran Bridge down river. This 1699 drawing portrays the effect of bridge building in the city. As the bridges segmented the river, quays were erected along its banks; Place shows one under construction on the north side of the river. Houses were subsequently built along these quays.

In 1600 Dublin was a small town, probably comprising between 15,000 and 20,000 persons (certainly less than 1.3 percent of Ireland's population), and was smaller than most English provincial centers (Cullen 277 no. 2). Luke Gernon, a visitor in the 1620s, recorded that the medieval town was largely unchanged, "most frequented more for conveniency than for majesty." He said it "resembleth Bristol but falleth short" (Falkiner 350). Over the century the population grew at a rate of about 1.5 percent per annum, which outshone even London's growth of about 1 percent per annum over the same period. The demands of such dramatic growth necessitated the reorganization of parishes. The old parish of St. Michan, north of the river, for instance, was divided into three in 1697. New churches were built and older churches rebuilt. By the 1690s, only St. Audeon's retained even part of its medieval fabric despite considerable restoration in 1670. St. John's, in the heart of the medieval city, was rebuilt once in the early sixteenth century and again in 1680–82. St. Nicholas Within had also been largely reconstructed in the sixteenth century and rebuilt in 1707. St. Werburgh's was enlarged in 1662 and St. Bride's and St. Michael's rebuilt in 1684 and 1676, respectively. Some new churches, such as St. Peter's, in 1680, and St. Andrew's, in 1670–74, were built to meet the religious needs of the growing city. Others such as St. Kevin's and St. Stephen's, were demolished to make way for new building.[5]

According to Place's drawings this widespread rebuilding was not con-

fined to churches. As early as 1630 Sir William Brereton on a visit to the city recorded: "this city of Dublin is extending its bounds and limits very far, much addition of building lately and some of those very fair and stately and complete buildings" (Falkiner 385). Of all the plasterers who came to Dublin in the first forty years of the seventeenth century, more than half arrived between 1636 and 1640 along with nearly three-quarters of the bricklayers and a third of all the joiners and carpenters (Fitzpatrick). In the late seventeenth century, fashionable areas were set out. The city corporation, encumbered by debt, was forced to plan a development of ninety plots around St. Stephen's Green in 1664, and a further scheme of 150 plots along the north side of the river was planned in 1685 (Gilbert 4: 257, 271, 299–307, 323–25, 329–32). Private development was also carried out, such as the new suburb laid out by Lord Longford on his own land adjacent to St. Stephen's Green (Burke). By the end of the seventeenth century, Dublin was the principal commercial center of the country, with almost half the nation's trade passing through it. The largest houses in Place's view of the city from the north are those of the merchants along the riverfront.

The cultural significance of the city also grew enormously. The appointment of John Ogilby and Thomas Stanley as joint masters of the revels in 1663 linked the growth of theater with the vice-regal court, which provided a stimulus for such entertainment (Clarke 26–32, 43–48, 58–60). Coffeehouses flourished by the 1680s, not only as centers of business, but also as ways of disseminating news. The bowling green on the north side of the river Liffey, which Place noted in his drawing from the wooden bridge, was a smart center of sociability for the upper classes. The intellectual life of the city was guided by the Dublin Philosophical Society, founded in 1683, and modeled on the Royal Society in London. The city was also the site of the country's university, Trinity College. The young Donough Clancy, from West Cork, not only wrote to his brother in the college for schoolbooks in 1639, but also looked forward to going to the college himself because "I am very desirious to be brought up among gentlemen, to see fashions and all other kind of breeding." He enclosed with his letter a number of Latin verses to show that he was "as handsome a scholar as any of my age" (Clancy). An anonymous writer comparing Dublin with London in 1680 observed that "men live alike in these two cities." Thus the bookseller John Dunton's comment that by 1699 Dublin, although "twelve times less than London, is yet the biggest next to it in all our dominions" is not a surprise (MacLysaght 376). London was not the only criterion for comparison. One observer in 1686 placed Dublin in

14. Francis Place (1647–1728), *Dublin from the Wooden Bridge*, 1699, ink and wash on paper, 22.5 × 68.2 cm, National Gallery of Ireland no. 7515. (Courtesy of the National Gallery of Ireland)

the top twelve European cities, and in 1687 Sir William Petty compared it favorably with Paris, London, Amsterdam, Venice, and Rome and declared it far in advance of any English provincial town (Hull 2: 225–26).

Francis Place's drawings captured Dublin at this key moment in its development. By the time of his visit in 1699, the first phase of seventeenth-century development was complete. The redevelopment that took place in eighteenth-century Georgian Dublin obliterated much physical evidence of the ideas and priorities of the seventeenth-century builders. Church architecture, which is an important guide to the beliefs of any community, is a case in point. The church of St. Andrew, built after the parish was created in 1665 to cope with the expanding urban population, was reconstructed in 1805. Evidence of its earlier appearance comes from Place's drawing of "the south side of the oval church," which attests to the extent to which Protestant theological thinking had taken hold in seventeenth-century Dublin. The church was built in 1670–74 to an elliptical plan, 60 × 80 feet, by William Dodson, one of the most prominent of the contemporary Dublin architects (Loeber, *Biographical Dictionary* 48–51). The design expressed the triumph of Reformation ideas in Dublin. The Dublin churches inherited by the Church of Ireland at the Reformation were made up of a series of functionally distinct internal units: the nave, with its pulpit, for preaching, and the chancel for the sacrament; transepts had usually been partitioned into side chapels but these were removed at the Reformation. An elliptical church such as Place drew was not amenable to such a functional division between word and sacrament, a division opposed by the Reformers. Place left no sketches of the interior of the building which might have revealed the relative positions of the pulpit and altar, and thus the relationship between word and sacrament. The traditional layout of St. Andrew's at the end of the eighteenth century, probably reflecting an older tradition, was that the pulpit stood behind the altar to signify the equality of word and sacrament (Warburton, Whitelaw, and Walsh 1: 510–13). While the less radical St. Peter's, built in 1680, separated word and sacrament by locating the pulpit midway down the church, it, too, omitted the chancel screen, long a tradition but neither required nor prohibited by the canons of the Church of Ireland.[6]

If the newer churches in late seventeenth-century Dublin incorporated many of the new ideas of the Reformation, most of those drawn by Place sat on pre-Reformation sites, with ground plans constrained by their medieval origins in built-up areas. Alterations to their internal arrangements, however, were the most tangible signs to the laity of the theological

shift that had taken place. The Dominican Richard Bermingham noted in 1619 that "the Protestants have broken up the stone altars that were in our churches and altered the arrangement of the church in order that the marks of their original delineation should disappear" (Walsh 51). Most seventeenth-century churches were simple square structures but were prominent on the skyline in Francis Place's drawings by virtue of their towers, which rose above most of the buildings in the city. These towers had a practical function since the bells hung there were an important means of communication within the city, and the ringing of the bells was an important function of the parish clerk. At the simplest level, the ringing of the bell indicated the times of worship. It also marked out other holy moments. The nineteenth canon of the Church of Ireland required that "the minister of every parish shall the afternoon before the said administration [of communion] give warning by the tolling of the bell . . . to the intent that, if any have any scruple of conscience, or desire any special ministry of reconciliation he may afford it to those who need it." The ringing of the bell also set a divine seal on events both sacred and secular, such as the king's birthday or the anniversary of the Irish rebellion on October 23. Such events were occasions for special church services and were usually accompanied by popular festivities, such as bonfires (Cressy). In 1677 the bells of the united parishes of St. Catherine and St. James on the west side of the city were rung on St. George's Day, October 23, November 5 (in memory of the 1605 gunpowder plot), on the king's birthday on May 29, on the Duke of Ormond's entrance into the city, on the Prince of Wales's birthday, and on his wedding day. In 1690 the message was rather different. Bells rang after the Battle of the Boyne, for the coronation of William III and Mary, for the taking of Athlone, and for the Battle of Aughrim (Representative Church Body p117/5/1, folio 170, 341). Failure to ring bells with sufficient enthusiasm was severely regarded and the bell ringers in Christ Church Cathedral were imprisoned for failing to ring the bells after the birth of a son to James II in 1688 (Robinson 262). The use of bells was so great in most churches that the bell rope had to be replaced each year.

A church tower was symbolical as well as functional. As Place's drawings clearly show, it defined and drew attention to the location of the sacred in the landscape. This is also evident from the number of churches in the drawings that had added spires to their towers to achieve greater prominence. During the seventeenth century the skyline of the city grew. Viewed from the north in Place's drawing, the waterfront had acquired three-and-a-half-story buildings by 1698 although most of the city was still two storied.

It was mainly churches in this part of the city which had increased their prominence by adding steeples. St. John's, near the waterfront, had done so by 1639, and in 1694, St. Michael's found it necessary to add another 35 feet to the steeple that was already 52 feet high. In 1741 the Cathedral of St. Patrick, furthest away from the high buildings in the commercial district, became the last of the Dublin churches to acquire a steeple.

This definition of sacred space by use of the church tower and steeple was, as shown in Place's drawings, confined to the Church of Ireland. The Church of Ireland had repudiated most of the church furnishings of the Catholic Church; the symbols of the Passion, for example, were effaced from Christ Church in 1563 and the relics and statues in the cathedral removed. At St. Audoens a wall painting of the Blessed Virgin Mary and St. Anne was whitewashed over (Lennon 134). The interiors of most Anglican churches in Dublin had been whitewashed by the 1690s, and in most the Ten Commandments, Apostles' Creed, and Lord's Prayer had been painted in gold above the communion table. The royal arms were usually painted over the west door, beside which stood the baptismal font. St. John's was unusual in retaining a picture of its patron saint, which was re-gilded in 1682 (Representative Church Body p328/5/1: 97). At a central place at the east end was the altar, which was often, as it was in St. Michael's, set two or three steps above the body of the church although the altar had little decoration apart from a carpet (Representative Church Body p118/5/11, folio 136). While the priest might no longer reenact the sacrifice of Calvary, the altar still formed a physical focus of worship. Kneeling for prayer and communion, and gestures such as bowing when entering the church and at the name of Christ during the service, gave the building a sense of the sacred (King).

Other religious groupings had also emerged. By 1700 Dublin could boast four Presbyterian congregations, with another at Clontarf near the city, as well as three Baptist congregations, a scattering of independents, and a synagogue. By 1716 four Huguenot congregations had formed. There were three Quaker meeting houses by 1692 when a new, large meeting house was built in Sycamore Alley to accommodate all of Dublin's Friends. Despite legislation against these churches, none concealed themselves. The surviving classical frontage of the Eustace Street Presbyterian church could not be missed. The theology of these churches, however, emphasized not the physical building but rather the gathered congregation. As Robert Craighead, the Presbyterian minister at Derry, put it in 1694, Christ had promised to be where two or three worshipers were met

together "not in the place but to the assembly." Joseph Boyse, minister of the Presbyterian congregation on Wood Street in Dublin, was one of those who, in 1694, became embroiled in a pamphlet war with William King, bishop of Derry. Boyse denied the validity of the "bodily worship" that gave the Church of Ireland churches a sense of the sacred, arguing that "the signification of our homage by word being more distinct, clear and full than by gestures." The gestures of the Presbyterian community had much less of the sacred about them. In Dublin they stood for prayer and sat for the reception of communion, rather than kneeling as the Anglicans did (Craghead 96–97, Boyse). In the view of the Presbyterians, the buildings, of themselves, had little importance if divorced from the gathered saints who met there, and therefore there was no theological reason to mark them out in the landscape.

Catholic theology, however, dictated that the locations of churches should be marked out as particularly holy sites. At Catholic worship the holy was made manifest in the eucharist and in the relics of saints, which rested in churches. Thus prayers said in the sanctity of the church were held to be more efficacious than those said at home, a belief reflected in the interiors of Catholic churches in seventeenth-century Dublin (Fitzsimons 2). Catholic churches were usually highly decorated. Kildare Hall, the long, low building topped by a lantern at the center of Place's view of Dublin from the north, was used by the Jesuits as a church probably until the 1650s. Sir William Brereton visiting it in 1630 described its pulpit as "richly adorned with pictures and so was the high altar which was advanced with steps and railed like cathedrals, upon either side thereof was there erected places for confession" (Falkiner 382). The furnishing of Catholic churches in the eighteenth century was equally elaborate. In the church in Liffey Street, built in 1729, the altar front was covered with leather and embossed with the name of Jesus. The altar had a gilt tabernacle and six gilt candlesticks and the altarpiece bore a picture of the conception of the Blessed Virgin Mary. Paintings of the apostles Peter and Paul hung on each side. In Place's Dublin, however, such churches, still viewed as politically seditious, rarely advertised their presence. Thus they scarcely feature on Place's sketches. Yet they did have a strong sense of the location of the holy. New churches were set up as close to the older sites as possible and they often reused some of the furnishings of pre-Reformation churches. In 1749, for instance, the Catholic church on St. Mary's Lane had "a large image of the B[lessed] V[irgin] with Jesus in her arms carved in wood, which statue before the dissolution belonged to St. Mary's Abbey (Donnelly).

While church towers and spires dominate Francis Place's view of the city from the Phoenix Park (plate 15) secular buildings such as the tower of the Thosel stands out at the center of the drawing. The same tower also appears prominently on Thomas Bates's 1695 landscape of the city from the same vantage point (Crookshank and the Knight of Glin 31). Architecturally it is unlike the church towers in that it is a series of bulbous stories rather than square but its function is similar: to draw attention to an important civic space. The Thosel was built by the corporation between 1676 and 1682 to be a meeting place for the corporation as well as for some of the guilds and to be a merchants' exchange and market hall. It was nearing completion at the time of Thomas Dineley's visit in 1680. Dineley's drawing, together with the corporation minutes, provides details of its appearance and construction (National Library of Ireland ms 392, folio 53). As Place's drawing suggests it was about 100 feet tall and 64 feet wide. Its 44 foot tower is the only one visible in all of Place's drawings of the city from the different vantage points. The town clock was placed in the tower and the whole construction was completed by a cupola. Of the two stories below the tower, the lower story, 22 feet high and open arched, housed the merchants' exchange, a symbolic interchange between the corporation and the merchant community on which the city's prosperity rested. It was here also that the mayor and aldermen, dressed in their gowns, met royal officials on the way to church on Sunday mornings. They would "salute the government . . . and then attend it to church" (MacLysaght 383). On the first floor of five bays was the large room where the lord mayor and aldermen met and a second room where the commons and sheriffs met. A room was also set apart for the merchants' guild, called the Trinity Guild, and another as a record storage room (Gilbert 5: 316, 360). The common council room was decorated in the smartest style, wainscotted with Danzig oak which cost £123. 2s. 3d. and the commons sat on three dozen turkey work chairs. Most of the other rooms were painted but featured gilded detail (Gilbert 5: 257, 372, 384, 387, 502).

What were most prominent to visitors to the Those were the symbols of loyalty to the crown with which it was decorated. The royal arms were placed at the center of the exterior. In 1684 the corporation erected on either side of the royal arms two 8 foot statues, one of Charles I and the other of Charles II. These were intended to be prominent, since when first carved, by the Dutch sculptor William de Keysar, they were judged too small and an additional 2 feet were added (Gilbert 5: 271, 291, 319–20). Inside the building there were portraits of the king; the corporation paid

15. Francis Place (1647–1728), *A View of Dublin from the Phoenix Park*, 1698, pen and ink with colored wash on paper, 27.5 × 45.2 cm, National Gallery of Ireland no. 7516. (Courtesy of the National Gallery of Ireland)

£24 for a portrait of James II in 1689 (Gilbert 5: 497–98). This theme of loyalty by the city to the crown extended to the corporation regalia. In April 1661 the king conferred on the mayor of Dublin a cap of maintenance, to be borne before him in processions, together with a collar to be worn by the mayor. The city mace, also to be borne before the mayor, was re-gilded in 1685 to match the new splendor of the Thosel, and had the royal arms emblazoned on it (Gilbert 1: 42–43). All this iconography distinguished the loyal city dwellers from the potentially disloyal Irish in the surrounding countryside. It also demonstrated their Anglicization, and therefore in the eyes of English and Anglo-Irish contemporaries, their civility.

The clock was an important feature of the Thosel. The possession of a clock by a corporation was a sign of the distinct character of the town. It connoted the difference between the rhythm of urban life, governed by the clock, and of rural life, governed by the weather and seasons. English towns had begun to acquire clocks by the middle of the sixteenth century, and Dublin, by quickly acquiring its own, asserted not only its modernity, but also its Englishness. The late seventeenth-century annals of Dudley Loftus noted under the year 1560: "This year were set up three public clocks, the one in the castle another in the city and a third at St. Patrick's church which were at the first setting up a very great pleasure to the people and became the subject of verses made on that occasion with much ease by putting the name of Ireland into the place of England which was the only difference between these and other verses which had been made in England upon the like occasion" (White 236). The Thosel clock, surrounded as it was with the royal arms, symbolized to Dubliners what was expected of them.

A building on the scale of the Thosel signaled a new development within the corporation and in particular a new sense of civic pride in the late seventeenth century. The corporation, for instance, observed in 1684: "this city (being the metropolis of this kingdom) is lately very much increased in building." Such civic pride had led to the building of the Thosel. When consideration was first given to what was to prove a ruinously expensive project, repairs to the old Thosel were proposed, but deemed "in no wise fit or suitable to the dignity of this city" (Gilbert 5:96). Underlying the new sense of civic pride was a subtle shift in the status of the city in the late seventeenth century. In the early part of the century Dublin had been less the capital of a kingdom, as was its constitutional position, than the center of a colony. Most settlers in Ireland were too concerned with their own provincial affairs to give much thought to the city where, until the 1630s, there was little to attract them. Government in Dublin, with

Dublin Castle as its seat, was low-key with little resembling a court at the hub of social life. This was reflected in the architecture of the Castle. Sir William Brereton, visiting Dublin Castle in 1635, was surprised at how modest it was. The House of Lords was "a room of no great state or receipt" and the Commons "but a mean and ordinary place." The Council Chamber was "a very plain room" (Falkiner 380–81). From the 1630s this began to change under the influence of a new lord deputy, Thomas Wentworth, but the outbreak of war in 1641 retarded the process. By the 1660s, however, there was a new sense among settlers forged during the 1650s that Ireland was indeed a real kingdom and that Dublin was its capital.

The arrival in Dublin of the king's deputy, the Duke of Ormond, in July 1662, was an event of some splendor in comparison with the arrival of Wentworth in the 1630s. Ormond was greeted by four masques along his route into the city, the last being one of Bacchus at the gate of Dublin Castle.[7] The message was clear: there was confidence that the vice-regal court would quickly reestablish itself after the Cromwellian reign and this was to be of fundamental importance to the shaping of the late seventeenth-century city. It was necessary to demonstrate in a tangible form the power of the newly restored monarchy and the government in Ireland, since as Ormond later remarked to his son, "It is of importance to keep up the splendour of the government" (Historical Manuscripts Commission 189). Francis Place's drawings show the difficulty of the task in a city where space was at a premium and building projects were constrained by a shortage of funds. Ormond contented himself with refurbishing Dublin Castle, a process which was hastened by fires in 1671 and in 1684. The administrative functions of the Castle were also reorganized. Parliament, now meeting more frequently than ever, was transferred to the cramped quarters of Chichester House (each chamber measuring only 57 feet by 21 feet), and the prison was also moved. Dublin Castle was now to be a center for the viceroy only. Robert Ware's description of the Castle in 1678 referred to the rebuilding, sponsored by the Earl of Essex following the fire of 1671, as "a beautiful form of a fair building unto which you ascend by a noble staircase" (Maguire, Loeber *Rebuilding*). By the 1690s, following the rebuilding necessitated by the 1684 fire, John Dunton could compare the castle with London's Whitehall. He added, "and indeed the grandeur they live in here is not much inferior to what you see in London if you make allowances for the number of great men at court there" (MacLysaght 385–86). The French traveler Joervin de Rocheford made the same point at the end of the

1660s when he noted that Ormond "has a fine court and a suite altogether royal, among them are several French gentlemen" (Falkiner 413).

All of these improvements, however, had little effect on the physical appearance of the city. Externally the Castle remained unimposing and appears only in Place's views from the north of the city. It was dwarfed on the skyline by the Thosel, the church spires, and the houses of the merchants. If the power of the state was to be shown to its full effect through the architecture of its buildings, it would have to happen outside the city. An attempt in 1684 to relocate the courts outside the city was opposed by the corporation on the grounds that it would divert business from the city (Gilbert 5: 346, 377). Some success was achieved in locating government away from the medieval core. Place's drawing from the wooden bridge shows the new Custom House on the north side of the river; it was larger than any of the houses of the gentry going up alongside it. However, the greatest success in locating institutions of govenment outside the city was with the Royal Hospital built in the 1680s at Kilmainham, just to the west of the city. The idea for a soldiers' hospital modeled on Les Invalides in Paris was sponsored by the Duke of Ormond. The architect was the Surveyor General, Sir William Robinson. Costing almost £24,000, it was a building intended to impress (Craig 153–56). Francis Place was clearly impressed. As might be expected, it appears in his view of Dublin from the west, but he also made four sketches of the building itself, each from a different perspective, and another showing it in a wider context, with the city in the distance (plate 16).

Francis Place's attempt to describe Dublin in the late 1690s, just before the great rebuilding of the eighteenth century was about to begin, reflects almost every aspect of the city's life. His drawings document the context of the social, religious, administrative, and political life of the city. If there are any regrets about his work, it is that it was not more extensive and that it was confined to the exteriors of buildings. Place's panoramic views of the city are unique, recording, as they do, not only the topographic landscape of Dublin, but also the mental landscape of its inhabitants.

NOTES

1. British Library, additional ms. 41769, folio 40. On the economy of seventeenth-century Ireland see Raymond Gillespie, *The Transformation of the Irish Economy*. Dundalk: Dundalgan Press, 1991.

16. Francis Place (1647–1728), *The Royal Hospital, Kilmainham, Dublin*, ca. 1690–1700, ink, pen, and wash on paper, 18 × 33.4 cm, National Gallery of Ireland no. 7517. (Courtesy of the National Gallery of Ireland)

2. British Library, additional ms. 41769, folio 35. For the activities of the press, see Raymond Gillespie, "Irish Printing in the Early Seventeenth Century" in *Irish Economic and Social History,* 15 (1988): 81–88. As William King, Archbishop of Dublin, wrote in 1716, "I believe we are as backward in Ireland as to architecture and indeed to all arts and sciences as to most countries in Europe nor is it any wonder it should be so considering we are a depending province. . . . " Trinity College, Dublin, ms. 2533, 271–72.

3. For the marriage negotiations of those represented, see Nicholas Canny, *The Upstart Earl.* Cambridge: Cambridge University Press, 1982, 87–91.

4. Reproductions of most of Place's Irish drawings are accessible in John Mahen, "Francis Place in Dublin" in *Journal of the Royal Society of Antiquaries of Ireland,* 62 (1932): 1–14; John Maher, "Francis Place in Drogheda, Kilkenny, Waterford etc." in *Journal of the Royal Society of Antiquaries of Ireland* 64 (1934): 41–53; Rolf Loeber, "An Unpublished View of Dublin in 1698 by Francis Place" in *Bulletin of the Irish Georgian Society,* 21 (1978): 7–15 (Dublin from the north); Theo Moorman, "Some newly Discovered Drawings by Francis Place" in *Burlington Magazine,* 94 (1952): 159–60 (Drogheda); Patricia Butler, *Three Hundred Years of Irish Watercolours and Drawings.* London: Weidenfeld and Nicolson, 1990. 28–29 (Waterford); Tyler, *Francis Place* (Dublin Bay) and Patrica Butler, "The Ingenious Mr. Francis Place" in *GPA Irish Arts Review* no. 4 (Winter 1984): 39 (Royal Hospital, Kilmainham).

5. The most convenient guide to Dublin churches is Maurice Craig and H. A. Wheeler, *The Dublin City Churches.* Dublin: n.p., 1948.

6. A drawing of the internal arrangement of St. Peter's, 1686, is in the cess book of St. John's parish, Representative Church Body, Dublin. p45/6/1.

7. For descriptions of Ormond's entry to the city, see Thomas Carte, *History of the Life of James, First Duke of Ormond,* 2, London, 1736, 313; *Calendar of State Papers, Ireland 1663–5,* 651. This episode is Ormond's return from a brief spell in London. For his first entry into the city in 1662, see *Calendar of State Papers, Ireland 1660–2*: 553–54. Compare these with Wentworth's rather subdued entry into Dublin described in British Library, additional ms. 29587, folios 19–20.

WORKS CITED

Andrews, John. *Plantation Acres.* Belfast: Ulster Historical Foundation, 1985.

Boyse, Joseph. *Remarks on a Late Discourse of William Lord Bishop of Derry.* London, 1694.

Burke, Nuala. "An Early Modern Suburb: the Estate of Francis Aungier, Earl of Longford," *Irish Geography* 6 (1972): 365–85.

Clancy, Donough. Letter. Trinity College, Dublin. Mun P/23/407, folio 352.

Clarke, W. S. *The Early Irish Stage.* Oxford: Clarendon Press, 1955. 26–32, 43–48, 52, 58–60.

Craghead, Robert. *An Answer to a Late Book Entitled a Discourse Concerning the Inventions of Men in the Worship of God.* Edinburgh, 1694.

Craig, Maurice. *The Architecture of Ireland.* London: Batsford, 1982.

Cressy, David. *Bonfires and Bells: National Memory and the Protestant Calendar in Elizabethan and Stuart England.* London: Weidenfeld and Nicolson, 1989.

Crookshank, Anne and the Knight of Glin. *The Painters of Ireland, 1660–1920.* London: Barrie and Jenkins, 1978. 57.

Cullen, L. M. "The Growth of Dublin, 1600–1900." *Dublin City and County.* Ed. F. H. A. Aalen and Kevin Whelan. Dublin: Geography Publications, 1992. 252–77.

Dineley, Thomas, ms. 392. Thomas Dineley papers, National Library of Ireland, Dublin.

Donnelly, N., ed. *Roman Catholics: State and Repair of R.C. Chapels in Dublin A.D. 1749.* Dublin: Catholic Truth Society of Ireland, 1904.

Dublin City Archive, ms.18, fol. 110.

Falkiner, C. Litton, ed. *Illustrations of Irish History and Topography.* London: Longmans, 1904.

Fitzpatrick, Brendan. "The Municipal Corporation of Dublin, 1603–40." Dissertation, Trinity College, Dublin, 1984. Appendix 3.

Fitzsimons, Henry. *The Justification and Exposition of the Divine Sacrifice of the Mass.* N.p., 1611. 2.

Gilbert, J. T., ed. *Calendar of the Ancient Records of Dublin.* 19 vols. Dublin, 1889–1944. 5: 96.

Grossart, A. B., ed. *The Lismore Papers.* 10 vols. London, 1886–88. 2:30.

Historical Manuscripts Commission. *Report on the Manuscripts of the Marquis of Ormond.* New ser. 7. London: HMSO, 1912.

Hull, C. H., ed. *The Economic Writings of Sir William Petty.* 2 vols. Cambridge, 1899.

King, William. *A Discourse Concerning the Inventions of Men in the Worship of God.* Dublin, 1694.

Lennon, Colm. *The Lords of Dublin in the Age of Reformation.* Dublin: Irish Academic Press, 1989.

Loeber, Rolf. "Sculptured Moments to the Dead in Scventeenth-Century Ireland: A Survey from Monumenta Eblanae and other Sources." *Proceedings of the Royal Irish Academy* 81 (1981): 267–93.

———. "An Unpublished View of Dublin in 1698 by Francis Place." *Bulletin of the Irish Georgian Society,* 21 (1978): 7–15.

———. "The Rebuilding of Dublin Castle: Thirty Crucial Years, 1661–1690." *Studies,* 69 (1980): 45–69.

———. *A Biographical Dictionary of Architects in Ireland.* London: John Murray, 1981.

MacLysaght, Edward. *Irish Life in the Seventeenth Century.* 3rd ed. Dublin: Irish University Press, 1969. Appendix B, 376.

Maguire, J. B. "Seventeenth Century Plans of Dublin Castle." *Journal of the Royal Society of Antiquaries of Ireland,* 104 (1974): 8–11.

Representative Church Body, the cess book of St. John's parish, Dublin. P328/7/1.

Robinson, J. L. "Christ Church Cathedral, Dublin: Proctors Accounts." *Journal of the Royal Society of Antiquaries of Ireland,* 41 (1911): 259–64.

Tyler, Richard. *Francis Place.* York: York City Art Gallery, 1971.

Walsh, R., ed. "A Memorial Presented to the King of Spain on Behalf of Irish Catholics." *Archivicum Hibernicum.* 6 (1917): 27–54.

Warburton, John, Whitelaw, J., and Walsh, R. *The History of the City of Dublin.* 2 vols. Dublin, 1818.

White, N. B., ed. "The Annals of Dudley Loftus." *Analecta Hiberica,* 10 (1941): 224–38.

Irish Antiquarian Artists

Maire de Paor

I T IS HARDLY possible to walk around an exhibition like that of *Irish Watercolours and Drawings* without being conscious of the passage of time. A portrait says to us, "This is what she, or he, looked like then." A landscape is a glimpse of a long ago day in the Dargle Valley in County Wicklow, or a moment in the life of the Dublin streets, frozen in time. The lightness of touch, the sketchiness, of watercolors and drawings, add to this sense of evanescence, of the tension between permanence and impermanence. And the artists, in the age of Romantic imagination, themselves liked to emphasize the theme of the passage of time:

> The clouds that gather round the setting sun
> Do take a sober colouring from the eye
> That has kept watch o'er man's mortality
> (Wordsworth, *Ode on Intimations of Immortality*, 633)

Artists enjoyed furnishing their landscapes with the melancholy pleasure of ruins as much as the colorful figures of an Arcadian peasantry. This aspect of eighteenth- and nineteenth-century drawing has an added piquancy in Ireland.

The history of changing styles and tastes in European art is interrupted in Ireland. Although the country didn't quite miss the Renaissance, it missed a great deal of it, since at the time, one civilization was replacing another by bloody war and conquest. A few fragments of late medieval murals survive, but otherwise Ireland has very little to show of graphic art

from the early Middle Ages to the second half of the seventeenth century, and not much of any quality until a century later. What then developed in Ireland was a colonial art. In some ways, by the eighteenth century, the cultural relationship of the English colony in Ireland (what came to be known as the "Protestant Ascendancy") to its land of origin was like that of the American colonials. But there was a major difference. Ireland's white European native population and the ease of access for British and continental artists and craftsmen made the country appear, if viewed one way, a part of the "home countries."

By the early modern period there was virtually no native art or craft. The indigenous social and cultural systems had been destroyed, and a large part of the native population was destitute. The absence of peasant visual art, for example, is quite striking. Native Irish culture survived in words and in traditional music.

The beginnings of a modern art that depicts this native Ireland in the sixteenth, seventeenth, and early eighteenth centuries arise largely from the conquest. With a few exceptions (such as some drawings by Albrecht Dürer of Irish people in continental Europe) our view of Ireland at that time derives from the process of the English conquests, and comes from descriptions and surveys and—most tellingly—from maps. Maps in Ireland were associated with the imperial process of reduction and colonization and were frequently seen as instruments of foreign domination. Yet in the nineteenth century, when the mapping of the country to the large scale of six inches to the mile was systematically undertaken, with accompanying descriptions, the new Ordnance Survey soon became a scholarly venture. It included in its scope archaeology and topographical and place name studies, and employed many outstanding scholars such as John O'Donovan and Eugene O'Curry, who came from the native tradition of learning, and others such as George Petrie who were sympathetic to it. The tensions between the military and cultural aspects of the survey are well illustrated in Brian Friel's play *Translations*.

The art of the colonials in Ireland has two aspects: representation of themselves and their world; and representations—or rather, discovery—of the world they had conquered. In Ireland as in America, the ignoble savage discerned by the early conquerors became (once subdued) the noble savage and, ultimately, the Romantic peasant.

Interest in the classical world was revived by the Renaissance, and from the sixteenth century scholars and travelers began to take an interest not only in the writings, but also in the material remains of Greece and Rome.

At the same time topographical studies were beginning in England, and the publication of Camden's *Britannia* in 1586 directed attention to British antiquities. In the eighteenth century, to travel to Greece and Rome and study their remains (and often also to collect classical antiquities) was part of the education of the aristocracy. The compilation of albums of drawings of classical architecture and art and of their Renaissance adaptations became an extremely important cultural influence north of the Alps, bringing a revised version of the classically based designs of Palladio, for example, to adorn the squares and streets of Ascendancy Dublin. The bourgeois substitute for the aristocratic Grand Tour was the study of local antiquities—a pursuit which could be engaged in much more cheaply and which was also stimulated both by Romanticism and by nascent nationalism.

Field studies and descriptions of antiquities were being made in the seventeenth century by people such as John Aubrey and Edward Lhwyd. Lhwyd was a Welsh antiquary and polymath whom many consider the founder of modern field archaeology; he visited Ireland in 1699 and has left us the first description of the great passage grave at Newgrange. The collecting of curios and antiquities began also about this period. The growing taste for the Romantic and picturesque in the landscape, for "Gothick" ruins, druids, and hermits, was another stimulus, and the publication in 1760 of James MacPherson's *Fragments of Ancient Poetry* (purporting to be the epics of an ancient Gaelic poet, Ossian) drew attention to all things "Celtic," including antiquities. It evoked a never-never land of ancient heroic times: "A green field, in the bosom of the hills, winds silent with its own blue stream. Here, 'midst the waving of oaks, were the dwellings of the kings of old.' But silence, for many dark-brown years, had settled in grassy Rath-col; for the race of heroes had failed along the pleasant vale" (MacPherson 271).

The British interest spilled over into the colony, and Ireland was a fertile field for these studies. It spilled over to the surviving representatives of the ancient Gaelic culture and its leaders, too: to Charles O'Conor of Belnagare, for example, who was a significant figure anticipating the "revivalism" of later times. The Romantic landscape begins to appear in Gaelic poetry, as in the opening passages of Brian Merriman's *Cuirt an Mheán Oiche* (The Midnight Court):

> I liked to walk in the river meadows
> In the thick dew and the morning shadows

> At the edge of the wood in a deep defile
> At peace with myself in the first sunshine. (136)

The mixture of elements in the educated, mid-eighteenth-century sensibility is well illustrated by Maurice ("Hunting-Cap") O'Connell of Derrynane in his journal of a journey from Dublin to London in 1765:

> Between Bangor and Conway is the Inaccessible and Extraordinary Mountain Pen Man Mawr, Projecting into ye Sea; on ye edge of which is ye High Road wch is cover'd from ye Edge of ye stupendous Cliff by a six foot Wall, the Country at ye same time being Romantick and Agreeable
> . . . First the British Museum exposed to view in Montague House. . . . You go up a grand Hall cover'd all over Wall and Ceiling with Noble paintings in the best hands, ascend a noble staircase wth these Decorations still growing on you, and among other notable paintings you see the Sun in two opposite Corners of the Hall, shining on ye Eye, as to cause an Astonishing Deception. Thence you lead into a suite of rooms Most Magnificent in themselves, where you see an Innumerable fund of curiosities Antient and Modern, Two Egyptian Mummies, Two Pillars of Agate and Amber, a vast Collection of Antient Roman curiosities, Dresses, Arms, Medals, Tools, Sacrificing Implements, Coins, Statues, Paintings and Carvings (I, 141–44).

All this interest led to speculation and controversy and to a demand for antiquarian and topographical drawings featuring both "Celtic" and druidic remains and also the Romantic ruins so much in fashion in the late eighteenth century. Prints and engravings were needed as embellishments of the civilized home, and sets of engravings were produced and found a ready market. These were in the nature of picture books—what would now be called "coffee-table books"—and varied considerably in quality as well as in the intentions and methods of the artists. Some were concerned only to produce pleasing pictures, while others, more strictly antiquarian, wished to offer as accurate a record as possible. George Petrie, the famous antiquary, had perhaps mixed motives, although in the introduction to his essay, "The Round Towers and Ecclesiastical Architecture of Ireland," he describes his purpose in this instance as strictly antiquarian:

> I have but one word to add now respecting the illustrations to this work. It will be seen that they make but slight pretensions to the character of works of art. Where no fine writing was attempted, showy illustrations, got up with a view to popular effect, and leading to an almost necessary sacrifice of truthfulness, would be very little in harmony. For their accuracy, however, I

can fearlessly pledge myself. This has been the point attended to above all others, and of which the absence of all affectation of freedom of handling, or forcible effect, will give abundant evidence. They may be considered as quotations from our ancient monuments, made with the same anxious desire for rigid accuracy as those supplied from literary and other sources in the text; and though slighter or more attractive sketches might have sufficiently answered my purpose, they would not have been sufficient to gratify my desire to preserve trustworthy memorials of monuments now rapidly passing away. (I, ix)

This last sentence is of course the one most relevant to the archaeologist in considering the works of all these artists.

Although Ireland remained for a long time a country of moldering ruins, even before the onset of industrial activity many monuments were considerably altered by the processs of decay. This accelerated considerably with the advent of the bulldozer and the factory. Therefore, early accounts and illustrations remain the starting point for any effort to find out as far as possible the shape and state of Irish monuments in earlier times. Even when the purpose of the artist was not accuracy, and when many liberties were taken with the original, such drawings can still be instructive and fill many gaps in our knowledge. They also inform us about the age in which they were made and the preoccupations and fancies of the period and, in some cases, provide aesthetic pleasure.

The earliest topographical drawings of antiquarian interest were done by visitors in the late seventeenth century and include the work of Thomas Phillips, an engineer working for the Duke of Ormonde; Thomas Dinely, whose sketches of abbeys and other monuments on his tours in Ireland and France (1675–80) were published under the title *Observations*; and Francis Place, the most accomplished of the three, who visited Ireland in 1698–99. But it was through the foundation of the Irish Antiquarian Society and the patronage of people like its chairman, William Burton Conyngham of Slane Castle, General Charles Vallancey of the Ordnance Survey, Charles O'Conor of Belnagare, and Edward Ledwich that antiquarian artists began to flourish in Ireland. One of the earliest of these was Gabriel Beranger, a French Huguenot who came to Ireland in about 1750 from Rotterdam. He was an artist by profession who spent much time sketching antiquities. He was noticed by Vallancey and Conyngham, who employed him and Angelo Bigari, an Italian artist, to make drawings of Irish monuments. Many of them, mostly watercolors, survive in the collections of the National Library and the Royal Irish Academy. A selection of the academy's collection of

Beranger's work recently published includes both original drawings and some based on the work of other artists. While he was more a painstaking draftsman than a major artist, the drawings have great value, as Peter Harbison puts it, in preserving "for posterity, illustrations of certain buildings which have entirely disappeared and of which no record exists" (13).

The founding of the Dublin Society's (later the Royal Dublin Society's) drawing school in 1746, and, later, its school of landscape and ornament, meant that artists were being produced in Ireland. Of much more significance from the antiquarian point of view was the foundation of the Royal Irish Academy in 1785 and the beginning of the Ordnance Survey's work in the early 1820s. General Vallancey, who was director of the Royal Engineers in Ireland, became intensely interested in archaeology while surveying the country. He had been pushing for the foundation of a select committee of antiquarians from the Dublin Society, and finally, in 1772, the society appointed one to enquire into "the antient state of arts, literature and antiquities." This merged with a scientific society, the Neophilosophers, to become in 1785 the Irish Academy of Science, Polite Literature and Antiquities, which received its charter from George III in 1786 as the Royal Irish Academy.

Vallancey, remembered nowadays largely for his extraordinary theories and lunatic etymologies, was a founder member. His view that the Irish derived their culture from the Phoenicians and that the round towers were Phoenician fire temples led to a famous controversy with Petrie. But his enthusiasm and determination, and that of his friend Charles O'Conor, were instrumental in getting drawings made of antiquities and in having Irish manuscripts copied. In the words of Thomas Davis, "General Vallancey's erroneous theories, like those of Dr. Stukely in England, no longer mislead, but their enthusiasm stirred up an interest in archaeology which was the nurse of our later knowledge." Another founder member, William Conyngham, commissioned drawings of antiquities many of which later appeared in Francis Grose's *Antiquities of Ireland*, published in 1791.

Grose was the son of a Swiss jeweler who settled in England in the early eighteenth century. He studied drawing and soon developed antiquarian interests and produced various writings on armor and military antiquities, and a series of views of ancient monuments prepared during tours of England, Wales, and Scotland. He arrived in Ireland to begin the last of the series in the spring of 1791 but died in May. Edward Ledwich, who had himself published a book on Irish antiquities, took over that project, added a text, and included drawings of his own and many other existing views of

Irish ruins and archaeological remains. Many of the artists from the Dublin schools had drawings engraved for this publication, including John Barralet, James George O'Brien (alias Oben), and Anthony Chearnley. Other drawings were by Jonathan Fisher (who may have been self-taught) and Angelo Bigari, the Italian. When looking at these plates from an archaeological point of view, one must remember that they may have been drawn up much later from sketches done in the field, and that engravers often took the liberty of adding figures and other embellishments. Nonetheless, much is recorded which has since disappeared, and by and large the record is much more accurate—particularly in the proportions of the architecture—than in many of the drawings in the Beranger collection, which make an interesting comparison.

As well as picturesque ruins, many of these topographical artists recorded the county seats and buildings of their own time. The paintings have an antiquarian interest since some of the buildings are now gone and others are considerably altered in setting and appearance. The most famous is James Malton, whose views of Dublin engraved in aquatint superbly record eighteenth-century Dublin at the height of its glory. He came to Ireland with his father in 1785 and worked as a draughtsman with James Gandon when the Custom House was being built (plate 17). A series of twenty-five views was published as a book, but it appears that these were based on large watercolors, the biggest collection of which is housed in the National Gallery, Dublin. His precise and beautiful drawings give us a picture of a cityscape that no longer exists and detailed depictions of some demolished masterpieces. Another series of Dublin views was prepared by Samuel Frederick Brocas and published between 1818 and 1828. His watercolors are lively views of street life, although the buildings are less impressively drawn than Malton's (plate 18).

As we come into the nineteenth century, one figure stands out as a giant, head and shoulders above the rest—George Petrie, the last of the great polymaths: antiquary, artist, scholar, musician, and collector (plates 19 and 20). He was born in 1790, the son of a Scottish miniaturist who had settled in Dublin, and trained as an artist first in Samuel Whyte's drawing school and then in the Dublin Society's school, where he won a silver medal. In the manner of the time, he made many sketching tours, frequently in the company of other artists, among them Francis Danby and James Arthur O'Conor, both of whom he accompanied to London in 1813. It was during these tours that his interest in antiquities developed, and he not only sketched but described them in contributions to the

17. James Malton (1760–1803), *The Custom House, Dublin,* 1793, watercolor over ink on paper, 53.6 × 77 cm, National Gallery of Ireland no. 2705. (Courtesy of the National Gallery of Ireland)

18. Samuel Frederick Brocas (1792–1847), *Trinity College and College Green, Dublin,* ink and watercolor on paper, 24.4 × 40.2 cm, National Gallery of Ireland no. 2558. (Courtesy of the National Gallery of Ireland)

19. George Petrie (1789–1866), *Pilgrims at St. Brigid's Well, Liscannor, Co. Clare,* watercolor on paper, 18.5 × 26 cm, National Gallery of Ireland no. 2381. (Courtesy of the National Gallery of Ireland)

20. George Petrie (1789–1866), *The Last Circuit of Pilgrims at Clonmacnois, Co. Offaly,* pencil and watercolor on paper, 67.2 × 98 cm, National Gallery of Ireland no. 2230. (Courtesy of the National Gallery of Ireland)

Dublin Penny Journal and the *Irish Penny Journal.* His accuracy in drawing led to his work being used as illustrations in many publications, particularly guidebooks. He exhibited in the Royal Academy in 1816 and was elected an associate member in 1826 and a full member in 1828. In the same year he was elected a member of the Royal Irish Academy and became librarian at the Royal Hibernian Academy. In 1832 Petrie won the Cunningham Gold Medal of the Royal Irish Academy for the best essay on round towers, a landmark in Irish archaeology later published as a substantial book, *The Ecclesiastical Architecture of Ireland.* Although now we might not agree with all his datings, his scholarly chronological approach was far ahead of his time. For the first time, reason and common sense replaced fantastic speculation.

From 1833 to 1846 Petrie was in charge of the antiquities section of the topographical survey of Ireland by the Ordnance Survey. His work on the survey enabled him to continue the collecting of antiquities which he had begun in his early youth. His collection was later acquired by the Royal Irish Academy, from which it later went to form the basis of the collection of the National Museum in Dublin. Unfortunately, although he was the first to recognize the importance of chronological arrangement and descriptive catalogues, he never completed a catalogue of his own collection, so that many of the objects remain undocumented. Petrie was instrumental in laying the foundations of the manuscript collection of the Royal Irish Academy, to which he presented the Annals of the Four Masters. In his assessment of the manuscript material, he had, as the late David Greene put it, "cleared away the last vestiges of Vallancey's Celtomania and laid down a programme for Irish studies which errs only on the side of austerity and realism" (161).

Petrie was also a notable collector of Irish music. In 1855 the *Petrie Collection of the Ancient Music of Ireland* was published, consisting of 147 airs arranged for the piano, with notes by Petrie. He returned to painting to provide for his family after his work on the Ordnance Survey ceased. He was elected President of the Royal Hibernian Academy in 1856 but resigned in 1859 during a time of controversy. The large collection of watercolors he left shows the combination of artistic and antiquarian skills he had acquired in his lifetime. His knowledge of architecture and his exact draftsmanship combined with a poetic vision to impressive effect. As his biographer William Stokes writes: "In a large proportion of his works we have the feeling and skill of a painter in union with the knowledge of the

antiquarian" (11). His handling of light and distances is particularly pleasing. His antiquarian drawings set new standards of accuracy.

Francis Danby, a friend of Petrie, left Ireland early. His only known Irish topographical work is watercolors now in the Ulster Museum in Belfast. A contemporary, Andrew Nicholl, was a self-taught artist from Belfast who specialized in landscapes. He was also interested in antiquities, botany, and other aspects of the Irish countryside. He was one of a team of artists who contributed illustrations to Halls' *Ireland* and also helped the Halls with archaeological information. He painted most of the "Romantic" scenery of Ireland from one end to the other. Another Northern artist, James Howard Burgess, who contributed twenty-five drawings to the Halls' book, was a drawing master in Belfast. Many of his drawings show antiquities, mainly in the north of Ireland, painted in a Romantic fashion.

But the real heirs of Petrie were his pupils, George du Noyer and William Frederick Wakeman. Du Noyer was the son of a French music teacher who married in Dublin. His interest in antiquities was aroused when he was a draftsman for the Ordnance Survey, and many of his drawings resemble those of his master. He worked also for Halls' *Ireland*, contributing eighteen drawings. A large series of his watercolors and drawings exists in the Royal Irish Academy (plate 21). Wakeman also studied drawing with Petrie and through him joined the Ordnance Survey. He made numerous illustrations of antiquities for the Survey and for guide books and other publications (plate 22). He himself published *A Handbook of Irish Antiquities*. All the archaeological material from the Ordnance Survey was deposited, between 1857 and 1860, in the library of the Royal Irish Academy, including twelve volumes of sketches by artists such as Beranger, Petrie, Wakeman, and du Noyer.

From the end of the eighteenth century onwards, there were published a considerable number of accounts of tours of Ireland, of which the best and most insightful is that of the Halls. Mr. and Mrs. Samuel Carter Hall toured Ireland first in 1840 and afterwards almost every year for about ten years. Their *Ireland, Its Scenery and Character*, published in three volumes between 1841 and 1843, was illustrated by fine steel engravings from many of the leading Irish topographical artists. These county-by-county accounts, though informed by the prejudices and naivetés of the writers, give a sympathetic account of pre-famine Ireland and record the customs and way of life of a now vanished world.

Ireland often followed Scotland (in particular the highlands and islands, to which MacPherson in particular had drawn interest) in the program of

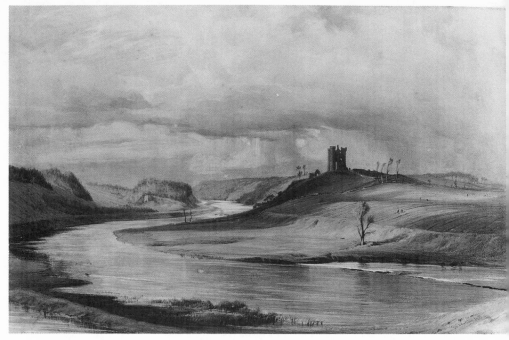

21. George Victor Du Noyer (1817–69), *Dunmoe Castle, County Meath,* 1844, watercolor on paper, 39.1 × 48.4 cm, National Gallery of Ireland no. 3980. (Courtesy of the National Gallery of Ireland)

many travel writers. Since Ireland had somewhat less of the wild barren scenery of the north and west of Scotland and rather more ruined abbeys and castles, the descriptions of Ireland tend to contain a larger element of the antiquarian. Ireland became a province of the picturesque. When, in due course, the grand tour of the northern aristocracies had evolved into something like the beginnings of modern tourism, Killarney competed with the Rhine in its combination of ancient ruins and Romantic scenery. Tennyson sounded the last note of this early Romantic tourism in his verses on Killarney:

> The splendour falls on castle walls
> And snowy summits old in story:
> The long light shakes across the lakes
> And the wild cataract leaps in glory . . .
> <div align="right">("Blow, Bugle Blow")</div>

22. William Frederick Wakeman (1822–1900), *The Round Tower and Graveyard at Clonmacnois Monastery, Co. Offaly,* ink on paper, 27 × 36.9 cm, National Gallery of Ireland, no. 7412. (Courtesy of the National Gallery of Ireland)

But about the middle of the nineteenth century, other, utilitarian and practical attractions replaced archaeology for the hard-headed and self-improving tourists of the age. The English edition of Baedeker's *Rhine* is introduced by sections on money, hotels, geology, and wine, and, for a long time, the traveler was expected to take an interest primarily in such practical and progressive matters. The minor industry of antiquarian topographical drawing begins quickly to diminish, both in scale and in significance.

At about the same time, photography began to provide a documentation of ancient buildings that was both objective and accurate. And the old wet plates, in dealing with stationary objects, provided a record that was minutely detailed. The photographer could take the cap off the pinhole lens, go away and have luncheon, and return at leisure to end the exposure, taking a longer time than a watercolorist to make a picture, but ending up

with a portrayal of every dimple and haircrack in the masonry of a ninth-century church or a thirteenth-century castle. This is beautifully exemplified in the plates of Lord Dunraven's *Notes on Irish Architecture* (many of which may be due to the skill of the young Margaret Stokes, who as his assistant editor did much of the work).

With the advent of the camera, the symbiosis of graphic art and archaeology effectively ended. Photography very quickly became an essential tool of the archaeologist, to the extent that archaeological stimulus has considerably influenced parts of the photographer's craft (most notably photography from the air and its interpretation). But that is another story. The pictures that are worth a thousand words to the present-day archaeologist from before about 1850 are largely those of the watercolorists and engravers who worked from sketches in the field. If we make suitable allowance for their being presented in the idiom and through the sensibilities of their day, they provide, as well as the pleasure which is at least part of the object of all art, information: an archive supplied by bygone eye and hand.

WORKS CITED

Greene, David. "Aspects of George Petrie II—George Petrie and the Collection of Irish Manuscripts." *P.R.I.A.* 72 (1972), 158–163.

Harbison, Peter. *Beranger's Views of Ireland.* Dublin: Royal Irish Academy, 1991.

MacPherson, James. *The Poems of Ossian.* Boston, Mass., 1859, 269–274.

Merriman, Brian. "The Midnight Court." *Kings, Lords and Commons.* Trans. Frank O'Connor. London: Macmillan and Co., 1961. 136–66.

O'Connell, Mrs. Morgan John. *The Last Colonel of the Irish Brigade: Count O'Connell and Old Irish Life at Home and Abroad 1745–1833.* London, 1892.

Petrie, George. *The Ecclesiastical Architecture of Ireland, Anterior to the Anglo-Norman Invasion,* Dublin: Hodges and Smith, 1845, Vol. I, IX.

Stokes, William. *The Life and Labours in Art and Archaeology of George Petrie, LL.D., M.R.I.A.* Dublin, 1868.

Tennyson, Alfred Lord. "Blow, Bugle, Blow." *Oxford Book of English Verse, 1250–1918.* Ed. Sir Arthur Quiller-Couch. 2nd ed. Oxford: Clarendon Press, 1942, 851.

Wordsworth, William. "Ode on Intimations of Immortality from Recollections of Early Childhood." *Oxford Book of English Verse, 1250–1918.* Ed. Sir Arthur Quiller-Couch. 2nd ed. Oxford: Clarendon Press, 1942, 626–633.

Geological Artistry:
The Drawings and Watercolors of George Victor du Noyer in the Archives of the Geological Survey of Ireland

Jean Archer

THE NINETEENTH CENTURY was an age of precision in cartography, when the beautiful but often woefully inaccurate maps of an earlier epoch were replaced by official maps constructed by teams of governmental surveyors. In the Americas, in Europe, and in the colonial world, governmental cartographic surveys opened up exciting opportunities for young men with a taste for outdoor life. Some were recruited for their artistic talents and were called upon to deploy their skills in the depiction of unusual objects and in the portrayal of topography, often in remote regions. One such man was the Irish geologist George Victor du Noyer.

Du Noyer enjoyed a happy career until it came to a sudden and tragic end. He was a talented artist who, unlike so many who shared his muse, succeeded in finding a professional niche wherein his talents were effectively used. That niche allowed him to use his pencils, pens, and brushes in the mundane task of making his living while providing him with ample opportunity to indulge his artistic creativity throughout the length and breadth of Ireland. Tragically, du Noyer died when he was only fifty-two years old. In Armagh, on New Years Eve 1868, he developed scarlet fever. Three days later he was dead.

Throughout his surveying career in first the Ordnance Survey and then the Geological Survey of Ireland, George du Noyer was a compulsive sketcher and watercolorist. He filled sketch pad after sketch pad with scenes that were relevant to his geological work, or to his archaeological interests, or that simply appealed to him. His enormous output is pre-

served mostly in a number of Dublin institutions, principally the Royal
Irish Academy, the Royal Society of Antiquaries of Ireland, the Geological
Survey of Ireland, and the National Botanic Gardens. The four institutions
all have substantial holdings of du Noyer's work, but it is the material in
the Geological Survey of Ireland which forms the subject of this essay
(plates 23–28). This is apposite because the Geological Survey of Ireland
employed du Noyer from 1847 until his untimely death twenty-two years
later. Had du Noyer not enjoyed the opportunities presented to him as a
geological surveyor, his legacy to posterity might have been far smaller than
the substantial oeuvre which he left behind.

Du Noyer was born in Dublin in 1817 into a French Protestant family
that had settled in Ireland after the French Revolution. As a boy he was
educated in the Reverend William Jones's "seminary for general educa-
tion" in Great Denmark Street. His artistic talent was already well devel-
oped when, as a teenager, he entered the Drawing Schools of the Royal
Dublin Society. This was a crucial step in his life, for there he encountered
the teacher who was to be the seminal influence on his life. That teacher
was the watercolorist and antiquarian, George Petrie. From Petrie, du
Noyer acquired his lifelong interest in Irish scenery and Irish antiquities,
and it was Petrie who set du Noyer's career upon its course by obtaining for
him an appointment as draughtsman in the Ordnance Survey.

The Ordnance Survey had embarked upon the mapping of Ireland in
1825, but Thomas Colby, the superintendent of the Survey, and his able
lieutenant, Thomas Larcom, had ambitions extending far beyond the basic
task of mapping Ireland's features and then publishing the work on the six-
inch-to-a-mile scale. They wanted to compile a detailed inventory of all
facets of Ireland, from botany and geology to history and social conditions.
This was the controversial Ordnance Survey Memoir Scheme, which was
to have resulted in a published memoir for every one of Ireland's 2400
parishes. Work started upon this ambitious—and costly—project in 1832,
and George Petrie was placed in charge of the collection of information
about Ireland's archaeology. On Petrie's recommendation du Noyer
joined the staff of the memoir in 1835. There he remained for the next
seven years, until the project was terminated, having proved too costly for
continued governmental funding.

The end of the undertaking was precipitated in 1837 by the publication
of its first fruits, *The Memoir of the City and Northwestern Liberties of Lon-
donderry*. A stay of execution was allowed for one part of the project to per-
mit Joseph Ellison Portlock to finish his *Report on the Geology of County*

Londonderry and of parts of Tyrone and Fermanangh. Published in 1843, the illustrations are taken almost exclusively from du Noyer's drawings.

The *Templemore Memoir* of 1837 contains seven pages of illustrated plates, all engraved from du Noyer's wash drawings and watercolors. Three of the plates are paleontological in nature and depict some of the first fossil trilobites and graptolites to be found in Ireland. The others are botanical plates and illustrate grasses, including one species that is now extinct. The hand-colored copies of the botanical engravings are very handsome and represent the only examples of du Noyer's natural history paintings reproduced to a standard approaching that of the great nineteenth-century commercial publishers of natural history illustrations.

The Londonderry memoir contains twenty-eight pages of illustrations of hundreds of fossils, lithographed, one and all, from the pen and wash drawings meticulously prepared by du Noyer and now in the archives of the Geological Survey of Ireland. Scattered throughout the memoir's eight hundred pages are thirty small woodcuts taken from du Noyer's topographic drawings and two lithographed and folded pages of du Noyer's panoramic landscapes, illustrating geological features such as "the great western escarpment of the basaltic [plateau]" in the vicinity of Dungiven and the "mica schist hills of Doan and Spellhoagh." The style of these panoramic views is that adopted by du Noyer for the many topographic drawings and watercolors he subsequently prepared for the Geological Survey of Ireland. The foreground is open and the eye brought to distant horizons by the use of trees and hedgerows to emphasize perspective. The scenes are enlivened by billowing cumulus clouds and small figures; the latter also provide scale.

When du Noyer left the Ordnance Survey in 1842, his appointment to the Geological Survey of Ireland was still five years distant. During this break in his geological career he was employed as drawing master in St. Columba's College, established in 1843 to provide the sons of the Anglo-Irish gentry with an education modeled on the style of English public schools. The chance for du Noyer to exchange a pedagogic career for that of a geological surveyor came with the foundation of a government-financed scientific institution charged with the construction of geological maps of Ireland.

The Geological Survey of Ireland came into existence in April 1845. Du Noyer appears not to have applied for a post at the time of its foundation but his opportunity arose in 1847. The Survey was then under the control of Thomas Oldham, who had been an assistant to Portlock in his geologi-

23. George Victor Du Noyer (1817–69), *View of Benyerenagh Mountain, Co. Derry*, 1838, ink on paper, 21.7 × 20 cm, Geological Survey of Ireland, no. FS1.3.9. (Courtesy of the Geological Survey of Ireland)

24. George Victor Du Noyer (1817–69), *Fossil Ammonite from the Liassic Rocks of County Derry,* 1838, watercolor on paper, 10 × 5.2 cm, Geological Survey of Ireland, no. FS1.1.5. (Courtesy of the Geological Survey of Ireland)

25. George Victor Du Noyer (1817–69), *Dundalk and Enniskillen Railway,* 1838, water-color and ink on paper, 12 × 7.5 cm, Geological Survey of Ireland, no. FS 1.1.5. (Courtesy of the Geological Survey of Ireland)

26. George Victor Du Noyer (1817–69), *Glencree Co., Wicklow from Nearby Lough Bray,* ca. 1852, monochrome wash on paper, 9 × 4.5 cm, Geological Survey of Ireland, no. FS1.1.8. (Courtesy of the Geological Survey of Ireland)

27. George Victor Du Noyer (1817–69), *Coast of Wexford West of Tramore,* ca. 1850, pen and wash on paper, 16.8 × 14.8 cm, Geological Survey of Ireland, no. FS 1.1.8. (Courtesy of the Geological Survey of Ireland)

28. George Victor Du Noyer (1817–69), *Contortions in Slates and Thin Grits, Booley Bay Wexford,* 1850, watercolor and ink on paper, 25 × 16.9 cm, Geological Survey of Ireland, no. FS 1.1.8. (Courtesy of the Geological Survey of Ireland)

cal survey of Derry and was a former colleague of du Noyer's. Oldham and du Noyer had made geological sections for Portlock, and when Oldham, in his new capacity, required an experienced surveyor for a special assignment, he turned to du Noyer. The assignment was a survey of the geological sections being opened up as the new railway lines were built radiating from Dublin. The appointment was only a temporary one, but du Noyer accepted with alacrity and left the confines of the schoolroom to join the navvies who were exposing great linear welts in Ireland's rocky skeleton.

The geological sections that du Noyer made along the railway lines were plotted on graph paper specially printed for the "sections of railway cuttings" on a horizontal and vertical scale of forty feet to the inch. There are thirteen manuscript rolls of them in the archives of the Geological Survey of Ireland, each several meters long. Along the length of each is the section itself, a thin band of color, which varies according to the type of rock represented and is sandwiched between ink lines that denote the upper and lower surface of the cuttings. Ink lines superimposed on the color wash indicate geological structures. Neat notes in ink crowd together where the sections were geologically interesting. Occasionally pen and wash drawings have been added in the space above the section itself to show some geological features of exceptional note.

A modest expansion of the Geological Survey in 1849 allowed du Noyer's appointment to a permanent post as assistant geologist, and in 1867, when a substantial expansion of the Survey took place, du Noyer became the first holder of the new rank of district surveyor. As a Survey officer, du Noyer's prime task was to explore various parts of Ireland, plotting every rock exposure on the Survey's six-inch-to-the-mile field sheets. From the field sheets, the 205 one-inch-to-the-mile geological maps of Ireland were produced that the Geological Survey published between 1856 and 1890. Du Noyer's work took him throughout southern Leinster and much of Munster, and he was mapping the rocks in Ulster, around Armagh, when death overtook him on January 3, 1869.

The sketches, drawings, and paintings by du Noyer in the Geological Survey's archives depict geological phenomena almost without exception. Two strands of geological investigation are represented in the holding. One is the strand of outdoor geological work undertaken by the geological surveyors who tramped the countryside, recording its geological features on their field sheets and seeking evidence germane to the interpretation of geological structure. Among the foremost lines of evidence sought were the remains of once living organisms preserved in the solid rock as fossils

which serve to date rocks according to the geological time scale. The second of the strands in du Noyer's geological opus relates to the study of fossils, which was carried out in the comparative comfort of the paleontological laboratory. Du Noyer's paleontological work belongs to the earliest stages of his geological career, when he prepared the illustrations for Portlock's Derry memoir. Although they predate his Geological Survey days, the original pen and wash drawings of all but one of the twenty-eight pages of fossil illustrations in the Derry memoir are preserved in the Geological Survey, along with a full, bound set of India paper proofs and five different proofs of three of the plates. The published illustrations and the India paper proofs were lithographed by the London firm of Standidge. The other proofs were pulled by Dublin printers from stones lithographed by du Noyer himself. The story of these proofs, which have only recently come to light, can be pieced together from a footnote in a monograph published in 1867 by the eminent paleontologist J. W. Salter. In the footnote, Salter deplores the destruction through some misfortune at the printers of the beautiful plates prepared by du Noyer and decries the poor quality of the published plates, which, he tells us, were hastily re-lithographed in London. Du Noyer, seemingly, lithographed all the plates himself only, probably, to have the stones prematurely cleaned by some over-zealous printer's apprentice and then replaced by stones prepared by hands untutored in the subtleties of paleo-conchological illustration. The published plates are flat, murky, and uninteresting representations which lack the fine detail and the three-dimensionality of du Noyer's original drawings. The proofs pulled from the "lost" stones lithographed by du Noyer himself are much clearer, the line work is sharper, the shading much lighter, and the overall effect much livelier.

Liveliest of all du Noyer's fossil illustrations are the few paleontological watercolors in the Geological Survey's collection. Like the fossil drawings, the watercolors date from the period of du Noyer's association with Portlock. In these exceptionally fine watercolors du Noyer has succeeded in conveying the precise specifications of the fossils and at the same time has transformed the lifeless grey stones into objects of great beauty, through his use of lighting effects and false coloring.

The depiction of individual natural history specimens was du Noyer's particular forte. Fish, flowers, fossils, fruit, and fungi—specimens of each were meticulously painted by du Noyer in watercolors which are almost miniaturist in detail. One can only regret that du Noyer had little scope to execute this type of watercolor in his official work for the geological survey,

and that the fossils assembled by the Survey's collectors were illustrated by the resident paleontologist.

The paleontological strand of du Noyer's career had been played out by the time he joined the Geological Survey in 1847. From then on, he concentrated on geological surveying. The manuscript material generated by du Noyer's geological surveying, now in the archives of the Geological Survey of Ireland, includes his geological sections, his field sheets, and numerous drawings and paintings illustrating geological features.

Among the most interesting of du Noyer's geological sections are those he constructed for Portlock. Like many contemporary geological sections, some of du Noyer's northern Irish riverside cliff sections are semi-pictorial. The upper surface of the cliffs and their facial soils are shown realistically, complete with vegetation, but the rocks are represented in bright shades of blue, pink, red, and yellow. The later railway sections are more conventionalized geological sections, and are noteworthy for the sheer volume of meticulous scientific observation represented rather than for artistic quality.

Du Noyer's field sheets and the fair copies he prepared of them are fine examples of the very specialist art form practiced by surveyors of yesteryear. On each of du Noyer's field sheets, pastel color washes depict the outcrop of the rocks formations represented, and washes have been applied over the notes he meticulously recorded as he walked through the countryside. Few officers of the Geological Survey of Ireland took such evident pride in the appearance of their field sheets, and none so successfully embellished vacant portions of their field sheets with sketches, drawings, and paintings.

A practitioner of geological surveying during the early days of photography, when cameras were bulky and unsuitable for routine use in the countryside, du Noyer's illustrations were used in the lecture room and for the illustration of official publications. In du Noyer's work the Geological Survey had the perfect combination of geological knowledge and artistic skills.

Du Noyer's geological drawings and paintings in the Geological Survey's collection fall into three overlapping categories: landscapes, coastal scenes, and rockscapes. The landscape watercolors typically depict open, sun-drenched countryside. The views are wide-angled panoramas illustrating large-scale geological features. An ambiance of halcyon days pervades many of these landscapes, and perhaps was intended by du Noyer to symbolically represent bounteous nature in the regions depicted. His landscapes stand in contradistinction to the mountain scenery in some of Petrie's best-known landscapes. Petrie portrayed the grandeur and inhos-

pitability of the mountain fastnesses through the use of exaggerated mountain heights, swirling storm clouds, and somber purplish greys. Du Noyer's rolling hills and sundrenched lowlands which encapsulate his love for the countryside. In common with other nineteenth-century naturalists, he seems to have viewed nature through pantheistic lenses.

Du Noyer adopted a very different style for the depiction of the Wicklow Mountains, which he surveyed during the late 1840s and the early 1850s. In spite of the constraints imposed by his employment, which required the precise representation of geological phenomena, du Noyer exaggerated the summits and slopes of the mountains in a series of exquisite monochromal miniatures which have much of the quality of his early natural history watercolors. Alone among du Noyer's landscapes these miniatures contain conventional Romantic elements, yet they are restrained and the scenes remain plausible. Du Noyer also used pen and wash drawings to particularly good effect in the representation of coastal scenes in counties Dublin, Wicklow, and Wexford.

The attractiveness of du Noyer's pen and wash drawings of coastal scenes belies their utilitarian purpose as illustrations of geological structures. In du Noyer's drawings and watercolors the geologically important planes in the rock mass are depicted by ink lines or brush stokes applied to a palely shaded background in the pen and drawings and to a background of pale browns, greys, and greens in the watercolors. Pencil or ink notes alongside record the nature of the rocks, and in the lower corner of each picture is marked the number of the relevant survey sheet.

There is a considerable degree of stylization in du Noyer's representation of the rocks in his coastal scenes. In his rockscapes, which depict specific geological sites, there is very often a much greater degree of stylization. In some of the larger watercolor rockscapes, highly stylized exposures of rock are placed in a naturalistic setting to striking effect. These watercolors were almost certainly prepared for use in the lecture theater and would have left the audience in no doubt about the geological information conveyed.

Du Noyer's drawings and paintings were also used to illustrate the Geological Survey of Ireland's official publications, and appeared in textbooks as well. Unfortunately, most of his geological works were reproduced as small woodcuts, which do scant justice to the originals. Some of the drawings and watercolors are still reproduced in the geological literature of today, either for special effect, or to illustrate geological features that are inaccessible to photographers, such as the sea cliffs about the Dingle Peninsula in Ireland's southwestern corner.

The watercolors and drawings represent a relatively minor part of du Noyer's work for the Geological Survey of Ireland, in which he was employed first and foremost as a geological surveyor. In this capacity he made a major contribution to our knowledge of Ireland's geological structure through the official publications of the Geological Survey of Ireland and through papers he published in scientific journals. The opportunities provided by his career with the Survey also enabled du Noyer to make an appreciable contribution to the documentation of antiquities in the Irish countryside.

Life as a geological surveyor brought du Noyer to parts of Ireland he would otherwise scarcely have visited and provided him with ample opportunities to execute the very large number of drawings and watercolors of carved stone and castles, of crannogs and churches, of cathedrals and crosses, now in the du Noyer holdings of the Royal Irish Academy and the Royal Society of Antiquities of Ireland. The Academy's holding was donated by the artist, an act of largesse that was rewarded by lifelong honorary membership of the Academy. The dozen folios of du Noyer's work in the Royal Society of Antiquities were acquired by subscription shortly after the artist's death. Among the principal subscribers were du Noyer's former colleagues in the Geological Survey who had been deeply shocked by the news of his death.

Nowadays, du Noyer is honored by members of Ireland's academic community for his contributions to Irish antiquarian and geological studies. Reproductions of du Noyer's work published during the last decade by the Geological Survey of Ireland and by the National Gallery of Ireland, and his inclusion in Patricia Butler's *Three Hundred Years of Irish Watercolours and Drawings* and in Charles Nelson and Eileen McCracken's recent history of the National Botanic Gardens, have provided the wider public with an opportunity to become acquainted with du Noyer's work for the first time since the days when he regularly exhibited in the Royal Hibernian Academy.

WORKS CITED

Butler, Patricia, *Three Hundred Years of Irish Watercolours and Drawings*. London: Weidenfeld and Nicolson, 1990.

Coffey, Petra, "George Victor Du Noyer 1817–1869." *Sheetlines*, 35, 1993, 14–26.

Colby, Thomas Frederick, *Ordnance Survey of the County of Londonderry. Volume the first.*

Memoir of the city and northwestern liberties of Londonderry. Parish of Templemore. Dublin: Hodges and Smith, 1837.

Gages, M., "Biographical Notice of the Late George V. Du Noyer M.R.I.A." *Proceedings of the Royal Irish Academy,* Vol. 10, 1866–69. 413–14.

Herries Davies, Gordon L., *Sheets of Many Colours. The Mapping of Ireland's Rocks 1750–1890.* Dublin, Royal Dublin Society, 1983.

Kinahan, George Henry, "Obituary. George Victor Du Noyer." *Geological Magazine,* Vol. 6, 1869. 93–95.

Nelson, E. Charles, and McCracken, Eileen, *The Brightest Jewel. A History of the National Botanic Gardens Glasnevin, Dublin.* Kilkenny: Boethius Press, 1987.

Portlock, Joseph Ellison, *Report on the geology of the County of Londonderry and of parts of Tyrone and Fermanagh.* Dublin: Milliken and Hodges and Smith, and London: Longman, Brown, Green and Longmans, 1843.

Scannell, Maura J. P., and Houston, C. I., "George V. Du Noyer (1817–1869). A catalogue of plant paintings at the National Botanic Gardens, Glasnevin." *Dublin Society,* Vol. 2, 1980.

Francis Wheatley: His Irish Paintings, 1779–83

James Kelly

I N 1801, THE OBITUARIST in the *Annual Register* produced what most contemporaries would have adjudged a fair assessment of Francis Wheatley's life and work. Wheatley was, the memorialist observed, "an artist of talents that might have raised him to the highest distinction" but who never quite fulfilled the high expectations of his admirers: "his works in general are not distinguished for vigour and expression, [though] they are recommended by taste and elegance. He was not so correct in his representation of rural imagery as a favourite landscape painter of the present day [Constable], but he was not so vulgar in his conceptions nor so gaudy in his execution as other living artists, who have contrived to raise their talents into higher reputation" (22–23).

On first reading, this may appear a classic case of damning with faint praise, but it is, in fact, an equitable and sustainable verdict. Wheatley was not one of the first-rank artists of his generation. He was, however, an imaginative draftsman and a fine colorist with considerable knowledge of painting. During his time in Ireland, in the late 1770s and early 1780s, he produced a corpus of work in oils and watercolors that provides a unique and valuable perspective on politics, the daily life and travails of the population at large, and the landscape.

Wheatley spent only four years in Ireland, but they were among the most productive and profitable years of his artistic career. All of his Irish work possesses appeal; some of it is quite beautiful; none of it is exceptional. His major oil paintings, for instance, are more interesting for the infor-

mation they convey than for their aesthetic excellence. His landscapes and watercolors, likewise, are never dull, but they are not masterpieces. The finest are charming, but others are prosaic and predictable. His scenes from everyday life provide as fascinating a vista of the daily grind of the poor in late eighteenth-century Ireland as his better-known oil paintings do of the political and social preoccupations of the aristocracy, but this fascination derives more from their uniqueness than their intrinsic quality.

I

Francis Wheatley was born in London in Wild Court, Covent Garden, in 1747. His father, a master tailor, recognizing his son's artistic talent, placed him at an early age with Fournier, "an excellent drawing master and teacher of perspective" (Gandon 205). Wheatley subsequently studied at the drawing school run by William Shipley, the founder of the Society of Arts. Although this constituted his only formal artistic education, he was clearly perceived to be an artist of great promise, as he was awarded his first premium by the Society of Arts when he was only fifteen years old (Webster 3). He subsequently embraced a bohemian lifestyle, spent a number of years on the continent, and made a brief visit to Ireland in 1767 (Strickland ii, 519). He apparently continued to develop his artistic skills during this time, because he won further premiums from the Society of Artists in 1767. Two years later, he was admitted to the fledgling Royal Academy, and had a number of portraits and miniatures exhibited by the Society of Artists (Webster 3–7).

Wheatley's first loyalty was to the Society of Artists rather than to the Royal Academy, though the latter was the more prestigious. He even became a fellow and a director of the society in the early 1770s (Webster 7–11). His main artistic influence at this time was John Hamilton Mortimer, "an historical painter of the first order," who was one of the leading lights in the Society of Artists (Pasquin 135). It was from Mortimer, according to Pasquin, that Wheatley "learned" the technique and principles of portraiture and history painting "by continuously copying his drawing and paintings" (Pasquin 135). Wheatley and Mortimer worked together in the mid-1770s decorating Brocket Hall for Lord Melbourne, while Wheatley's subsequent employments included the repair of *The Cascade Scene* at the Vauxhall Gardens and the interior decoration of Lord Melbourne's townhouse in Piccadilly (Webster 10–11). This was a not unimpressive body of work for an artist of Wheatley's years, but it was

insufficient to fund his extravagant and raffish lifestyle, with the result that he deserted the Society of Artists for the fast growing Royal Academy in the late 1770s. The two "small, whole length portraits" he exhibited at the academy in 1778 were well received (Whitley ii, 396). But before he could capitalize on their success, Wheatley was besieged by mounting debts (Gandon 206) and charged with "criminal conversation" and assault by his fellow artist John Alexander Gresse (Webster 29–30). So it was that in the summer of 1779, to escape his creditors, he fled London for Dublin accompanied by Elizabeth Gresse.

II

Wheatley arrived in an Ireland that was distinctly different from that which he had visited in 1767. In the intervening twelve years, the political landscape had been transformed. In the first place, the decision of Dublin Castle during the viceroyalty of Lord Townshend (1767–72) to assume direct responsibility for the management of the Irish parliament gave the Castle a heightened role in the administration of the kingdom. Furthermore, the colonists in America and John Wilkes in Britain, had inspired the radicalization of domestic political opinion. Further still, the election of a younger generation of members of parliament had resulted in the emergence of a vocal interest determined to press forward vigorously with the traditional Protestant nationalist demands of commercial and constitutional equality with Great Britain. By the time Wheatley arrived, in the summer of 1779, the outspoken orator, Henry Grattan, had emerged as the most resolute voice of Irish Protestant nationalism (Kelly, forthcoming); but the most manifest threat to political stability was provided by the Volunteers. They had been formed to compensate for the reduction in the number of troops in the Irish army establishment due to the military exigencies of the war in America, and their rapid politicization during 1778 and 1779 introduced a new and utterly unpredictable element into the domestic political equation (O'Connell 135–60).

Wheatley could not have overlooked the passionate public support in Dublin for the Patriots' campaign to remove the commercial restrictions binding Irish commerce. However, he had no record of political involvement, and his priority was to secure paying commissions that would enable him to accumulate sufficient capital to return to London free of the threat of incarceration for indebtedness. But he was unknown in Ireland, so there was little prospect of lucrative employment in the short term. The most

remunerative genre was portraiture, but this sector was dominated by Robert Hunter, an accomplished portraitist, who had already painted several lords lieutenant, a number of chief secretaries, and most of the eminent domestic politicians of the day, and who had just won the commission to paint the portrait of the current viceroy, the Earl of Buckinghamshire (Crookshank, "Robert Hunter," 169–85).

Portraiture did not represent Wheatley's only area of artistic accomplishment, however, or the sum of interest in the arts in Ireland at this time. Indeed, the artistic scene in Ireland, inert for much of the early eighteenth century, had sprung to life following the improvement in the kingdom's economic fortunes after the costly famine of 1740–41. This is well attested to by the establishment of a number of art schools by the Dublin Society in the mid-1740s, and by the foundation in 1764 of the Irish Society of Artists, which undertook to organize an annual exhibition of paintings, drawings, prints, and sculptures (Crookshank, "The Visual Arts," 517–18). In the decade following its first exhibition, at Napper's Great Room in George's Lane in 1765, the Society of Artists provided gallery space for the most notable domestic and foreign artists based in Ireland. However, both it and the Dublin Society schools experienced continuing difficulties. The schools survived because they had an influential patron in the Dublin Society; the Society of Artists was less well circumstanced. It received a once-off parliamentary grant of £500 in 1767, but its income from other sources fell short of what was necessary to enable it to meet its costs (Gilbert iii, 344–46). The society survived but, throughout the late 1770s, it exhibited only intermittently (Breeze passim).

The inability of the Society of Artists to create a milieu in which Irish artists could make a living obliged many to go abroad. This was a well-established practice; Ireland had long produced more artists than it could sustain (Crookshank, "The Visual Arts," 521). In the second half of the eighteenth century, Irish artists travelled in some numbers to London (Webster 30) and to Rome in search of inspiration, as well as work (Figgis 28–36; Turpin, "Continental Influences in Eighteenth-Century Ireland," 50–52). The root cause of the diaspora was the shortage of patrons in Ireland. The aristocracy was small, and the number of landowners of sufficient wealth and motivation to commission art with any frequency, smaller still. Moreover, their tastes tended toward the conservative. Their major interests were portraiture, which accounts for the eminence of portrait painters in domestic artistic circles, and landscape. What is more significant is that most of them believed that art produced by foreigners was, by

definition, finer than the domestic product. It pained skilled Irishmen like Robert Carver and Thomas Hickey, both of whom practiced with some success in London, that "paltry daubings . . . executed by Signor Somebodini" were afforded rapturous welcomes by the so-called connoisseurs in Ireland, while their finer productions were neglected or ignored (Gilbert iii, 348–49). Thus as they strove in vain to alter this perception, a steady stream of foreign artists visited the kingdom in search of commissions. By no means all were successful, but a considerable number profited financially, as well as artistically, from their Irish sojourns. John Astley, for example, earned the not inconsiderable sum of £3000 during his three-year stay in the 1750s. Angelica Kaufmann was kept extremely busy throughout her visit in 1771, while the irascible Gilbert Stuart brought Robert Hunter's long reign as the pre-eminent domestic portraitist to a close when he arrived in the country in 1787 (Crookshank, "The Visual Arts," 521). Such experiences must have encouraged Wheatley to believe he could do well in Ireland if he struck the right note with the art-consuming elite. His first task was to get its attention.

Wheatley chose to advertise his talents by capturing on canvas the Volunteers' resolve to secure the repeal of the commercial restrictions binding Irish commerce. It was, James Gandon observed, an excellent choice of subject; "the Irish Volunteer Corps . . . was composed of the most respectable citizens, and the cavalry was formed of noblemen and gentlemen of the highest rank in Ireland, and commanded by his grace, the . . . Duke of Leinster" (Gandon 206).

III

The political temperature in Ireland rose appreciably in the autumn of 1779 following the reconvening of members of parliament in October for the new session. Led by Henry Grattan, Barry Yelverton, Denis Daly, and Barry Barry, the patriot interest seized the political initiative and, on October 12–13, persuaded a majority of M.P.s to ratify an address to the king which incorporated a specific call for the concession to Ireland of the right to "free trade" (Kelly, forthcoming). This was a serious reversal for Dublin Castle, which had aspired to resist the clamorous demand for concessions "out of doors" with the support of the House of Commons. Castle officials had been perturbed that summer by the Volunteers' involvement in the campaign for free trade. They were disturbed by their appearance on the streets on the opening day of the new session in a quite blatant attempt to

encourage M.P.s to approve an address for free trade; and by their subsequent decision to line Dame Street as the Speaker, Edmond Sexton Pery, they implemented the instruction of the House of Commons that he should personally carry the address in favor of free trade to the lord lieutenant at the Castle (O'Connell 168–73).

The Castle administration quickly realized it was powerless to resist the rising tide of public and parliamentary support for free trade in Ireland. The patriots, for their part, were emboldened by their successes to intensify their campaign. They initiated proceedings in the House of Commons to ratify a six-month rather than the usual two-year money bill, while the patriot-led Volunteers underlined their support for the cause by turning the traditional November 4 celebrations honoring William of Orange into a major public demonstration in favor of free trade. Wheatley evidently kept abreast of developments in the political sphere (they were amply covered in the public prints), for he concluded that the plans for November 4 provided him with an ideal opportunity to display his talents before the Irish public. It was, by all accounts, a spectacular occasion. According to *Finn's Leinster Journal* (Nov. 10, 1779), nobody could "remember the glorious fourth of November to have been so eminently distinguished." Members of the united corps of Dublin Volunteers assembled at 11:00 a.m. at Stephen's Green, where "they went through their exercise, different evolutions and firings with an ease and exactness that would do honour to veteran troops" before marching to College Green to take their places before the statue of King William and the Houses of Parliament (*Finn's Leinster Journal*). The sight of between 750 and one thousand Volunteers lined up in such impressive style thrilled the large crowd which commanded every vantage point to witness the occasion (*Freeman's Journal*). Wheatley was among the throng, and it was from a "drawing" he made on the day that he produced his landmark painting *A View of College Green with a Meeting of the Volunteers* (plate 29).

In the history of Irish painting, *A View of College Green* is the only work that attempts to capture the powerful impact of the Volunteers on Irish life and politics in the late 1770s. Moreover, it is a broadly accurate representation. Wheatley's precise portrayal of the assembled Volunteers firing the customary *feu de joie* captures well the festive atmosphere of such events. It shows clearly how the foot and cavalry corps assembled before Grinling Gibbon's statue of the king, and the enormous public interest in proceedings. However, Wheatley failed to depict the more overtly and aggressively political dimension of the occasion. One cannot glean from the painting

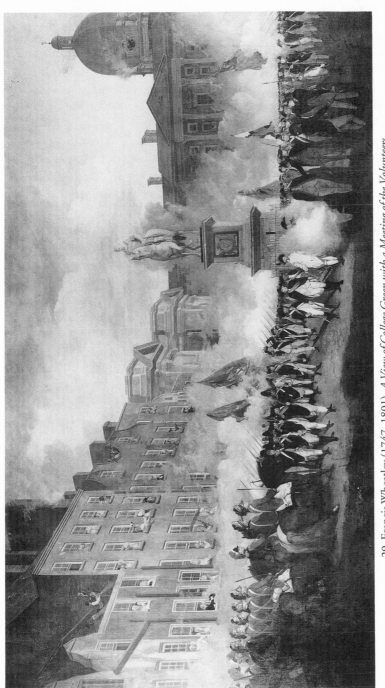

29. Francis Wheatley (1747–1801), *A View of College Green with a Meeting of the Volunteers on 4 November 1779*, oil on canvas, 175 × 323 cm, National Gallery of Ireland no. 125. (Courtesy of the National Gallery of Ireland)

that the Volunteers marched with cannon, as well as muskets, to College Green (Kelly, "James Napper Tandy," 4); that the cannon bore placards bearing the slogans "Short Money Bills," "A Free Trade or ———," "Relief to Ireland," "A Free Trade or Speedy Revolution"; that the placards were "hung on each side of the pedestal" of King William's statue for all to see; and that several cannon rounds were fired as part of the *feu de joie* (State Papers 63/467. folio 95).

Wheatley's failure to present the more aggressive political dimension of the November 4 demonstration can be attributed to his anxiety to give pride of place in the painting to the commanders of the various Volunteer corps present. The likenesses of the Duke of Leinster, Sir Edward Newenham, Luke Gardiner, John Finlay, counselors Pethard and Caldbeck, and such other notables as Sir John Allen Johnston, David Latouche, John Fitzgibbon, and the visiting Russian Princess Daschkov (*Finn's Leinster Journal;* Strickland ii, 519–21, 526) enhanced the commercial potential of the work. It is improbable that Wheatley was not also aware, when he completed the painting in the spring of 1780, of the mounting unease of prominent aristocrats with the politicization of the Volunteers, and that he chose deliberately to play down this aspect of the event. In so choosing, Wheatley was almost certainly exercising his aesthetic, as well as his commercial, judgment. The incorporation of cannon and placards would not have enhanced the painting as a work of art; their omission does, however, warn us against perceiving the painting as a wholly correct portrayal of events at College Green between 12:30 and 1:00 p.m. on November 4, 1779.

Wheatley's priority was to make money. Thus his introduction of "several portraits of distinguished individuals" (Gandon 206) into *A View of College Green* is immediately comprehensible, and may even have contributed to the painting's popularity. The work was exhibited by the Society of Artists in its 1780 show along with four others—two landscapes and two small portraits—by Wheatley (Breeze 30–31). It attracted "considerable notice" (Gandon 206), but Wheatley cannot have been entirely happy with the response since the painting did not sell. It generated sufficient interest to prompt the collection of a large subscription for an engraving (Gandon 206), but Wheatley probably saw little profit from the venture, as it was not finally effected (from a smaller watercolor) until 1784 by Collyer of London (Strickland ii, 521–22; Webster 31–33).

At first glance, Wheatley's inability to find a buyer for *A View of College Green* appears puzzling, given the patriot fervor in the country following

the concession of free trade. However, Wheatley was nothing if not resilient. When no purchaser came forward, he invited subscriptions to enable him to raffle it off. We do not know the outcome of this raffle, which was scheduled to take place in January 1781, but the painting finally found an appropriate home in the collection of the Duke of Leinster (Strickland ii, 520–21).

One of the likely reasons for Wheatley's failure to find a purchaser for *A View of College Green* is that it did not fit easily into any known style of painting. It could not be categorized as a portrait, according to the accepted definition of the term, despite the many well-known faces on the canvas, or as a history painting, though some critics continue to perceive it and his later work of the House of Commons as "homages to the Patriot movement" (Gibbons 244, note 75). Traditionally, history paintings, with the exception of battle scenes, derived their themes from mythology, classical history, and the Bible. Wheatley's painting shows no such debt. This conventional approach was under threat at this time, as Benjamin West's *Death of Wolfe* (1770) and Copley's *Death of Chatham* (1779) demonstrated that it was possible to produce a quality, modern history painting (Turpin, 233–36). *A View of College Green* bears comparison with these paintings. It is, indeed, tempting to agree with the recent judgment, apropos of Wheatley, that "due to the pressure of Irish politics, [Irish] history painting was finally forced to confront the exigencies of actual history" (Gibbons 244, note 75) but the fortuitous nature of his visit to Ireland, his palpable anxiety to attract the attention of prospective patrons, and his inability to find a buyer caution one against making too many claims for the work. Wheatley's Irish contemporaries were unfamiliar with and, perhaps, uninterested in this style of painting. Domestic economic difficulties may also have contributed to their reluctance to buy. The Irish economy underwent a serious downturn in the late 1770s and early 1780s which reduced the disposable income of the picture-buying public, including that of the premier peer of the kingdom, the Duke of Leinster (Kelly, "Scarcity and Poor Relief in Eighteenth-Century Ireland," 38–62).

A View of College Green is an important, if somewhat limited, painting. Wheatley lacked the imagination and technical virtuosity to capture the full drama of the November 4 demonstration. His presentation of the physical setting and the actors is precise, but static; it possesses little of the dramatic quality of Copely's *Chatham* or David's *Oath of the Tennis Court*. It is, as Bruce Arnold has argued, "basically a collection of cameo portraits and a journalistic record of an event" (Arnold 88). However, if this detracts

from its value as a work of art, it adds to its worth as a historical record. The painting is, and will remain, an invaluable illumination of the otherwise overwhelmingly verbal record we retain of the stormy world of Irish politics in the late 1770s.

Despite his inability to find a purchaser, Wheatley was sufficiently encouraged by the response to *A View of College Green* to embark shortly afterward on another uncommissioned, large-group painting. The biannual parliamentary session traditionally represented the best opportunity for Irish artists to secure work and, influenced by this, Wheatley undertook to paint a group picture of the House of Commons (plate 30). He chose the major debate of April 19, 1780, when Henry Grattan made his celebrated speech in support of his motion calling for the concession of legislative independence to the Irish parliament (Kelly, forthcoming).

Like the November 4 Volunteer demonstration, the debate in the Irish parliament on April 19 was highly charged. The public galleries were crowded and the air thick with the expectancy that had built up since Grattan had signaled his intention to move his motion a number of weeks previously. Wheatley conveys the high level of interest in the debate by providing a full view of the crowded public galleries, but his depiction of the debate in the chamber lacks a focus for the viewer. This is surprising. If, as claimed, Wheatley was given access to the chamber, he failed to use the privilege to advantage. Grattan, whose speech was the center of public interest, is not immediately visible in the sea of recognizable faces that dominates the chamber. In his eagerness to include as many members as possible, with the goal (one assumes) of increasing the marketability of the painting and of winning commissions, Wheatley sacrificed the dramatic tension of the occasion. As a consequence, the viewer is provided with a revealing perspective on the architecture and seating arrangements in the Commons' chamber, and an impression of several score M.P.s, but little sense of the drama of the day. For this reason, Mary Webster is wrong to criticize Wheatley for portraying the assembled M.P.s in a state "of unusual attentiveness" (Webster 37); Grattan's oratory was so intense that day, according to some contemporary reports, that members were briefly awed into silence (Rosse Papers, F 13). However, the static nature of the painting belies the vibrancy of the speech (Watson 40). The artist's depiction of Grattan is more successful. The viewer is given a sense of what one observer described as Grattan's grotesque actions while speaking (*Diary and Correspondence of James Harris* iv, 347), though it does not equal the image of him provided by Mary Barker, who described him as "the most truly

30. Francis Wheatley (1747–1801), *Irish House of Commons,* 1780, oil on canvas, 162.5 × 215.9 cm, Lotherton Hall, Leeds City Art Galleries

ridiculous figure I ever saw . . . a little figure as stiff as a poker" (Barker Ponsonby Papers). In a sense, *The House of Commons* is a group portrait that has become a history painting, not because it was conceived as such, but because the era and the people it depicts have passed into history.

It is not clear how the contemporary public responded to the painting. Because the Society of Artists had collapsed, Wheatley had no obvious venue at which to show his work when he completed it in June. He had endeavored from the outset to ensure he made a profit on the painting by opening a subscription list for an engraving based upon it, but no such work appeared during his lifetime (Webster 37). Nor does he appear to have found a buyer for the painting. According to one unverified report, he gave it to Silver Oliver, the M.P. for County Limerick, in return for some act of kindness (Strickland ii, 523); another report has it that the painting was disposed of by raffle just prior to Wheatley's return to England

(Pasquin 135; Gandon 208). Its exact history remains obscure up to 1790, when it was presented for sale at the auction held by Christie's of paintings owned by Dr. Charleton of Bath (Strickland ii, 523–24).

The House of Commons was Wheatley's last attempt at producing a large-scale painting of a major public event. He made no attempt to record Henry Grattan's triumphant speech of April 16, 1782, for example, or any of the other momentous political events that occurred during his stay in Ireland. He did produce an impressive watercolor, now in the National Gallery of Ireland, of Speaker Pery's entry, unattended except for the mace bearer and a number of onlookers, through the magnificent portico to the chamber of the Irish House of Commons in 1782. This may have been intended as a study for a larger work, but no such painting was ever completed.

Indeed, it is probable that Wheatley had no further incentive to produce such large uncommissioned works. If Pasquin and Gandon are correct, he had done enough to establish a reputation among "the persons of taste and fashion" (Pasquin 135), which led directly to three prestigious and probably lucrative commissions for group portraits and a number of other paintings in the next couple of years. The most elaborate of these is the large canvas depicting the onlookers at a Volunteer review on Lord Aldborough's demesne at Belan Park, County Kildare (plate 31), now in Waddeston Manor, Buckinghamshire, England. Entitled *Lord Aldborough on Pomposo, a Review in Belan Park*, it is a delightful, informal group portrait of Aldborough, his family, and friends, gathered together to watch the local Volunteers—the Aldborough Legion—go through their paces. Aldborough was colonel of this corps, which he had founded in 1777, and one of the twelve Volunteer generals in the kingdom. The legion was one of the best-accoutred corps, and its elegant uniform of scarlet and black with silver lace attests to the earl's eagerness to cut a dash politically, as well as socially (MacNevin 220, 223).

Group scenes were clearly regarded as Wheatley's forte in Ireland. About the same time that he painted the Earl of Aldborough, he was invited to paint a not dissimilar scene, now in Castle Howard, Yorkshire, of the lord lieutenant, the Earl of Carlisle, in the Phoenix Park with his family. Carlisle was a competent and generally popular lord lieutenant who adopted a pragmatic stance in his dealings with the clamorous patriot demand for legislative independence. Good management and sensible tactics enabled him to establish a working majority in parliament in the winter of 1781–82, and he was attempting to convince the government of Lord

North of the need to satisfy Irish demands when, in the spring of 1782, he was forced from office in controversial circumstances (*Carlisle Mss.*, passim; McDowell 275–81). Wheatley's painting makes no allusion to the hectic political environment in which Carlisle operated. Per contra, it evocatively captures the lord lieutenant and his family during a restful moment as they enjoyed a leisurely ride through the Phoenix Park. As Ross Watson has observed, this painting "marks a development in Wheatley's integration of landscape and figures" (Watson 43–45).

The same claims cannot be made for the final large-scale group portrait Wheatley painted in Ireland, now in the National Portrait Gallery, London. Variously titled (Strickland ii, 523, 525–26) but now known as *A Review of Troops in the Phoenix Park by General Sir John Irwin*, it features General Irwin, the commander-in-chief of the Irish army, leaning on his horse under a tree, receiving a dispatch from an officer. In the background, lines of cavalry can be seen performing maneuvers. As with Wheatley's

31. Francis Wheatley (1747–1801), *Lord Aldborough on Pomposo Reviewing Volunteers at Belan House, County Kildare,* 1781, oil on canvas, 154.9 × 239 cm, National Trust, Waddesdon Manor, no. W1/51/6

House of Commons, the draftsmanship is precise, but the painting is lifeless. The colors are bright and not inapposite, and the figures fit well into the environment, but they do not relate to each other in a convincing manner.

Some of the same reservations can be expressed about Wheatley's painting of *The Marquess and Marchioness of Antrim*. It was completed in 1782 and is another family grouping. It is, in the view of Mary Webster, one of his most successful works. Though conventional and comparable, in some respects, to *The Earl and Countess of Carlisle in the Phoenix Park*, Wheatley paid "more attention than was usual with him to harmony of tone throughout the whole picture" (Webster, "Wheatley's Lord and Lady Antrim," 42–45). However, there is no disguising the fact that it is a composition devised and executed in the studio, rather than in situ. Lord and Lady Antrim do not sit easily in the landscape in which they are placed.

As well as the large canvases we have been considering, Wheatley also painted a number of smaller portraits of individuals and small groups. The best known of these is his rendering of Henry Grattan, now in the National Portrait Gallery, London. This dates from 1780, and is almost certainly a study for *The House of Commons*. It is a tender, but rather unengaging, portrait that captures some of the singleminded zeal Grattan displayed in his quest for legislative independence, but little of his conviviality or charm. Despite this, it stands up well against Gilbert Stuart's larger and more accomplished portraits of Grattan.

Wheatley also completed commissions of varied quality of a range of minor political figures and society personalities. These include Anthony Webster, the actor; John (later Viscount) O'Neill; the Macartney family; Captain Edward O'Brien; an attractive portrait of *Two Children of the Maxwell Family*; Fridiswide Moore; Captain Charles Churchill; and others, some of which cannot be traced (Webster 42–43; Strickland ii, 526). Their number bears witness to the accuracy of Gandon's observation that once he had attracted public attention Wheatley did not want for professional employment in Ireland (Gandon 206).

IV

As well as his essays in group portraiture, Wheatley painted a number of landscapes in watercolors and oils, and a vivid series of scenes from Irish life in watercolors. Interest in Romantic landscape painting had been ignited in Ireland in the mid-eighteenth century by the works of Poussin, Claude, Watteau, and Lancret in France, and Gainsborough in England.

There was also an established domestic tradition of landscape painting; Thomas Roberts and William Ashford, the leading domestic landscapists, secured commissions from the richest patrons in the land (Crookshank and Glin 127–36). Wheatley did not possess the delicacy of touch or vision of the artists just cited, but he was familiar with the genre from various "studies from nature" he worked into finished compositions during the 1770s (Webster 13–17). Moreover, the death of Thomas Roberts in 1777 left this field rather thinly populated and offered possibilities, which Wheatley failed to exploit to the full. He did paint at least one large seascape, *The Seashore at Howth*, in oils, but it was not deemed a great success. By contrast, his better-known *Salmon Leap at Leixlip with Nymphs Bathing* is more appealing. It combines a more relaxed technique, a deftness of touch, and a greater variety of colors. Wheatley's watercolor *Fishermen Beside the Salmon Leap* is likewise interesting; it provides an unusual view of this famous site (Webster 45–48).

As well as his small corpus of landscapes, Wheatley produced a number of topographical scenes and specific views in watercolors for engraving (plate 8). Inevitably, these lack the depth of his larger, more ambitious oils, but the engravings by Thomas Milton and W. and J. Walker of his renditions of Malahide Castle, the Casino at Marino, Howth House (all County Dublin), Enniskerry (County Wicklow), St. Wolstans, the Salmon Leap at Leixlip (County Kildare), Tarbert (County Kerry), and elsewhere figured in some of the most important late-eighteenth century topographical publications: Milton's *Collection of Select Views from the Different Seats of the Nobility and Gentry of Ireland*, the *Copperplate Magazine*, and Francis Grose's *Antiquities of Ireland* (Watson 49, note 20; Strickland ii, 526–27). Moreover, these engravings had a considerable impact; it is believed in some quarters that they influenced Thomas and James Malton—the most successful topographical artists in Ireland in the late eighteenth century (Webster 45; Arnold 75).

When he was not occupied with group portraits or topographical work, Wheatley underlined his versatility by painting small pictures of rustic scenes. He produced most of the twenty or thirty such works he did in this style toward the end of his time in Ireland. They are what Mary Webster has termed big drawings, composed "in pen with blue and grey washes, tinted in blue, yellow, greenish yellow and red" (Webster 48). Wheatley's first essays in this genre were scenes from Donnybrook and Palmerstown fairs (Gandon 208), and his drawings capture the rude and bohemian lifestyle of the tradespeople, stallholders, beggars, peddlers, and produce sell-

ers who attended these fairs (plate 32). They are extremely engaging and, one must assume, accurate representations of the dress, deportment and activities of the habitués of such events. Most of them are now located in the National Gallery of Ireland and the Henry Huntington Art Gallery in California. Artistically, they bear witness to the admiration Wheatley entertained for the Dutch artist Philip Wouvermans.

As his watercolors of Donnybrook and Palmerstown fairs sold well and were quick and easy to produce, Wheatley followed them up with others in a similar style. He possessed a natural facility for such work; his ability to "delineat[e] the character of the peasantry, in perfect accordance with the humours he met with on these subjects" ensured a ready market and led to others of oyster sellers, gypsy encampments, fishermen, and so on (Gandon 208). Stylistically, they are similar to those of the Donnybrook and Palmerstown fairs and, together, provide one of the most rewarding and appealing vistas onto the daily life of the common people of late eighteenth-century Ireland. It is no surprise that they were among Wheatley's most popular works during his lifetime.

Wheatley himself failed to build on the reputation he forged in Ireland. He was unable to correct the habits of expense and indulgence that had forced his flight from London. By the latter half of 1783, he had run up debts in Ireland he was unable to defray. Moreover, his irregular liaison with Elizabeth Gresse came to public notice, and he was obliged to depart the scene of his greatest artistic achievements and to return to London (Gandon 208–09).

V

Wheatley endeavored in vain to replicate his Irish success on his return to London, despite his efforts in a range of genres. His paintings of the Gordon riots and *The Second Duke of Northumberland and a Shooting Party* attracted considerable attention; his drawings *The Cries of London* were exhibited to popular acclaim by the Royal Academy, to which he was elected in 1791, but the financial security and popularity he desired eluded him (Webster 50 ff). Moreover, frequent attacks of gout in his later years "disabled him [from painting] . . . for a considerable time before his death" (*Annual Register* 22–23). Obliged to become a pensioner of the Royal Academy, he died, in straitened circumstances, in June 1801 (Whitley ii, 220).

Though not in the front rank of late eighteenth-century artists, Francis Wheatley enlivened the artistic community in Ireland during his four -year

32. Francis Wheatley (1747–1801), *Buying Ale at Donnybrook Fair,* 1782, watercolor on paper, 40.3 × 61 cm, National Gallery of Ireland, no. 3027. (Courtesy of the National Gallery of Ireland)

sojourn there. As we have seen, the aesthetic value of several of his larger group portraits is vitiated by his failure to capture the drama of the subjects he painted and by a lack of judgment in his placement of people in some of his group portraits. It is true also that he was not an artistic innovator. Joseph Burke, for example, has argued that the arrangement of the figures in *Lord Aldborough on Pomposo* derives from military parade pictures and prints (Burke 300). However, we should not allow this to mask his contribution to the Irish artistic scene, which was in something of a trough on his arrival in 1779. Wheatley was not in a position to save the ailing Society of Artists, which displayed some of his work at its final exhibition in 1780, but his paintings of the Volunteer demonstration on College Green on November 4, 1779, and of the House of Commons on April 19, 1780, are among the most individualistic and distinctive Irish pictures of the last quarter of the eighteenth century. They may not possess the emotional intensity of the first work of Copley, West, and David, but they have provided posterity with unique and evocative images of Protestant nationalism at its peak.

Indeed, together with Gilbert Stuart, who painted the best portraits of the main personalities of "Grattan's parliament," he provides the primary visual record of this celebrated era in Irish parliamentary history. The irony is that Wheatley painted his two most famous canvases on his own initiative and was forced to raffle them to make a sale. Less than thirty years later, this would not have been necessary. In January 1813, rumors that an unspecified painting of the Irish parliament, possibly Wheatley's *House of Commons*, had come on the market prompted Henry Grattan, Jr., to instruct his brother to offer between 250 and 350 guineas for it (Grattan papers). It is not clear if James Grattan's bid held, but interest in "Grattan's parliament" continued to grow. Nicholas Kenny, in 1844 (Strickland ii, 523, note), and Henry Barraud, in 1872 (*Irish Builder* 50), drew on Wheatley's work of 1780 for their paintings of the House of Commons in 1782 and 1790, respectively. Both won praise; but neither equal Wheatley's original.

Francis Wheatley may not have possessed the intangible quality that makes great art. But his versatility, his willingness to paint paupers as well as peers, political as well as pastoral scenes, and fishermen as well as fairs makes the corpus of work he produced in Ireland unique in the history of Irish painting. As has been well said, Wheatley's paintings "capture the late eighteenth-century [Irish] scene better than any other artist" (Crookshank and Glin 153).

I wish to thank Ruairi O Cuiv for his support while writing this article, the Earl of Rosse, the National Library of Ireland and Trinity College Dublin for permission to consult papers in their care.

WORKS CITED

Annual Register. 43 (1801): 22–23.

Arnold, Bruce. *A Concise History of Irish Art.* London: Thames and Hudson, 1969.

Barker Ponsonby papers. Trinity College, Dublin.

Breeze, George. *Society of Artists in Ireland: Index of Exhibits 1765–1800.* Dublin: National Gallery, 1985.

Burke, Joseph. *English Art 1714–1800.* Oxford: Oxford University Press, 1976.

Carlisle Mss. London: Historical Manuscripts Commission, Report 15, Appendix 5, 1897.

Craig, Maurice. *Dublin 1660–1860.* Dublin: Allen Figgis, 1969.

Crookshank, Anne. "Robert Hunter," *Irish Arts Review Yearbook* (1989–90): 169–85.

Crookshank, Anne and the Knight of Glin. *The Painters of Ireland 1660–1920.* London: Barrie and Jenkins, 1978.

Crookshank, Anne. "The Visual Arts," *A New History of Ireland. iv. Eighteenth-Century Ire-*

land 1691–1800. Ed. T. W. Moody and W. E. Vaughan. Oxford: Oxford University Press, 1986. 499–541.

Figgis, Nicola. "Irish Artists and Society in Eighteenth Century Rome," *Irish Arts Review*, vol. 3, no. 3, (Autumn 1986): 28–36.

Finns's Leinster Journal, 6 Nov. 1779.

Freeman's Journal, 6 Nov. 1779.

Gandon, James and Mulvaney,Thomas. *The life of James Gandon*. London, 1846.

Gibbons, Luke. "A Shadowy Narrator: History, Art and Romantic Nationalism in Ireland 1750–1850," *Ideology and the Historians*. Ed. Ciaran Brady. Dublin: Lilliput Press. 1991. 99–127.

Gilbert, J. T. *A History of the City of Dublin*. 3 vols. Dublin, 1859–61.

Grattan papers, Henry to James Grattan, Jan. 17, 1813. National Library of Ireland, ms 2111.

Irish Builder, XV (February 1873): 50, "The Irish House of Commons in 1790: Painting by Henry Baraud."

Kelly, James. "James Napper Tandy: Radical and Republican," *Dublin and Dubliners: Essays in the History and Literature of Dublin City*. Ed. James Kelly and Uaitear MacGearailt. Dublin: Helicon, 1990. 1–21.

———."Scarcity and Poor Relief in Eighteenth Century Ireland: The Subsistence Crisis of 1782–84." *Irish Historical Studies* 28 (1992): 38–62.

———. *Henry Grattan* (Dundalk: forthcoming).

Longfield, A. K. "Stratford-on-Slaney." *Journal of the Royal Society of Antiquaries of Ireland* 75 (1945): 24–31.

Diary and Correspondence of James Harris, first Earl of Malmesbury. 4 vols. London, 1844.

McDowell, R. B. *Ireland in the Age of Imperialism and Revolution*. Oxford: Oxford University Press, 1979.

MacNevin, W. J. *History of the Volunteers*. Dublin, 1882.

O'Connell, M. R. *Irish Politics and Social Conflict in the Age of the American Revolution*. Philadelphia: University of Pennsylvania Press, 1965.

Pasquin, Anthony [pseud. for John Williams]. *An Authentic History of the Professors of Painting . . . who have Practiced in Ireland . . .* London, 1796.

Rosse papers. Birr Castle, County Offaly.

State papers. S.P. 63/467 folio 95, Buckinghamshire to Weymouth, 6 Nov. 1779. Public Record Office, London.

Strickland, Walter. *A Dictionary of Irish Artists*. 2 vols. Dublin: Irish University Press,1968.

Turpin, John. "Continental Influences in Eighteenth-Century Ireland." *Irish Arts Review* 4 (Winter 1987): 50–57.

———. "Irish History Painting." *Irish Arts Review Yearbook* (1989–90): 233–36.

Watson, Ross. "Francis Wheatley in Ireland." *Bulletin of the Irish Georgian Society* 9 (1966): 35–49.

Webster, Mary. *Francis Wheatley*. London: Routledge and Kegan Paul, 1970.

———. "Wheatley's Lord and Lady Antrim." *Irish Arts Review* 1 (Spring 1985): 42–45.

Whitely, W. T. *Artists and Their Friends in England 1700–1799*. 2 vols, London: Medici Society, 1928.

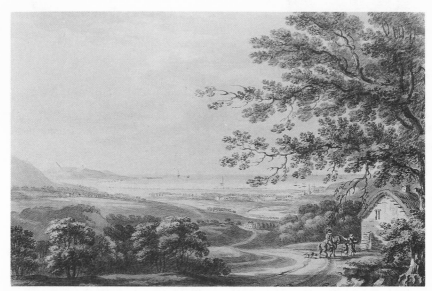

33. Thomas Sautell Roberts (1760–1826), *View of the Countryside near Bray, County Wicklow, Looking towards Killiney Bay,* 1793, watercolor over ink and pencil on paper, 25.7 × 37.5 cm, National Gallery of Ireland no. 18991. (Courtesy of the National Gallery of Ireland)

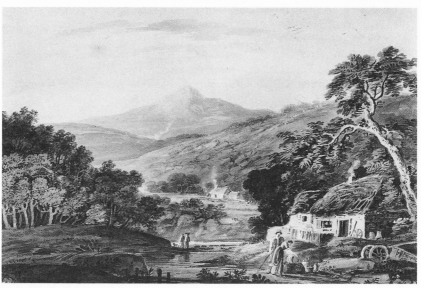

34. John Henry Campbell (1757–1828), *The River Dargle near Enniskerry, County Wicklow,* watercolor on paper, 37.2 × 37.4 cm, National Gallery of Ireland no. 6344. (Courtesy of the National Gallery of Ireland)

The Traditional Irish Thatched House: Image and Reality, 1793–1993

Brian P. Kennedy

ROMANTICIZING THE IRISH thatched house is not a new invention. Thomas Sautell Roberts (1760–1826), in his *View of the Countryside near Bray, County Wicklow, Looking toward Killiney Bay* (National Gallery of Ireland, Dublin), a watercolor painted in 1793, exploits its charms (plate 33). An undated but certainly early nineteenth-century watercolor, *The River Dargle near Enniskerry, County Wickow* (National Gallery of Ireland, Dublin), by John Henry Campbell (1757–1828), presents an idyllic landscape, in which a contented farming couple are at work outside their cottage, just downstream from the neighboring cottage (plate 34). These images typify the theory of the picturesque fashionable in England and Ireland in the late 1700s and early 1800s.

During the 1790s, when Roberts painted his watercolor, several influential treatises on the "picturesque" were published in London. William Gilpin's *Observations Relative Chiefly to Picturesque Beauty* was published in 1792, with the aim "of not merely describing; but of adapting the description of natural scenery to the principles of artificial landscape; and of opening the sources of those pleasures, which are derived from the comparison" (1–2). Richard Payne Knight's *The Landscape, a Didactic Poem* (1794), Uvedale Price's *Essay on the Picturesque* (1794), and Humphrey Repton's *Sketches and Hints on Landscape Gardening* (1795) articulated the picturesque theory "as giving definition to the aesthetic concerns of the connoisseur and the amateur, gentleman artist." (Barrell 96). Price, in

lucid style, explained the picturesque as a category of aesthetic values that supplemented those expounded thirty-eight years before by Edmund Burke in his essay "A Philosophical Inquiry into the Origin of our Ideas of the Sublime and the Beautiful." Picturesque theory suggested that, if left to their own devices, artists who were unguided by gentleman connoisseurs would become absorbed by the technical aspects of their craft and ignore the essential requirement of polite, good taste.

A beautiful landscape evidenced the divine order underlying it; nature was superior to art, but, in the interests of the picturesque, the artist modified a landscape to improve its aesthetic aspect. The thatched cottage, considered an appropriate element in an improved landscape, was included in many books of architectural designs published between 1790 and 1810. One of the most influential was by the English artist James Malton (c. 1760–1803) who is best known for his book *A Picturesque and descriptive view of the city of Dublin* (1799). In his *Essay on British Cottage Architecture* (1798), Malton promoted the traditional English thatched cottage as among "the most pleasing . . . ornaments of art that can be introduced to embellish rural nature." The successful architect John Nash (1752–1835) improved the estates of the landed gentry by rebuilding or altering their houses and by designing attractive cottages, lodges, and architectural follies. A perfect example, the early nineteenth-century cottage *orné* at Cahir in County Tipperary (known as the Swiss Cottage), designed possibly by Nash for the earls of Glengall, was restored recently by the Office of Public Works (plate 35). Its thatch roof, rustic timberwork, and elegant interior decoration provided a suitable ambiance for a landed family to savor peasant life in for a few days at a time, dressing in traditional costume and sleeping in a masterpiece of cottage design set in a renowned, scenic environment.

Thomas Sautell Roberts, whose watercolor view of the countryside near Bray, County Wicklow, coincides precisely in date with the major English publications on the theory of the picturesque, was a member of a noted artistic family. His father, John Roberts (d. 1796), designed both the Protestant and Catholic cathedrals in Waterford City, and his brother, Thomas Roberts (1748–78), was arguably the best Irish landscape painter of the eighteenth century. Sautell, as he is known, to distinguish him from his brother, studied architecture at the Dublin Society Schools and was apprenticed to Thomas Ivory, the designer of the Blue Coat School (King's Hospital) in Dublin. He then decided to make a career as an artist and, during the 1790s, began to specialize in watercolors. A series of his Irish

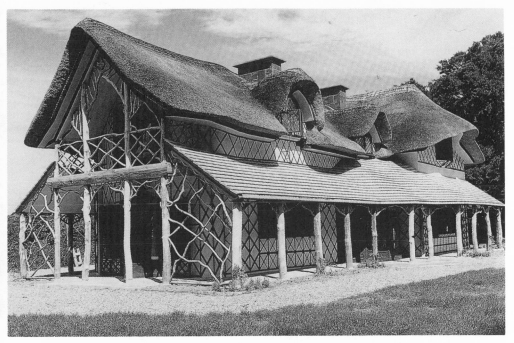

35. "The Swiss Cottage," Cahir, County Tipperary, designed possibly by John Nash (1752–1835)

scenes was engraved in aquatint and published, between 1795 and 1799, as *Illustrations of the Chief Cities, Rivers and Picturesque Scenery of the Kingdom of Ireland.* He was a regular exhibitor at the Royal Academy and at the British Institution in London. He was one of three artists selected to nominate the founder members of the Royal Hibernian Academy (R.H.A.) and exhibited nine works at the first exhibition in 1826. He died tragically that year when, after a coach accident left him incapacitated and unable to paint, he committed suicide.

John Henry Campbell's parents were from Hertfordshire in England and he may have been born there. After his father's appointment as a partner with Graisbery, the King's Printer in Dublin, he attended the Dublin Society Schools, a fellow student of Thomas Sautell Roberts. He produced many oil paintings but was renowned for his watercolors of landscapes in counties Dublin and Wicklow. He exhibited at the inaugural R.H.A. exhibition in 1826 and again in 1828, the year he died. Unlike Roberts, he was not elected to membership of the R.H.A., but it is recorded that his contemporaries regarded him highly.

Roberts and Campbell made their livings by selling their works and giving art lessons to members of the aristocracy. Their watercolors of the Irish countryside and its peasantry expressed what the polite society, who purchased such pictures, wished to believe about the rural poor. They exploited the country cottage in contrived images designed to please their buyers, taking care that their Irish landscapes complied with Gilpin's views about the non-representation of peasants at work. The English theorist distinguished between the moral view, in which the industrious mechanic was a pleasing subject, and the picturesque, which rejects industry and in which idleness adds dignity. In Roberts's watercolor, a woman and child are in conversation with a man on a horse, perhaps begging from him or asking the way. All is quiet and serene, boats can be seen on the horizon, the air is too still to even stir the leaves. In Campbell's, a man stands idle while a woman leans over a barrel, probably washing clothes. The man is wearing a loosely fitted greatcoat, breeches, linen shirt, and felt hat; the woman wears a fitted and waisted gown with a blue petticoat underneath, both of which would have been colored with home dyes. The thatched houses in both pictures are neat and well maintained, symbols of rural contentment, nestling gently into the landscape.

Both watercolors represent County Wicklow, which was relatively prosperous at the time. Nonetheless, in portraying a happy peasantry in their pictures, the artists ignored the hardship of life in a thatched cottage, and, instead, convey a moral message. Patrons were to be spared reminders of poverty, famine, and poor housing and sanitary conditions. Artists who wished to advance their careers studiously avoided such themes (Hemingway 46). The thatched dwelling with stone walls and roof line reiterating the graceful curves of surrounding treetops in Roberts's watercolor expresses a oneness with nature, a house in concord with its surroundings.

In the 1790s, the life of a day laborer was a precarious one. He rented his land from the local farmer and lived with his family in a small cottage. He grew potatoes as his staple diet and, if the plot was large enough, some oats too. He would work approximately 150 days to pay the annual rent which rose sharply as landlords and their agents struggled to recoup the huge costs of managing their estates (Daly 11). If a laborer was ill, his family faced destitution and homelessness. He had no capital and his only possessions were the furniture and furnishings in his cottage. In Munster, in 1787, "the lower order of the people [was] in a state of oppression, abject poverty, sloth, dirt and misery" (Cullen 11).

Although the watercolors by Roberts and Campbell misconstrue the

standard of living of the Irish peasantry, they offer visual evidence to support the study of the thatched dwelling in Ireland. All traditional Irish rural dwellings have so many common elements that they fit neatly into the category of European dwelling that the German scholar Joseph Schepers called *ernhaus*—"the small house in which the evolution of the hearth has been the central element" (quoted in Danaher "Traditional Forms" 77). The saying "There's no fireside like your own fireside" emphasized the heart of the home. Most of the Irish burned turf fires that were rarely let die. Every night, the couple in Campbell's picture would have smoored the fire (covered it with ashes) to keep it alive until morning. The woman of the house cooked all the meals on the hearth and kept tea constantly on the boil. The phrase *nua gacha bidh*, the freshest of every food, meant that each meal was cooked in a separate utensil over the fire and not in a fixed oven, as in many other countries. The family and guests sat in order of importance, grandparents and visitors closest to the fire. The hearth was also the focal point for the great tradition of storytelling, the art of the *seanchaí*.

The centrality of the hearth to Irish life is further underscored in the labeling of house types. Åke Campbell classified two-room cottages as either central-chimney or gable-chimney (1: 207–34; 2: 173–96). He called those with three rooms central-hearth structures. The house in Roberts's watercolor is the central-chimney type and Campbell's is gable-chimney. Kevin Danaher (Caoimhín Ó Danachair) delineated three traditional Irish house types, each typical of a particular region ("Traditional Forms" 79–81). Alan Gailey in his excellent book *Rural Houses of the North of Ireland* has simplified the classification into two styles, direct-entry and hearth-lobby (140–96). In the direct-entry house, as in Campbell's picture, the exterior opened directly into the main living space (plate 36). In the hearth-lobby house, a jamb wall partitioned the entrance and the hearth (plate 37). The occupants, seated by the fire, could observe a visitor at the door through a little window in the jamb wall. Some cottages would probably have had a half-loft (also called a "skeagh," "flake," "thallage," or "farray") over the kitchen, heated by the rising warmth of the fire below; if not used for sleeping, it was used for storage. Direct-entry houses frequently had a bed-outshot (in Irish, *cúilteach* or *cáilleach*, and in English called "coolytee" and "hag" or "haggard"), which was a recessed portion of the rear side-wall, large enough to contain a bed. From the outside it looked like a small projecting block. Beds were often boxed in or separated from the hearth by a curtain.

Additions to Irish houses tended to be in length rather than height, as

36. Plan of a direct entry house similar to that in Roberts's watercolor (F=Fire [hearth], N=Bed Outshot, K=Kitchen, B=Bedroom)

37. Plan of a hearth lobby house with a jamb wall through which the occupants, seated by the fire, could observe a visitor at the door. (K=Kitchen, F=Fire, B=Bedroom). The house in the Roberts watercolor is of this central chimney type.

the Campbell watercolor makes clear. More recent additions are identifiable by roofing materials, slate or even corrugated iron, that differ from the original thatch. Within the house, panels of wood or large wooden dressers and cupboards, together with the central hearth, provided makeshift divisions of the rooms.

In Ireland, houses were built of stone or clay, timber being scarce. During the sixteenth and seventeenth centuries, the Irish forests had been denuded to make room for English plantations, to provide fuel for English industries, and to remove hideouts for Irish rebels. Houses were often located near rivers to ensure the supply of water, as in the Campbell watercolor. They were never built on a burial place, ancient or modern (Ó Súilleabháin 17–20). The Irish held the dead in great respect and believed that final resting places should be left undisturbed, lest the awakened spirits seek vengeance. They also believed that a new house should never be constructed on the other side of the road from the old house, and that the stones of an old house should never be used to build a new one.

The stone buildings in the Roberts and Campbell views vary in scale. The large gable shown in Roberts's watercolor indicates the residence of a well-landed farmer. Such dwellings, frequently two-storey, were called "thatched mansions." In contrast, the small cottage in Campbell's painting is not far removed from the *bothán scóir* (the small, one-room cabins of the poor, landless laborers). The presence of another cottage further upstream is typical; dwellings were often built in a cluster or *clachán* to accommodate the close-knit Irish communities and dependent families.

The fewer the windows, the warmer the house. Campbell's cottage shows windows only in the long side walls and no openings in the gable walls. The gabled roof, the most common type, is pitched at the traditional slope of at least 50 degrees to counter persistent rains. Hipped roofs have four sloping sides; rounded-edge roofs protect against violent winter winds. Slate was scarce so houses throughout Ireland were topped with thatch, which provided a light roof and some soundproofing, and kept the house warm in winter and cool in summer. Thatching materials varied considerably. Straw was the most popular and the local crop is obvious from the color of the roof, pale gray-brown of wheat straw (as in the Roberts) and gold of new oats (as in the Campbell). Tall reed was favored near the big lakes and rivers in the center of the country; in Ulster, it was flax grown for the linen industry. There were at least five methods of thatching (Danaher "Traditional Forms" 84; Gailey 99–105). Campbell's cottage is probably scollop thatched, the straw secured to the sod directly

underneath by "scollops" (staples of cut and twisted twigs or rods). The roof of the larger house depicted by Roberts appears to have been roped thatched, the straw having been laid on the sod with no direct binding, secured to the roof by a continuous network of cord or rope, which was, in turn, secured to rows or weights or to the wall tops. In the gable wall, the pins to which the ropes were tied can be discerned.

A few times each year, the exterior and interior walls of traditional houses were given a coat of limewash, usually white, as in the two watercolors, but, occasionally, yellow, pink, beige, or sky blue. Lime wash, which protected the houses against wind and rain, was intended as a hygienic measure, but it also allowed the thatched building to blend in with the surrounding countryside.

During the mid-nineteenth century, the romantic landscape became less fashionable and artists began to portray the thatched-roof house in a different way. Greater British awareness of famine and emigration in Ireland may have moved subject painters to portray the poor inhabitants of such dwellings as curiosities and, only occasionally, with sensitivity. Ann Bermingham has shown that English rustic paintings decreased in number, in inverse proportion to the growing resentment, agitation, and alienation of the peasantry (*Landscape and Ideology*). The same is true of Irish rustic painting, to the extent that it exists as a genre. As the Irish peasantry was deprived of its land, more artists began painting landscapes without figures.

There was little overt representation in oil or watercolor of contemporary political themes during the nineteenth century. A few pictures that might be termed quasi-political showed the interior or exterior of thatched houses. For example, Frederic William Burton (1816–1900), in his large watercolor *The Aran Fisherman's Drowned Child* (1843, National Gallery of Ireland, Dublin) invites the viewer to witness local tragedy, and offers an insight into the life of a Galway fisherman, how he dressed, and the common utensils used in his kitchen (Bourke). Erskine Nicol (1825–1904), a Scottish artist who lived in Ireland from 1846 to 1850, mostly portrayed Irish social life in a humorous, satirical, and racist manner. In *The Ejected Family* (1853, National Gallery of Ireland, Dublin), however, Nicol is sympathetic to Irish cottiers. He shows a young workman with his wife and baby, an elderly man, his head bowed, and two children lying against a grass mound and staring at the thatched cottage from which the family has been evicted. Two powerful pictures by Elizabeth Thompson, Lady Butler (1846–1933), *Listed for the Connaught Rangers* (1879, Bury Art Gallery

and Museum) and *Evicted* (1890, Department of Irish Folklore, University College Dublin), which incorporate views of ruined cottages, are symbolic of poverty and desolation (Usherwood). These paintings prompt an emotional response from the viewer. Their purpose is not to impart specific information about the social conditions in rural Ireland. The statistics were entirely unpalatable and no artist showing at the Royal Academy wished to appear critical of the British government. In 1841, the first reliable census undertaken in Ireland revealed that only slightly more than 40 percent of all rural houses had between two and four rooms, and a further 37 percent had one room only. In some West Donegal parishes, more than 65 percent of dwellings had only one room.

Legislation was enacted in 1885 to enable local authorities to settle the poorest laborers in new houses properly constructed with solid walls and slate roofs. At the same time, the Congested Districts Board helped laborers in the west of Ireland build outhouses, reducing the number of byrehouses, in which people and animals had traditionally shared shelter, separated only by a drain cut in the floor. Despite this modest attempt at housing improvements, as late as 1901 almost half of families in Connaught lived in cottages of fewer than three rooms (Daly 98). By 1921, however, over 40,000 new single-storey dwellings had been built in Leinster and East Munster. The landscape of Ireland became dotted with the ruins of vacated cottages. Some, hidden behind new homes, were converted into outhouses, a relegation of function which indicated what the Irish meant by "modernity." "Cottage" became almost a pejorative word, especially in the west of Ireland, where everyone wanted to live in a "house." The term "cottage" referred to a dwelling that was rented from someone else, whether a landlord or farmer in the past, or a local authority more recently. It meant that a "coltier" had not land of his own. The owner of a house was a "landowner," hence the superior status of the "house."

Luke Gibbons has written that the "capacity to reclaim the landscape for a political project is central to the development of cultural identity in Ireland, finding its most tangible preoccupation with ruins and ancient monuments" (62). In the late nineteenth century, despite the prevailing preference for modern, single-storey houses, the thatched cottage became a national symbol of an independent, natural, morally upright, and more spiritual way of life than was available in the overcrowded cities. The Irish independence movement was founded on the belief that the largest social class was rooted in the peasant tradition. The true native Irishman was the peasant, as illustrated by numerous artists including Jack Butler Yeats (*The*

Man from Aranmore, 1905, National Gallery of Ireland, Dublin), Seán Keating (*Men of the West*, 1915, Hugh Lane Municipal Gallery of Modern Art, Dublin), and William Orpen (*The Holy Well*, 1916, National Gallery of Ireland, Dublin). A commentator in the lively but short-lived journal *Ireland To-Day* elaborated: "If there is one country in the world where one man symbolises nearly all national life and nearly the whole content of the national struggle, that country is Ireland, and that man is the Irish peasant." Clearly, "all art and all culture in a primitive society such as ours arose from the people; from the great yeomen, from folk music and folk lore, from communities and craftsmen in contact with the peasant and the soil." (quoted in Kennedy 17–18). The major figures of the Irish literary revival contributed to the fictional notion of Ireland as a country that had to decide between a rural utopia and an urban den of iniquity. As Fintan O'Toole has argued: "The notion of the peasant and of the country which the peasant embodied was not a reflection of Irish reality but an artificial literary creation, largely made in Dublin, for Dubliners" (112).

In the real Ireland, artists, visual and literary, became lyrical about their discovery of the sparsely populated west, by the beautiful scenery, the captivating effects of ever-changing light, the simple lifestyle, the folklore and traditions. Once again, as in the late eighteenth century, the picturesque possibilities of the thatched house were exploited. Like Roberts and Campbell's watercolors of about 1800, early twentieth-century landscapes of unspoiled, rural Ireland carried a clear, moral message: rural happiness was preferable to urban squalor. Artists such as Seán Keating, Paul Henry, James Humbert Craig, Frank McKelvey, Maurice MacGonigal, Charles Lamb, Seán O'Sullivan, and Maurice Wilks helped to create a visual corporate identity for independent Ireland. Commercial advertising made a stereotype of Paul Henry's views of the west of Ireland with their little thatched houses nestling among the hills (plate 38). Two of his paintings were reproduced as posters for the London Midland and Scottish Railway Company and distributed by tourist offices in Europe and America. The Irish government also considered pictures of thatched houses to be an ideal promotional image. The *Saorstát Eireann Official Handbook*, published in 1932, featured as many as ten illustrations of thatched houses.

In 1928, Éamon de Valera advocated the cottage as an appropriate residence. Independent Ireland, he said, "had to make the sort of choice that might be open, for instance, to a servant in a big mansion. If the servant was displeased with the kicks of the young master and wanted to have his freedom, he had to . . . give up the luxuries . . . available to him . . . in that

38. Paul Henry (1876–1958), *A Connemora Landscape,* oil on canvas, 51 × 46 cm, National Gallery of Ireland no. 1410. (Courtesy of the National Gallery of Ireland)

mansion. . . . If he goes into the cottage, he has to make up his mind to put up with the frugal fare of that cottage . . . if I had that choice to make . . . I would say, 'We are prepared to get out of the mansion, to live our lives in our own way, and to live in that frugal manner'" (Moynihan 233). Most rural dwellers, however, disagreed with de Valera. They associated the thatched dwelling with centuries of poverty and oppression, and desired more comfortable homes with running water and proper sanitary facilities. They cast blind eyes on de Valera's vision when the census of 1946 revealed that 61 percent of all dwellings in Ireland lacked running water, 62 percent had neither fixed bath nor flush lavatory, and nearly one half of all dwellings had no sanitary facilities. It is little wonder that, when offered a better standard of housing, they embraced it enthusiastically.

During the 1960s and 1970s, the Department of the Environment made available to the public basic blueprints for the building of houses. County councils throughout the country, in response to public demand, distributed grants to those wishing to convert from thatch to slate or tile roofs. Such has been the abandonment of thatched houses that this distinctive symbol of Ireland is fighting for survival. In 1975 Kevin Danaher lamented: "Modern houses, most of them far removed in type and appearance from traditional forms, are rapidly replacing the old; already wide stretches of countryside retain no one single example of a rural dwelling. The replacement of old-style farm buildings is even more rapid and more thorough, while workshops and mills from the pre-industrialised age are rare indeed. Even the handsome farm gateways, not wide enough for trucks, tractors and modern farm machinery, are being destroyed in large numbers" (*Ireland's Vernacular Architecture* 14).

In 1987, the minister for the environment responded with a bald and unequivocal "No," when asked in Parliament whether he would introduce a special grant for thatching, to acknowledge the importance of maintaining this fast-disappearing part of the national heritage (*Parliamentary Debates*). At that time, some councils were willing to place preservation orders on thatched dwellings, thus prohibiting their owners from replacing the thatch with slate, but refused to assist with the cost of rethatching. The government had a change of heart and grant dispersal has improved considerably; some local corporations and county councils are fostering the rethatching of certain approved dwellings.

A systematic survey conducted by the Office of Public Works since 1986 shows that in counties Dublin, Kildare, Wexford, and Wicklow and in the Aran Islands, many thatches have been removed. Probably slightly

more than one thousand remain in the entire Republic of Ireland (Higgin-botham). When John Millington Synge visited the Aran Islands, between 1898 and 1902, nearly every house had a thatched roof; in 1989 only forty-seven remained. In Wicklow, where there were, no doubt, hundreds of thatched cottages in 1793, when Roberts painted his watercolor, only fifteen are documented today. The image of Ireland as promoted on post-cards and, for example, on the dust jacket of the 1992 *Reader's Digest Illustrated Guide to Ireland*, bears little or no relationship to the reality. Photographers are often as careful not to offend their markets as were late eighteenth-century landscape painters. Lurking beside many a thatched cottage, but out of sight on most postcards, is modern housing, a motor-way, or an incongruous and unsympathetic corrugated-iron hay barn. (Kiang).

Some thatched houses, however, still reside amid beautiful scenery. Courses were introduced during the 1980s to train thatchers who have since been employed on a number of high-profile tourist projects. But, in light of the lack of financial incentives and good straw, and the inability of thatch-house owners to obtain adequate insurance at reasonable cost, the future of a precious aspect of Ireland's heritage remains bleak. As Bairbre Ó Floinn has put it, "If the big house can be seen to represent the 'great-men-and-great-events' of history, the small house can certainly be seen to repre-sent the mass of the people and tell their story" (147). The progressive disappearance of Ireland's vernacular architecture is a pressing and vital cultural issue. It is to be hoped that the government's support for thatch and thatching in recent years signals its rescue. As lovely as are Roberts's and Campbell's watercolors, and Henry's and MacGonigal's oil paintings, having to refer to them to recall that thatched houses once dotted the Irish countryside would be a shame indeed. Perhaps a return to the early nine-teenth-century aesthetic will save the thatch from extinction. In the man-ner of the Earls of Glengall in their cottage *orné* at Cahir, wealthy town dwellers may yet decide to reclaim the rustic delights of country weekends in a thatched house. Such decisions contributed to the preservation of thatched dwellings in England. Ireland may yet follow the trend.

WORKS CITED

Barrell, John. *The Birth of Pandora and the Division of Knowledge.* London: Macmillan, 1992.

Bermingham, Ann. *Landscape and Ideology: The English Rustic Tradition 1740–1860*. London: Thames and Hudson, 1987.

Bourke, Marie. *The Aran Fisherman's Drowned Child*. Exhibition Catalog. Dublin: National Touring Exhibition Service, 1987.

Campbell, Åke. "Notes on the Irish House." *Folkliv* 1 (1937): 207–34; 2 (1938): 173–96.

Cullen, Louis. *The Formation of the Irish Economy*. Cork: Mercier Press, 1969.

Daly, Mary E. *Social and Economic History of Ireland since 1800*. Dublin:The Educational Company of Ireland, 1981.

Danaher, Kevin (Caoimhín Ó Danachair). *Ireland's Vernacular Architecture*. Cork: Mercier Press, 1975 (republished as *Ireland's Traditional Houses*, with an introduction by Bairbre Ó Floinn, Dublin, 1991).

———. "The Questionnaire System." *Béaloideas* XV (1945).

———. "Traditional Forms of the Dwelling House in Ireland." *The Journal of the Royal Society of Antiquaries of Ireland* 102 (1972): 77–96.

Dennison, Gabriel and Ó Floinn, Bairbre. *A Lost Cause? A Review of Thatch and Thatching in Ireland with Proposals for the 1990s*. Prepared by *Ceann Tuí* for the National Heritage Council. Sept. 1990.

Gailey, Alan. *Rural Houses of the North of Ireland*. Edinburgh: John Donald Publishers, 1984.

Gibbons, Luke. "Romanticism in Ruins: Developments in Recent Irish Cinema." *The Irish Review*, 2 (1987): 59–63.

Gilpin, William. *Observations Relative Chiefly to Picturesque Beauty, Made in the Year 1772. On Several Parts of England; Particularly the Mountains and Lakes of Cumberland and Westmoreland* (1789). 3rd Edn., 2 vols. London, 1792.

Hemingway, Andrew. *Landscape Imagery & Urban Culture in Early Nineteenth-Century Britain*. Cambridge, England: Cambridge University Press, 1992.

Higginbotham, Michael. *Reports on Thatched Dwellings in Ireland: Dublin, Kildare, Wexford, Wicklow and the Aran Islands*. Dublin: Office of Public Works, 1987–1990.

Hutchinson, John. "Intrusions and Representations: The Landscape of Wicklow." *The GPA Irish Arts Review Yearbook 1989–90*. 91–99.

Kennedy, Brian P. "The Failure of the Cultural Republic: Ireland 1922–39." *Studies*, 81:321 (Spring 1992): 14–22.

Kiang, Tanya. "Irish Postcards and Mood Photography." *CIRCA*, 43 (Dec.–Jan. 1989).

Knight, Richard Payne. *The Landscape, a Didactic Poem in Three Books*. (1794) London, 1795.

Malton, James. *Essay on British Cottage Architecture*. London, 1798.

Moynihan, Maurice, ed. *Speeches and Statements by Eamon de Valera*. Dublin: Gill and Macmillan, 1980.

National Gallery of Ireland. *Illustrated Summary Catalogue of Drawings, Watercolours and Miniatures*. Dublin: National Gallery of Ireland, 1983.

Ó Floinn, Bairbre. "A Future for Irish Vernacular Architecture." *Archaeology Ireland* 3:4 (Winter 1989): 147–51.

O'Reilly, Barry. "The Demise of the Thatch." *Living Heritage* 7:1 (May 1990): 4–5.

Ó Súilleabháin, Seán. *Irish Folk Custom and Belief*. Cork: Mercier Press, 1967.

O'Toole, Fintan. "Going West: The Country versus the City in Irish Writing." *The Crane Bag* 9:2 (1985): 111–16.

Parliamentary Debates of Dáil Eireann. 28 April 1987, col. 62. Dublin: The Government Stationery Office, 1922–.

Price, Uvedale. *Essay on the Picturesque.* London, 1794.

Repton, Humphrey. *Sketches and Hints on Landscape Gardening.* London, 1795.

Sheehy, Jeanne. *The Rediscovery of Ireland's Past: the Celtic Revival 1830–1930.* London: Thames and Hudson, 1980.

Usherwood, Paul. "Lady Butler's Irish Pictures." *Irish Arts Review* 4:4 (Winter 1987): 47–49.

The Portrait Artist
As a Young Man:
Letters of Bernard Mulrenin, 1825–34

Alf MacLochlainn

ERNARD MULRENIN, R.H.A., was an artist who enjoyed a considerable reputation among his contemporaries but one whose fame has not lasted well, perhaps because few of the four hundred pictures he is known to have executed survive in public collections. [There are notices of Mulrenin in, among other works, Walter George Strickland's *Dictionary of Irish Artists* (Dublin, 1913, repr. Shannon, 1969) and John C. McTernan's *Here's to Their Memory: Profiles of Distinguished Sligonians of Bygone Days* (Dublin and Cork, 1977) and Ann Stewart and Catherine de Courcy's *Royal Hibernian Academy of Arts: Index of Exhibitors and Their Works 1826–1979, v. 1–3* (Dublin, 1985–87) lists the works he exhibited at the academy 1826–1868 *in extenso*. A debt to all of these works is acknowledged]

There is a small file of Mulrenin letters in the papers of Maurice Lenihan, 1811–95, best known as the author of the standard history of Limerick, in the Burns Library, Boston College. These letters could hardly have reached Lenihan through any personal connection; most of them were written while Lenihan was still a schoolboy in Carlow College and when Mulrenin died in 1868, Lenihan, then editor of the *Limerick Reporter and Tipperary Vindicator*, gave no personal note of the event in his newspaper but merely reprinted the obituary published in the *Dublin Evening Post*. But Lenihan, a diligent historian, was something of a magpie collector and

there is no doubt, from the physical evidence of giving-in and tearing-out of items in his collection in its painful journey to the public repositories, that the Mulrenin documents are a piece with the rest of the Lenihan papers.

The file consists of twenty-five letters of Mulrenin to Mary Quill, his fiancée, later his wife, between 1825 and 1834, and three associated letters, the whole running to some 16,000 words. Ellipsis in the extracts below is indicated by the traditional . . . and full transcripts of the letters have been deposited in the library of the National Gallery of Ireland. Many of the letters are crossed—happily, in some cases, in ink of a hue different from that of the text—and there is some damage caused by unsealing, and despite the artist's fine hand there remain a few difficult readings. Mulrenin's letters are all signed, rather formally, "B. Mulrenin."

The letters were written, obviously, only on occasions when the couple were not together—during their courtship in 1825, when he was on a visit home to Sligo in 1826, on business trips to London in 1830 and 1834, and when his wife was on holiday trips, with family friends, the Barklies, in Coola, Kilbeggan, County Westmeath, in 1832, and in Cork in 1834. (Bernard's visit to London in 1834 coincided in part with his wife's visit to Cork and Cove.) In 1826 and 1830, the couple's address in Dublin was 10 Lower Sackville Street; it was 40 Lower Sackville Street in 1832, and 29 Dame Street in 1834.

As Mulrenin, during the years in which these letters were written, was at the beginning of his career, we can safely yield to the temptation to entitle our essay "the portrait artist as a young man." For although Mulrenin painted other subjects, his principal activity was overwhelmingly portraiture, in particular the production of miniatures (plate 39).

Miniatures, it may be helpful to remind ourselves, were not called miniatures because of their small size but because they were painted with materials that included *minimum*, a red pigment used by earlier graphic artists, the illuminators of manuscripts. They were small, therefore, perhaps because they continued to be like ornaments on a book page. They were normally painted on panels of ivory, an expensive commodity and perhaps another reason for the small size of these works. A synthetic form of ivory was developed in the nineteenth century.

Strickland, in the standard work, gives us brief biographies and lists of known works for about a thousand artists, and of these, about one hundred are described as miniaturists or workers whose products included miniatures. The artists listed date back to the early eighteenth century, to a time

39. Bernard Mulrenin (1803–68), *John Hogan,* oil on canvas, 24 × 19 cm, National Gallery
of Ireland no. 2197. (Courtesy of the National Gallery of Ireland)

when the distinction between artists and craftspersons was by no means as clear as it might later appear. The person who would paint a coat of arms on your carriage door might also offer to paint likenesses of your family or an ornate screen for your shop or a backdrop for your theater. Because miniatures were small they were often designed to be worn as lockets or keepsakes and many of the miniaturists were members of the families of jewelers or silver- and goldsmiths, or worked for jewelers. If we distribute Strickland's one hundred miniaturists through the various decades in which they flourished, we can conclude that Mulrenin had about thirty possible competitors in the early years of his career.

Bernard Mulrenin was born in 1803, when the popularity of the miniature was just about to pass its peak. He was born in Sligo and his artistic aptitude was early recognized by the local gentry, probably the Coopers of Markree, who owned 34,000 acres in the country. There was no prize for identifying one major reason for the decline of the miniaturists—the decades of that accelerating decline, the 1830s and following, were the decades of the emergence of photography, a new device for satisfying the public's urge to possess likenesses of loved ones.

That the market depended on the urge to possess known likenesses rather than an urge to possess works of art seems clear from the record, certainly in the Mulrenin letters. Thus Margaret Madden of Kilkenny wrote to Mrs. Mulrenin in 1834: "I am sure Mr. Mulrenin will be glad to hear that we have sent off the box containing the pictures for Charles long since and trust it is very near Calcutta now. I am sure he will be delighted with them. We showed them to nearly half this county and the generality of people were much delighted with them, particularly my two sisters and Mama who were thought to be capital likenesses."

Soldiers going abroad were an important market, so much so that Strickland records one miniaturist, Buck of Cork, as maintaining a stock of outlines of military head-and-shoulders portraits requiring only rapid addition of facial features and appropriate epaulettes or other markings to satisfy the young men off to the Peninsular War, or the loved ones left behind with whom they wished to leave a fond reminder. On July 3, 1834, Mulrenin wrote: "The only source of uneasiness I have is that one or two of the pictures in the exhibition are wanting badly. Captain Gordon is daily expecting the rout for Gibraltar and of course he wishes to get his portrait."

Writing to his wife from Sligo he made a lame excuse for going to dinner in the officers' mess there—not that he enjoyed it, naturally, how could

he, so far from home and his new bride, but after all, he had to keep in touch with his market. His letter of July 15, 1826, reads in part: "I have a likeness nearly done of a Lieutenant Byrne and I hope to get three guineas next week." And a couple of days later, in response to an apparently depressed letter from Mary, he wrote: "Little does it avail the reception I have met in Sligo, little does it avail the company I have spent this very evening with, being invited by Lieutenant Byrne with all the officers to whom he gave a dinner this evening. Yes but while they were all enjoying the pleasures of a sumptuous dinner and agreeable society I am brooding over the contents of the letter I have received. Oh Mary Mary what is it you mean, do you think I am spending my time in dissipation or profligacy. I have this very day sat for nine hours at a likeness which I hope to finish tomorrow. "

And in the same letter, in more business like fashion, he conveyed instructions: "With respect to the likeness of Mr. Gibson and Captain Bustan you ought to give Captain B. his own if he calls for it and tell the other that if he should leave town I will finish it and send it to him." These letters were written from Sligo, whither Mulrenin went shortly after his marriage to visit his ailing father, but he kept his eye on business. There was a possibility of work in other big houses besides Markree. A postscript to the July 15 letter reads: "Gernon has been speaking of me at Hazlewood and they sent in for some of my pictures and to know my terms. I do not yet know the result." The Wynnes of Hazlewood owned only 13,000 acres. We may tentatively conclude, by the way, that the Coopers of Markree were Mulrenin's early patrons, because he did exhibit portraits of the Coopers and there is one letter, in some respects a strange one, from his brother Thomas, which refers to the Coopers as his land-lords and indicates they still thought well of Bernard. "My dear Bernard," Thomas writes from Coolaney, March 18, 1837: "I came this day and Mr. Cogan came with me and introduced me to Mr. Lawler who is now receiving the Marcrea rent. . . . Mr. Lawler asked me was I your brother and said he received a proposal from you a few days ago. . . . Mr. Cogan recommended me to propose for No. 5." The strangeness of this letter lies in the fact that Thomas is quite clearly less literate than his sophisticated if pompous artist brother in Dublin. Thomas's letter shows some hesitation about spelling and the lack of a practiced hand; Bernard, by contrast, is always accurate and beautifully neat. Thomas's letter, like so many of Bernard's, makes reference to Mary Mulrenin's health. "I hope by this time Mrs. Mulrenin is recovered from her late illness."

Mulrenin's wife was Mary, nee Quill, also born or at least reared in Sligo, where she had many friends on whom Bernard duly reported on the occasion of his visit there. What little we know of her comes mainly from quotation of her letters in Bernard's replies and his solicitous remarks to her, and it appears that she was either a chronic complainer or a genuine victim of chronic ill health. One might be tempted to think of her as a typical Victorian fainting heroine, but we must remind ourselves that the reign of Victoria was not to begin for some years. Indeed, Bernard was in London in 1830 when William IV succeeded to the British throne on the death of George IV.

Mulrenin was described in his obituary as one of the leading lights of the emerging native Irish intelligentsia; though those involved would not have used that term, we can be sure he would have been flattered and gratified by the description. Hence his response to the royal death and succession is of some interest. On June 26, 1830, the day of the king's death, he began his letter to Mary with a description of the previous day:

> I then came to my lodgings anxious to prepare for visiting Somerset House in the morning as the anticipated death of the king might shortly cause it to be closed. [Somerset House was the seat of the Royal Academy of the Arts, given to that body by the king.] I went about ten o'clock and was scarcely there five minutes when the intelligence of his death arrived. The doors were immediately closed but fortunately for me those already within were allowed to remain.

And later, on July 8, he wrote:

> The Royal funeral takes place next Thursday and of course the exhibition will open immediately after. I must stay till then. . . . You mentioned something about mourning. For God's sake give yourself very little trouble about it, not more than one third of the people here have anything like mourning and even then a bit of ribbon, or crape or muslin or some trifle of that kind for the ladies, and the gentlemen, some only, a black cravat, almost two inches of crape or blue gloves with black seam in the back of them.

We may find it odd that anyone not directly involved in public life, especially an Irish person, should have taken the royal mourning so seriously, and this for a monarch who had been hissed and booed through the streets of his own capital, whose broken marriage to a Protestant princess, unlawful marriage to a Catholic widow, and numerous affairs had made his name a byword for the dissolute life, while his successor, just proclaimed, had had to break off a twenty-year affair with Mrs. Jordan, a com-

moner, on becoming heir apparent. Nevertheless, Mary Mulrenin, in a relatively obscure level of society, in Dublin, relatively far removed from the capital city of the empire, felt compelled to adopt some public mourning dress. It was no wonder that some Irish intellectuals, even unionists such as Samuel Ferguson felt that the separateness of Ireland was being extinguished in the name of legislative union with Great Britain and began to cultivate a native culture.

Mulrenin's reverential allusion to a distant prospect of Windsor Castle, which we quote below, leaves no doubt of his loyalty to the monarch. He was duly impressed by the demonstration of a similar loyalty on the part of the British populace, even if they were neglectful of mourning. "My dearest Mary," he wrote (June 28, 1830), with the keen eye of a scenarist:

> Nothing that you can conceive of mobs and crowds and pageants can at all come near the sights to be seen here today, it being the day appointed for proclaiming William the Fourth. I went early in the morning to the Countess of Cork with Lord Dungarvan's letter and to show her the pictures. She liked them very well but said she was satisfied with those she already had which were made by me. She gave me two little miniatures of her daughters which I copied already for Lord Dungarvan (it seems he requested it in his letter). She asked for my address and said that should she hear anything suitable for me in the way of business she would let me know. I immediately returned and in my whole life I never met with such a difficult journey. The whole of the principal streets for miles were one moving mass of people. All the windows, balconies and even the top of the houses were literally covered with "dandies and dandizets," carriages in thousands and "chays" and "cabs" in tens of thousands. I passed on as well as I could until I came near Temple Bar which is just near my hotel and there it became quite impossible to move. I was in danger of being squeezed to death so instead of attempting to reach home by that way I returned a little and endeavoured to go round by the Temple, the ceremony having been gone through at Temple Bar which is the entrance to the city. The procession moved on, Fleet St., under my window—nothing I ever saw could equal the grandness of the spectacle. The Corporation Show of Dublin is like a puppet show compared to Covent Garden when compared to the splendour of the equipage that appeared on this occasion. The different officers of court wore the most superb trappings and all the different orders and officers in their respective decorations formed a picturesque variety.
>
> Having rested a while after my morning excursion I set out again towards Soho Square and Gerard St. in order to get some colours and call on Mr. Robertson. The distance is immense between the different parts of

the city and yet I am making out my way much better than I thought I could. Soho Sq. is a beautiful little place, all filled with carriages calling at the different shops. I found Mr. Robertson at home. He was rather civil for a Scotchman and "one" of "two of a trade," but I promised to call again. I had the good luck to see him at work and saw many of the pictures which he exhibited at Dublin. . . . Tuesday [i.e., the following day] Got up early this morning in order to be among the first at Somerset house. . . . Went to the exhibition and spent about three hours there. Met Mr. Cuming our President in the rooms. Came to my hotel and commenced copying the little miniatures contracted for Lord Dungarvan. . . . Take care you do not neglect my injunction . . . of taking plenty of exercise and to eat roast mutton and peas. This day week I left home and I never felt so long a week in my life. I propose going tomorrow to see the exhibition of Sir T. Laurence's pictures. . . . [crossed] . . . I must tell you that I sometimes find it impossible to understand some of the people here. The lower orders have more of that peculiarity than the gentry. They can discover in a moment that I am not a Londoner or indeed an Englishman and what do you think, I passed as a Frenchman yesterday evening and was getting on very well until a fellow who spoke French came by and one of the fellows who were puzzled before called him and said to me in English that he was a Frenchman. . . . Well what do you think, I really came off with flying colours for I had the few questions that occurred on my fingers end so I politely bade the Frenchman good evening. . . . The fact is I don't like to let some of them know that I am Irish since I find they try to impose on them . . .

A rough computation suggests that less than half of the matter in Mulrenin's letters refers to topics of public interest, even generously interpreted. The commonplaces of communication between a young husband and wife often remain as impenetrable as the conversations to which a crossed telephone line sometimes gives one unwanted access—chitchat about relatives, friends and neighbors, prices, accommodation, rent, and landlords. For example, he wrote from Sligo, in 1826, that is, while visiting his ailing father: "I would be happy you would send the shawl we were speaking of for my mother. The very cheapest you can get will be quite sufficient. I suppose a dark drab or so would answer." Indeed, reading the courtship letters of 1825 might give even a hardened manuscript librarian the feeling of guilt at intrusion on private matters were it not for the excessively romantic formality of their tone, accompanied as they are by some excruciatingly bad verse. "My dear Mary," one of them begins:

> For I cannot *yet* change *my* mode of addressing *you* as my heart and feelings are always the *same* and must continue so though I should lose every conso-

latory expectation of happiness—in the name of *all* that is just! what is this
I see from your pen or can I believe my senses? You learn it appears that
"those who are interested in my welfare think and say that I would act fool-
ishly to marry for some years." . . . Now believe me among my many failings
I could never reckon that of *avarice* while God gives me a competency I am
content I am convinced that I could though blessed with a wife live com-
fortably and that is all I ask at present. . . . I was just going to conclude this
tedious epistle and in opening a private drawer of my desk, to get a seal—
what should I meet but this hapless ring. . . . I have resolved to send it to
you and I'll tell you why—I send it because it was intended for you in the
first place, and no other shall ever see it. . . . I send it hoping you will be
charitable enough to fling it in the fire . . . then fling it where you will do
not by *any* means send it back as the result might be—that my distraction
would cause me to do what I might hereafter be sorry for.

The foregoing is extracted from a letter which runs in all to some 1,100
words—the reader has elsewhere been spared the underlining emphasis
freely used by Mulrenin throughout his correspondence. Bernard and
Mary were married in late 1825 or early 1826—in July 1826 he acknowl-
edges "the first letter I received of yours since you became my wife."

Much of what was for Mulrenin merely the dutiful reporting of items of
interest to his wife has become for us tesserae in a mosaic of social history.
For example, an attitude to the dread cholera is revealed in his remark (July
31, 1832): "Don't mind asking about the cholera. 'Tis not worse here than
when you went. As to Athlone—15 miles. Why when it was within 15
yards of us I may say we were scarcely alarmed." And a couple of weeks
later (August 15), presumably in response to some further remark by Mary
on the subject of cholera, he added a postscript: "Just as I was going to send
this letter who could you think walks in. Do you recollect Miss Benison
from Sligo now Mrs. Quill, married to your dandy namesake the school-
master. They tell me the cholera is in Sligo at last, Bolton the printer,
Anderson the doctor and some others have died. The cholera is decreasing
in Dublin during the last week."

The food and drink of foreign parts remain to this day a standard ingre-
dient of the letter home and Bernard deemed them worth a note for Mary.
Thus (June 26, 1830, from London): "I went in search of one of those 'eat-
ing houses' I heard so much about and after some hunting pounced upon a
place called the 'Rainbow.' Having asked for some fish I was informed that
there was only lobster and pickled salmon. I chose the lobster which was
very good and a glass of common ale, being afraid of the 'brown stout.'"

And on June 30: "About 6 o'clock I found my way into another 'eating house' for you see that even fine pictures cannot entirely support one and got a better and also a cheaper dinner than yesterday, drinks and all 1s.6d. . . . But few drunken persons to be seen. There is however an odd straggling odour of Bacchus to be found even here."

There is some evidence that Mulrenin later fell victim to the feared brown stout or to the odor of Bacchus, for on July 5, 1834, he continued a brief note recording his arrival in London on a Friday morning:

> Friday [*recte* Saturday] After all my fatigue I was prevailed upon by Mr. Wood and his brother who lives here to go see Matthews last [night]. I was much amused and got home early this morning. I went to find Mr. Symes, was not at home, met some of the Dublin artists, there is a great lot of them here. I have seen nothing but Somerset House exhibition yet. I intend going to see another exhibition after I post this letter in the post office. I hope to procure a frank for my next letter but fearing a longer delay would [make] my darling Mary uneasy I send this direct. The weather is oppressively hot. I can scarcely hold the pen to write. . . . The stone has not come yet. It comes by long sea. . . . When oh when shall I have a letter from you? How are you getting on? The 24 hours since I entered London I think so many days. Does it still rain in Cork? Do you be out 12 hours every day? Do you eat a good dinner? Do you sleep well? Do you laugh much and enjoy every fun? If you do not answer these questions in the affirmative I'll scold you. How is my faithful Ann? Oh the poor thing, 'tis now I have a fellow-feeling for her. 'Tis now I know what it is to be in an oven for baked I am as well as a Bath bun. I hope Mrs. and Miss Hayes get on well, I wish I could fly to Cork to make you all laugh and tell you about the London modes of living.

The short sentences, the conversational touch or unaccustomed levity, the oppressive heat (one knows the feeling), and the five lapses in one short passage from a writer usually so meticulous, all suggest that he was, as the modern euphemism has it, tired and emotional.

On June 24, 1830, he described his first voyage across the Irish Sea, from Dublin to Bristol by steamer, opening with another scenario, as of a sentimental genre work:

> Having left home in an anxious state of mind as you may recollect I went on board in rather a sentimental mood. The first object that caught my attention as we were putting off from the quay was a rather young widow with three young children in deep mourning. We were waving hats and hands to our friends on shore. She was also moving her little white hand towards the

shore but upon glancing my eyes on her at the moment I perceived that her soft blue eyes were turned towards heaven and that she was evidently taking a farewell perhaps a last of the land of her birth. . . . I staid on deck (most manfully as I thought) and felt no change until the vessel sailed as far as the lighthouse. I was beginning to think I should not be sick at all when just as she cleared the lighthouse they laid on the full power of the steam. She gave a sudden lurch and in an instant I was nearing falling on the deck. Down I went and there I lay tossing on a sofa (for I did not take a berth) untill 11 o'clock next day. Then when I thought we should be at Bristol we were only entering the channel between Wales and Devonshire. So to our great mortification the captain informed us that the wind and the tide having been against us all night we should lie at anchor at the mouth of the river untill evening tide at about 8 o'clock. We entered the Avon and sailed up amidst the most delightful scenery. I now began to enjoy a little having partly recovered while the vessel lay at anchor. Nothing that I ever saw could exceed the beauty of the scenery on each side of the river. Groups of children playing, young men and women walking along or looking at the numberless vessels as they sailed up and down. But such content, such happiness as their look displayed, such cleanliness and comfort in their dress, not one bare-headed or bare-footed urchin to be seen, that the contrast with my native land became unavoidable and whilst leaning over the vessel's side unobserved by anyone a silent tear stole down my cheek. This was the first effect the sight of English soil had on me. However after enjoying the most charming prospects for an hour in passing Clifden, celebrated for its hot wells, we landed near Bristol. Here we were beset by a mob of car-boys or as they call them "flys" and to do them justice a more savage set I never beheld. I had literally to fight my way through them and they nearly tore my luggage from my grasp. At length I got into a "fly" and off to Bristol. Arrived at the Tavern but the coaches for the night all gone. Well there I stayed, engaged a seat for the morning, went to bed, tossed about till 5 o'clock in the morning but no sleep, got up, walked about the streets till seven. Coach starts and off for Bath, arrived there at 9, no breakfast, off again and at the rate of 10 miles an hour till 3 o'clock when they stop to dine. But so short was the time and so badly was I prepared that the dinner was very slender. We drove on through the most delightful country, passing several very pretty country towns, through Windsor and here I was within 200 yards of his majesty and saw Windsor Castle most distinctly. Passed through Kensington and at last into smoaky dirty London. The moment I got into my hotel and desired to be shown to a bedroom I began to write this letter. My pretty "chambermaid" up to my heels with "what you please to want sir? Shall you have anythink haired," etc. "'hAny refreshments tea or coffee or anythink in the meat way." I ordered tea and went to bed where

I am just writing this now. . . . Friday 25th. After writing my letter I found it could not be sent off until this evening. . . . Went to the Palace to see the bulletin which was shown by Lords in Waiting as we passed through a grand suite of apartments. 10 o'clock went to the exhibition of water-colour painting having learnt that it closes tomorrow. Met some Dublin artists there. 2 o'clock wrote a letter of application to Lord F. Levison Gower to gain admission to the Stafford Gallery. Despatched some of my commissions by the 2 penny post. . . . P.S. Of course I shall expect a letter by the next post. . . . Address Peel's Coffee House, 177 Fleet St., London.

There is further reference to steamer travel later, when Bernard (July 28, 1834) advised Mary, in Cork: "The *Innisfail* is the best mode of coming. You need not fear any accident. I was not in the least sick coming over but we had a dreadful breakdown with the coach near Liverpool in England. Two of the horses killed under us and the third maimed."

Coaching in Ireland, too, had its dangers, at least to a sensitive subject such as Mary. Bernard bitterly regretted his carelessness about her traveling garb. To her, in Kilbeggan (August 5, 1832), he wrote: "I have just now received your letter and being already agitated with impatience to hear of your safe arrival at Coola you cannot think how I was shocked to find you had forgotten to put on so important a part of your dress on such a journey and on such a day. God send it may not be followed by any disagreeable consequences. I blame myself entirely for not having assured myself that you were prepared as you ought to be. You must unquestionably have got cold. . . . I hope Jane [Barklie] (also an invalid) has got over the journey safely." What was the garment omitted? Ten days later Bernard advised on Mary's arrangements for the return to Dublin, giving further particulars of travel facilities available:

Your anxiety to return home is I fear preventing you from enjoying the advantages which we hoped your health would derive from being in the country. From your last letter I almost inferred that it would be better you should come home but then remain in the state you are in and indeed (except that I suppose it must be taken as a jest) I cannot understand your saying that "I don't care for you and that I am glad to have you out of the way." Now this is too bad. Heaven can witness how anxious I am to see my dearest Mary. . . . You must of course come in a day coach inside. I have but last night got the habit and am going to send for the bonnet and a box to contain both. I your former letter you desire [me] to send them to "Tullanmore c/o Mr. Belton" but you did not say by the "boat" until your last letter. So were it not for that I should have sent them by the coach which by

the way is by far the better way for such light articles may be damaged in going by the boat.

The "boat" in question is a canal boat plying on the Grand Canal between Dublin and the Shannon; Tullamore, County Offaly, was one of the major towns on the line, with a handsome canal harbor and hotel. As there was a branch line to Kilbeggan, leaving the main line not far from Tullamore, it is not easy to understand the need for an agent, Mr. Belton, at that town. Bernard's letter continues: "and Dr. McKeever was just here this moment to ask how you were and is so pleased to find you are in the country where he says you must remain three months." (Bernard exhibited a portrait of Dr. McKeever in 1830.)

It is hard to escape the conclusion that Mary Mulrenin was not very interested in artistic topics, though there is one hint that she had been a model—or perhaps only a once-off subject for another artist—"Let me know," Bernard wrote (July 14, 1826), "has Mr. O'Donel left Dublin yet or have you sat for him and if you have got the frame from the gilder." And in that same letter from Sligo: "I have not yet commenced doing anything here but must on this day as I cannot refuse doing Mrs. Barklie's likeness. I wish you would call on Mrs. Stanton and ask what a set of colours and brushes for poonah painting would cost and if you get some small lithographic views of landscapes cheap at some of the shops I would be glad you would send three or four to the little Barklies as I could bring nothing to them."

His references to his work were usually to convey instructions, to explain how he was occupied, or to describe to her some item of more general interest, for example his visit to Westminster Abbey. On July 12, 1830, he wrote:

I went on Friday last to see Westminster Abbey and who could you guess were my companions there through its almost numberless aisles and chapels. The Daniel O'Connell and all his family. They happened to come in while I was there and I went round the whole place again with them. 'Tis altogether the greatest curiosity I saw since I came to London. I was astounded with admiration and awe approaching to veneration while I viewed the stupendous Gothic arches that form the roof of part of the building, the carving and the work of the different monuments where art seems to have exhausted its last effort to produce variety and richness of effect. . . . The marble statues resting on the monuments with hands joined in the attitude of prayer . . . had not escaped dilapidation. There you may see the once young and beautiful "Mary Stuart" in all but breathing marble

full of that loveliness which distinguished her. What a pity to see fingers or the nose or part of the drapery broken off these sacred relics.

Mulrenin's obituary would recall that he had claimed, shortly before his death, to be one of the few survivors who could recall the features and appearance of O'Connell from the life. And in that obituary, in 1868, there was no reference to a surviving widow nor to a predeceased wife, nor to any descendants. It seems likely therefore that poor Mary Quill from Sligo was indeed the delicate creature requiring all the tender care Bernard bestowed on her, and died long before him.

There is one point at which we detect an interest on her part in his career as well as in his devotion, for his letter of July 8, 1830, includes a passage of response to a remark of hers:

> You wish to know my opinion of Somerset House exhibition. You seem to think it may have discouraged me. By no means I assure you. It has had no other effect than to inspire me with more confidence than ever, at the same time feeling fully convinced that I have a great deal to labour for. But not at all above my reach. With God's assistance in less than one year I shall produce a picture that may not dread being placed near the proudest of them. The only cause of delay I now have is to see the exhibition of Sir T. Laurence's paintings and unfortunately the exhibition is closed until the funeral shall be over. Don't think that my time is misspent. There are many other exhibitions and private collections. I have been to see Mr. Shee and found him civil. Mr. Robertson, the Adelphi pictures. Mr. Jackson's collection, Mr. Lane and many others and Somerset House twice a week at least.

Later, while Mary was on holiday in Cork (June, 1834), he gave her useful summaries of his work in hand, including some reference to works attested in the list of his works as exhibited in the Royal Hibernian Academy:

> I am working for the "bare life" in hopes to get to London but I fear it will not be in my power. Another new job and a promise of getting to copy Robertson's beautiful miniature of the Lord Lieutenant for his private sec-retary who wishes to have it set in some fancy way. The stone arrived from Ackerman's today and I hope to begin the lithography soon. . . . Mr. Symes called—is just going to London. Hopes to see me there before the 10th July to paint the miniature of his "lady love." But can I be there? Mrs. Chesney's picture finished, Mrs. Lloyd's very nearly but Mr. Taylor's yet in hands and another commission this day. . . . Mary Barklie is here drawing and expects me home with her to dinner.

The stone was that for his lithograph of Taglioni, of whom he exhibited a sketch in the same year. And was he tutoring members of the family of their friends the Barklies? Further description of his work at this time is in his letter of June 26:

> With respect to my progress knowing that it will be interesting to you I shall endeavour to give you a short account of my employments. My chief anxiety for the present is occasioned by this lithography which I have undertaken of Taglioni for Ackerman of London. The stone came but I find some difficulty in getting the drawing out of the Academy even for an hour or two in the morning. I am up every morning at five working hard till half past nine striving to have it done in time. I have not yet been able to ascertain when the exhibition of Somerset House closes as that must determine about my going to London. For should it close too soon even tho' Mr. Symes business is to be done I don't think I should go at all to London. It would certainly be advantageous to be on the spot to see Halmandel myself respecting the printing of the drawing. But Mr. Symes leaves it on the 10th. and the exhibition closes at the farthest on the 9th. so you may judge of my anxiety and endeavours to finish what I have undertaken. There is Mr. Purser sitting and I am painting the Viceroy's picture but that I need not finish until my return.

On the professional side, therefore, he mentions, if sometimes apparently incidentally, such topics as his work and his materials, brushes, paints, framing, copying, his patrons, commissions, sittings, exhibitions, and other artists and their work including competitors. Thus on August 5, 1832: "Some groups of ladies, officers, etc., came this day and yesterday but have not yet put down 'de dust.' They promised to come next week. I have not heard of or from Mr. Webber or Judge Vandeleur since but no matter I shall in good time I hope." And in the same letter: "I have seen nobody since except poor Robertson who is going away. He left some portrait frames in my care as he could not conveniently carry them and what was worse had no use for them." This presumably was an expression of sympathy for an underemployed competitor. And when he had dashed home to Dublin from London in 1834, while Mary was still in Cork: "There is some English fellow has come here whilst I was away and got some of his pictures etc. left at Milliken's and trying to establish himself here so I must work hard now to pull up my lost time."

That Mulrenin was well aware that his profession was under threat from photography is clear from the interest he took in the subject. In 1859 he gave a paper before the fine arts section of the Royal Dublin Society and

the Photographic Society on a method he claimed to have devised for using photography to produce images worthy of being embellished by the artist's pencil and colors. The terms of his description of this procedure remain obscure and one would like to have seen a demonstration of what he actually did. They seem to suggest the transfer of the image-bearing emulsion from its original base to a piece of ivory or marble on which it could become the basis of something like a traditional miniature painting.

His paper as published opens with a description of a method for multiplying copies of drawings. *With reference to uncoloured photographs, were it necessary to have a considerable number of impressions from a negative—suppose a portrait—a plan might be adopted which would obviate the necessity of touching them afterwards. A highly finished drawing . . . may be based upon a good positive photograph . . . from this drawing an almost faultless negative may be obtained that would yield impressions requiring no amendment from the pencil. . . .*

The problem of color, of course, remained. *To obtain this union of pure colour and correct form advantageously, it is necessary that the accuracy of photographic outline and general effect of light and shade should be had on a durable material adapted to receive colour freely and retain it permanently. It should have a smooth and even surface, to admit the high finish so desirable in works on a small scale. Marble and ivory are found to possess these qualities in an eminent degree . . . no portion of the deposit on glass, or other materials, as positives or negatives, nor of the colouring matter in impressions from negatives, is allowed as forming any part of the painting. A preparation possessing qualities which fit it to become a component part of the colouring, is passed over the outline and general shading of the photograph to be used; its principal ingredient may be glycerine, honey, or any fluid which unites freely with watercolour, and retains a degree of moisture for some time; it is put on the reverse, which is easily effected with positives on glass; and impressions on paper may be rendered transparent, or a reversed print from the negative may be used. It is then placed on the marble or ivory, and, by a moderate pressure, is transferred in its principal effects, and ready to receive colour* (Journal of the Royal Dublin Society, II, April 1859, 229–30).

The "preparation" was presumably to be skin-colored; the putting on the "reverse," or the use of paper prints rendered transparent or reversed prints from negatives, to avoid the generation of a mirror image.

We may note that all eight subjects exhibited by Mulrenin at the Royal Hibernian Academy exhibition of 1859 were described as "painted on marble," only three of the nine he exhibited in 1860 were so described, and

none thereafter. This does not mean, of course, that these works were necessarily based on photographs, nor that other works exhibited were not silently based, in some way, on photographs. And we may feel entitled to suggest that Strickland was mistranscribing notes when he wrote that Mulrenin exhibited some small portraits on marble in 1839 and 1840, and should have written 1859 and 1860.

But one is further entitled to ask what advantage there was to such a practitioner as Mulrenin in the procedures outlined. We know that long before photography he was capable of working at a distance from his subject, from sketches made from the life, presumably. We know also that he was no stranger to the reproduction of miniatures by manual copying. When he called on the Countess of Cork in London, for example (June 28, 1830), he presented a letter of introduction from Lord Dungarvan (the grandson of the Countess's late husband, the seventh earl), as we have seen, and quickly set about preparing further copies of the miniatures she entrusted to him at Lord Dungarvan's request. (He exhibited a portrait of Lord Dungarvan in 1831.)

In *Here's to Their Memory* McTernan quotes, without indication of source or date, a Dublin newspaper advertisement by Mulrenin announcing for sale sets of photographic copies of his portraits of John O'Donovan, George Petrie, Sir Thomas Larcom, Rev. J. H. Todd, Rev. Charles Graves, J. T. Gilbert, William R. Wilde, and Eugene O'Curry. There is, in the National Library of Ireland, a bound volume, with the supplied title *The Irish archaeologists,* of original black-and-white vignette portraits on paper (some oval, all c.17.5 cm in height and c.14.5 cm in width) by Mulrenin of all of these save O'Curry, and one other, Dr. Reeves. And those present in this volume are in exactly the same order as in the advertisement quoted. It seems highly likely that these were, in fact, the originals of the photographic copies offered for sale. And Mulrenin exhibited portraits of O'Donovan, Larcom, Graves, Gilbert, and O'Curry together at the Royal Hibernian Academy in 1861, and Wilde and Petrie in other years.

Add to these portrait subjects John Hogan the sculptor, John Banim the novelist, Denis Florence MacCarthy the poet, Archbishop McHale, Daniel and Maurice O'Connell, shown several times or in several treatments, and we find that Mulrenin has given us a noble gallery of what we have chosen to call the Irish intelligentsia of his time.

Two of his works which we know to have issued in print deserve mention in this connection: a portrait of George Ensor, a political writer of advanced views on national and social questions, published by Allen of

Dame Street, and one of the Marquess of Anglesey, a lord lieutenant whose departure from Dublin in 1829 (he did enjoy a later reappointment) was marked as a day of mourning in Ireland, his views on Irish questions being so liberal. (This was printed by Hullmandel.)

Mulrenin was a minor leader of one of the factions in the split in the governance of the Royal Hibernian Academy in the 1850s, of which there is an account in Strickland *sub* Hayes, Michael Angelo.

In his later years, according to his obituary, "delicate health and advancing years made his income a precarious support." That obituary, of about a thousand words, in *Saunder's Newsletter* (March 24, 1868), is fulsome in the manner of its time in praise of his talent, while acknowledging a limitation in his treatment of subjects broader than portraiture, and recording that he "bitterly deplored the decadence in his peculiar branch of art caused by photography." He made use of it, however, "and with its aid produced a series of most interesting portraits of eminent Irishmen."

On some matters of fact the obituary is unfortunately not a reliable document. It asserts, for example, that "Very recently he illustrated the Rev. Mr. Meehan's work, 'The flight of the earls,' with several fine historic portraits, including that of the great O'Neill." The title is wrong and Mulrenin provided for the work in question only the frontispiece, a crude portrait of O'Neill. Fr. Meehan wrote in his introduction to the work in question, *The fate and fortunes of H. O'Neill, earl of Tyrone and R. O'Donel, earl of Tyrconnel; their flight from Ireland* . . . (Dublin, London, 1868): "It will be seen that the publisher has taken special care to enhance the work with portraits of some of the remarkable personages who figure in its pages. That of the great earl of Tyrone has been carefully copied by B. Mulrenin, esq., R.H.A., who justly ranks among the most eminent Irish painters of past or present times." He does not say from what original Mulrenin was copying; perhaps that original would justify features of the illustration which otherwise appear to deserve the criticisms that Strickland, very severely, applied to Mulrenin's works at large: "They are laboured in execution with excessive stippling, feeble in drawing and lacking in power and vitality." The *Irish archaeologists* series, the largest single group of Mulrenin's works to survive, does not deserve this harsh assessment. Fr. Meehan dropped the Mulrenin portrait of O'Neill from later editions of his work, but with Denis Florence MacCarthy and Sir William Wilde was among those at Murenin's funeral to the vaults of St. Andrew's, Westland Row.

At the other extreme from Strickland, siding with Fr. Meehan and the

obituarist, was John Francis Maguire, who wrote, in *The industrial move-ment in Ireland, as illustrated by the National Exhibition of 1852* (Cork, 1853): "For exquisiteness of finish, the miniatures of Mulrenin could not be surpassed, and scarcely equalled. Indeed, some may be inclined to think that effect is perilled by this over delicacy of execution. But this idea could hardly be entertained in the present instance, the result being so delightful." But it is proper to add that Maguire was the editor of the *Cork Examiner*, four times mayor of Cork, and a member of Parliament for the area and that *The industrial movement in Ireland* was in fact the handbook of a national exhibition held in Cork, to which, Maguire freely acknowl-edged, the works of three hundred artists were admitted with "no critical, exclusive, or jealous Committee of Selection . . . there were not a few which might have been agreeably dispensed with." It was after this dis-claimer that he proceeded to praise Mulrenin, and from such a personage in such a context, praise of that kind is only to be expected.

The obituarist also seems to be in error in stating that Mulrenin was originally connected with the Ordnance Survey and subsequently came to Dublin. We know that he was in Dublin in 1825, too early for an Ord-nance Survey career, and all his early correspondence is that of the self-employed artist. It is probably correct to state, as the obituary does, that he was proud to remember that Lady Morgan had been one of his earliest patrons—both Lady Morgan and Sir Charles gave him letters of introduc-tion to connections in London—but the added statement that she after-ward made mention of him in her *Salvator Rosa* as one of the most gifted of the young artists of Ireland is not supported by a consultation of that work.

There is no reason, however, to doubt the sincerity of the tributes the obituarist paid to Mulrenin's character: "Gentle and unobtrusive in man-ner and habits, he scarcely did justice to himself in living so apart from the world and public life; but his heart seemed devoted but to two objects—love of art, and love of his country."

It is perhaps unfashionable and risks the standard modern cry of "revi-sionist!" to suggest that that love of country, to a nineteenth-century Irish artist, with deep roots in his rural background and in the company of his fellow intellectuals in Dublin, did not seem inconsistent with loyalty to the British crown and the enjoyment of the patronage of British viceroys and of officers of the British army.

For assistance in the preparation of this essay my thanks are due to librarians and curators in the Burns Library (Boston College), with whose permission this edition of Mulrenin letters

in that library's custody is published; the James Hardiman Library (University College Galway); the National Gallery of Ireland; the National Library of Ireland; the O'Neill Library (Boston College); and the library of the Royal Dublin Society; and in particular to Tadhg Foley, University College Galway; Deborah Martin Kao, Department of Fine Arts, Boston College; Adrian Le Harivel, National Gallery of Ireland; Phil McCann, National Library of Ireland; and Leslie Williams, University of Cincinnati. Reponsibility for errors and interpretation is my own.

"The Irish Peasant Had All His Heart": J. M. Synge in *The Country Shop*

Adele M. Dalsimer

T HE *COUNTRY SHOP* (frontispiece and plate 40) appeared initial-
ly as a black-and-white illustration in Jack Yeats's *Life in the West of
Ireland,* a volume that depicts his impressions of life in Connemara,
Sligo, and Mayo. The engaging watercolor of the shop and its three occu-
pants is highly evocative. Amidst the meticulously detailed wares, the jowly
shopmistress, the humble peasant woman, and the disengaged countryman
make a provocative comment on rural Irish economics and society. Hob-
nailed boots, fabrics, spices, hair oil, whiskey, ropes, brooms, mirrors, a
lantern, a bridle, weighing scales, candles, and rosaries circumscribe the fig-
ures, providing the context for a conversation that seems to trouble the
peasant woman and upon which the countryman seems to eavesdrop. The
surrounding objects signify the narrative between the anxious peasant,
holding her thin purse of coins, and the middle-class proprietress, at the
picture's left center, prim and stolid on her stool, controlling the discus-
sion. Checking names and figures in her ledger, she contrasts markedly
with the sinewy, wide-eyed peasant, whose heightened color—flushed
cheeks and variegated blue and red garments—conveys intense emotion
and draws our attention. Yet she is rendered only in profile, her back
cropped by the picture's frame. Unable to see her fully, the viewer experi-
ences her submission to the shopkeeper. Although we see only half her
face, we sense the whole of her misgiving. Her coins can purchase only as
much as the shopkeeper, with her scales,[1] allows.

The muscular countryman occupies the right foreground and domi-

40. Frontispiece. Jack Butler Yeats (1871–1957), *The Country Shop*, ca. 1912, watercolor over ink on card, 26.6 × 19.5 cm, National Gallery of Ireland no. 3829. (Courtesy of the National Gallery of Ireland)

nates the picture.[2] His back turned to the women, his eyes downcast, he keeps his right ear carefully cocked to their conversation. Dressed in the wide-brimmed hat, collarless jacket, and rope-tied pants of Connemara, he seems proudly alien to the shop. The mirror, hanging from the middle rafter, reflecting elements of the outside world to which he belongs, symbolically separates the man from the women and their mercantile exchange. The largest and most heavily drawn figure, the countryman in position and size connotes the limitations of the shopkeeper's power and offers an alternative to the womens' discourse, though both seem unaware of him. Indeed, the man speaks to the viewer, not to them, and his relaxed demeanor contrasts with the peasant woman's intensity. A detached observer, he adds a second narrative to the scene.

Although *The Country Shop* first appeared in 1912, its origins lie in Yeats's tour of the Congested Districts, some seven years earlier, with J. M. Synge,[3] commissioned by the *Manchester Guardian*. In a letter to Stephen MacKenna, Synge conveys in words almost precisely what Yeats describes in picture:

> There are sides of all that western life, the groggy-patriot-publican-general-shop-man who is married to the priest's half-sister and is second cousin once-removed of the dispensary doctor, that are horrible and awful. This is the type that is running the present United Irish League anti-grazier campaign, while they're swindling the people themselves in a dozen ways and then buying out their holdings and packing whole families to America. The subject is too big to go into here, but at best it's beastly. All that side of the matter of course I left untouched in my stuff. I sometimes wish to God I hadn't a soul and then I could give myself up to putting those lads on the stage. God, wouldn't they hop! In a way it is all heartrending, in one place the people are starving but wonderfully attractive and charming, and in another place where things are going well, one has a rampant, double-chinned vulgarity I haven't seen the likes of (*The Collected Letters* 1, 116–17).[4]

Yeats's double-chinned shopkeeper is the wife of the patriot-publican, half-sister to the priest, who expresses Synge's distress over the rural economics of Connemara and Mayo.

There is, to be sure, in Synge's statement—and in Jack Yeats's drawing—a trace of that revivalist bias that saw little of value in Irish life "between the ranks of countess and colleen."[5] But nothing in the essays he published in the *Manchester Guardian* as a twelve-article series, *In the Congested Districts*, suggests that Synge was either pro-grazier or opposed to the

reform efforts of the United Irish League. The indignation he vents throughout the essays at the effects of eviction insists upon the opposite. Synge asserts that the peasants' enemies are the "provincial shopkeepers," who forged

> close links with the surrounding peasant community through trade, credit and barter arrangements, and the provision of employment. Assuming a mantle of leadership within their localities, they were "able to impose their wishes and interests upon the community in a fashion as astonishing as it is unwholesome." In particular, shopkeepers often dominated local politics. As a result of his preeminence, the shopkeeper "overruns the boards of guardians, the rural councils, the district and county councils," and "acts as secretary to the local branch of the [United Irish] league."(Jones 412)

Deeply troubled by the poverty and exploitation he found in the west of Ireland, Synge articulates his dismay at the despotic gombeen men who profess to be patriots and supporters of peasant land ownership even as they shortchange the peasants. Yeats mirrors Synge's contempt by positioning the shopkeeper's head between the rosaries that hang on the wall and the harp that decorates the whiskey jug on the shelf. Catholic and nationalist, the gombeen woman tyrranizes her compatriot, one of Synge's "starving" women.

But the enigmatic observer has no counterpart in Synge's descriptions of country shops either in the *Manchester Guardian* essays or in his letters. A successor to the heroic peasants that Yeats created for *The Aran Islands*, Synge's utopian study of rural Irish life, the countryman stands in the line of powerful portraits that appear in such illustrations as *Porter* (plate 41) and *The Hooker's Owner* (plate 42). He is not simply a typical Jack Yeats image, as Brian Kennedy suggests;[6] he is Yeats's homage to Synge's idealized vision of the Irish peasant.

Jack Yeats and John Synge traveled together to the Congested Districts of Connemara and Mayo in 1905. They would never again work from common experience, although Yeats illustrated Synge's *The Aran Islands* and *In Wicklow and West Kerry* working from text and photographs. C. P. Scott, the venerable editor of the *Manchester Guardian*, had asked each to record the human and agricultural devastation of Connemara and Mayo, which had been assaulted by famine for the fourth time in fifteen years. The newspaper had intervened on behalf of this region once before. In 1897, during a severe crisis, it had initiated the highly successful Manches-

PORTER

41. Jack Butler Yeats (1871–1957), *Porter*, 1907, after Synge 1892

THE HOOKER'S OWNER

42. Jack Butler Yeats (1871–1957), *The Hooker's Owner*, 1907, after Synge 1892

ter Relief Fund,[7] a private charitable drive, to help the Congested Districts Board eliminate starvation.

The Board had tried, since 1891, to avert tragedy by facilitating the enlargement of land holdings, moving residents to more arable land, improving native industries, and promoting any potentially beneficial activity. It provided jobs in public works and distributed Indian meal and seed potatoes. These efforts failed to forestall hunger, however, and were supplemented by funds, supplies, and other commercial assistance from such private charitable committees as the Irish Distress Fund, the Mansion House Fund, and Manchester Relief Fund (O'Neill 186).

The *Manchester Guardian* sent Synge and Yeats to Spiddal, County Galway, in June 1905. They ended their investigation a month later, in Swinford, East Mayo,[8] recording for the newspaper their impressions of the emergency and of the effects of prior relief measures. They covered districts[9] that still required vigorous assistance, but Synge chronicled with restraint, mindful to avoid both sensationalism and sanctification. He took care to credit the gains that had resulted from the earlier charity of the *Manchester Guardian* (*Collected Works: Prose* 327).

But even before he undertook it, Synge feared that the commission would constrain his customary approach to ethnography. Although flattered at first, he confided to Stephen MacKenna his concern about the assignment:

> I am packing to go off to the west to do articles on the Irish Distress by special commission of Manchester Guardian, an interesting job, but for me a nervous one, it is so much out of my line, and in certain ways I like not lifting the rags of my mother country for to tickle the sentiments of Manchester. However terms are advantageous and the need of keeping some rags upon myself in this piantic country has also to be minded. (*Letters* 1:116)

When the work was completed, Synge wrote to MacKenna of other ways in which his commitment to the *Manchester Guardian* and its readership had constrained him:

> We had a wonderful journey, and as we had a purse to pull on we pushed to out-of-the-way corners in Mayo and Galway that were more strange and marvelous than anything I've dreamed of. Unluckily my commission was to write on the "Distress" so I couldn't do anything what I would have wished to do as an interpretation of the whole life. Besides of course we had not time in a month's trip to get to the bottom of things anywhere. (*Letters* 1:116)

Synge makes clear that in Connemara and Mayo, he reprised the exhilarating strangeness and singularity he had already encountered among the peasants of Aran and Kerry and the vagrants of Wicklow.[10] But as an investigative reporter of poverty and of possible progress in the campaign against it, he could neither celebrate what was "strange and marvelous" in the Congested Districts, as he had in his other ethnologic writings, nor satirize aspects of the life he observed there, as he had in his plays.

The essays that make up "In the Congested Districts" depart from the idealization we associate with Synge's portraits of life in the Irish countryside. In *The Aran Islands*, the islanders become a human ideal; they exist "outside of history, in some vaguely timeless space," figures of "transcendent humanism" (Knapp 59). Synge's primitivism, Maurice Bourgeois long ago suggested, "got down to the bare elemental substance of basic humanity ignorant of the world-made man and of the man-made world alike" (78). *The Aran Islands* transforms "the local into the universal; there is no sense of historical time to distract in his portrayal of peasant characters" (Partridge 214 ff).

But the *Manchester Guardian* commitment demanded something very different. Rather than portraying the society as transcendent and eternally fixed, Synge had to show that it was open to change. Thus he honored the assignment. He presents—in limited detail—life in the Congested Districts as impoverished, yet not completely without color or vitality. We can see the moderation that marks Synge's reports. Some attention to the pleasures and vigor of Gorumna intersperse the portrayals of poverty in his account of that island. Synge cites the improvements that had been made since E. Keogh, secretary of the Manchester Relief Fund, launched his earlier appeal, suggesting that further progress will follow:

> [The] road to the lower western end of Gorumna led through hilly districts that became more and more white with stone, though one saw here and there a few brown masses of bog or an oblong lake with many islands and rocks. In most places, if one looked round the hills a little distance from the road, one could see the yellow and white gables of cottages scattered everywhere through this waste of rock; and on the ridge of every hill one could see the red dresses of women who were gathering turf or looking for their sheep or calves. Near the villages where we stopped things are somewhat better, and a few fields of grass and potatoes were to be seen, and a certain number of small cattle grazing among the rocks. Here also one is close to the sea, and fishing and kelp-making are again possible. (*Prose* 298–99)

Contrast this with Keogh's description of the region during the distress of 1898 in the vehemently nationalist *New Ireland Review*:

> Approaching the island from the direction of Carraroe boatslip, the visitor is struck with the appalling desolation of the scene. From the water's edge, across the whole island, the space seems occupied by bare rocks, those on the shore being washed white by the action of the sea. . . . A perfect maze of granite walls, bounding the holdings of their innumerable subdivisions, hides out all view of vegetation or of land. There are no trees or shrubs on Gorumna, and were it not for the almost numberless cabins that dot the face of the island, one could hardly believe the place inhabited, it appears so utterly uninhabitable. . . . Poverty there is on all sides, for poverty here is indigenous to the soil, or, to be more correct, the rocks, for there is no soil. (193)

Keogh describes the chronic destitution that engulfs Gorumna. "[H]ouses . . . food . . . clothing, all things which go to make up what we call the necessaries of life are—where they exist at all—of the poorest and meanest" (194). The people exist in "a condition that at present appears little superior to that of the brute creation which shares their daily existence" (200).

Keogh is tough and direct. He has no reason to soft-pedal his description of the despair on Gorumna. By comparison, Synge is guarded and restrained, by his own admission, silent about all that he found magical in the stricken areas. The people are neither unworthy of further help nor examples of redemptive wholeness.

The articles for the *Manchester Guardian* show Synge to be a realistic social investigator, aware of the public and political dimensions of his task (Thornton 30). His reports in "In the Congested Districts" focus largely on the inhospitality of the landscape, the various relief measures in progress and their impact on communal life. Synge suggests further remedies that might be undertaken, such as the supplying of good manure and new seed potatoes, the extension of land purchases, and the improvement of communications, either by railroad or sea lanes. Having observed none of their purported sloth and ignorance, he argues that the peasants would use such supplies and services to good advantage even amid the unyielding granite of Connemara and the bogs of Mayo. He understands their reluctance to accept drastic change, and promotes the development of indigenous forms of labor—kelp making, boat building, fishing—and peasant ownership of the land. Such schemes as the forestation at Carna, however, are doomed, he insists, because of the peasants' "valuable prudence" in the face of advice from experts "who know nothing of the peculiar conditions of their native

place" (*Prose* 340). The countryfolk will accept the sensible while rejecting the inefficient or irrelevant. What is imaginative and rich, Synge pleads, the homespun clothing of gray natural wool for men, for example, must be protected, and the brown shawls and deep madder-dyed petticoats and bodices, worn by the women:

> One's first feeling as one comes back among these people and takes a place, so to speak, in this noisy procession of fishermen, farmers and women, where nearly everyone is interesting and attractive is a dread of any reform that would tend to lessen their individuality rather than any very real hope of improving their well-being. One feels then, perhaps a little later, that it is part of the misfortune of Ireland that nearly all the characteristics which give colour and attractiveness to Irish life are bound up with a social condition that is near to penury, while in countries like Brittany the best external features of the local life—the rich embroidered dresses, for instance, or the carved furniture—are connected with a decent and comfortable social condition. (*Prose* 286)

Lest even well-intentioned official action disrupt the distinctiveness of a district, Synge balances his accounts of hardscrabble with respect for traditional ways. He describes the one-room hovels, built of loose stone and mud, that house family and livestock together. In each, there is little or no furniture (just a spinning wheel and a single bed in which the entire family sleeps). He finds one cabin especially disturbing:

> It was the poorest cottage we had seen. There was no chimney, and the smoke rose by the wall to a hole in the roof at the top of the gable. A boy of ten was sitting near the fire minding three babies, and at the other end of the room there was a cow with two calves and a few sickly-looking hens. The air was so filled with turf-smoke that we went out again in a moment into the open air. As we were standing about we heard the carman ask the boy why he was not at school. "I'm spreading turf this day," he said, "and my brother is at school. Tomorrow he'll stay at home, and it will be my turn to go."(*Prose* 322)

Nevertheless, Synge allows that genuine improvements have been made in the half-dozen years since the Manchester Relief Fund was established: "Putting aside exceptionally bad years, there is certainly a tendency towards improvement. The steamer from Sligo, which has only been running for a few years, has done much good by bringing in flour and meal much more cheaply than could be done formerly. Typhus is less frequent than it used to be, probably because the houses and holdings are improving

gradually, and we have heard it said that the work done in Aghoos by the fund raised by the *Manchester Guardian* some years ago was the beginning of this better state of things" (*Prose* 327). Admitting, however, that "it is not easy to improve the state of the people in the congested districts"(*Prose* 339), Synge advocates continuation of those remedies that the district dwellers have not rejected. Only peasant ownership, the greatest hope for their solvency, may staunch the hemorrhage of emigration, the region's greatest blight. In an unexpected, political conclusion, Synge pleads for Home Rule, aiming at the parliamentary-nationalist sentiments of the *Manchester Guardian*'s readership:

> The only real remedy for the distress is the restoration of some sort of national life to the people. It is this conviction that makes most Irish politicians scorn all merely economic or agricultural reforms, for if Home Rule would not of itself make a national life it would do more to make such a life possible than half a million creameries. With renewed life in the country many changes of the methods of government, and the holding of property, would inevitably take place, which would all tend to make life less difficult even in bad years and in the worst districts of Mayo and Connemara. (*Prose* 341–43)

Ending with a direct and explicit appeal to the political bias of his readers—albeit, for a futile undertaking—Synge reveals his grasp of political issues as well as his ability to engage his audience.[11]

Accompanying Synge, Jack Yeats recorded his impressions of the journey in small sketchbooks, the habit of a lifetime. His simple drawings match Synge's descriptions in subject, in detail, in effect, and in sensitivity to their assignment and their audience. His strong, linear style complements Synge's descriptions of a poverty-stricken people eking out an existence from barren, uncompromising land. Portraying a struggle foreign to most of the *Guardian* readership, the drawings contain neither magic nor mystery, neither the romanticization of his early *Broadsheets*, nor the idealization of banners he designed for the cathedral at Loughrea, County Galway.

Yeats's illustration *Near Castelloe* [*sic*] at around the same time (plate 43) accompanied Synge's first article in the *Manchester Guardian* about the coastal villages, west of Spiddal, in which he wrote:

> Before we stopped for the night we had reached another bay-coast line and were among stone again. Later in the evening we walked out round another

NEAR CASTELLOE

43. Jack Butler Yeats (1871–1957), *Near Castelloe,* 1905, after Synge 1892

small quay, with the usual little band of shabby hookers, and then along a road that rose in some places a few hundred feet above the sea; and as one looked down into the little fields that lay below it, they looked so small and rocky that the very thought of tillage in them seemed like the freak of an eccentric. Yet in this particular place tiny cottages, some of them without windows, swarmed by the roadside and in the "boreens,"or laneways, at either side, many of them built on a single sweep of stone with the naked living rock for their floor. . . . [A] little farther on a half-a-score of young men were making donkeys jump backward and forwards over a low wall. (*Prose* 288)

He continues:

As we came back we met two men, who came and talked to us, one of them, by his hat and dress, plainly a man who had been away from Connemara. In a little while he told us that he had been in Gloucester and Bristol working on public works, but had wearied of it and come back to his country . . . I asked him about the fishing in the neighbourhood we were in. "Ah," he said, "there's little fishing in it at all, for we have no good boats. There is no one asking for boats for this place, for the shopkeepers would rather have

the people idle, so that they can get them for a shilling a day to go out in their old hookers and sell turf in Aran and on the coast of Clare. (*Prose* 288–90)

Yeats's drawing also foregrounds the men, differentiating the countryman from the traveler, whose attire is clearly the more urbane. The countryman is larger than his companion; he seems stronger, yet more innocent, staring out directly at the reader. The traveler avoids the reader's gaze; his face, somewhat shaded, seems more aware, more worldly, in perfect keeping with the keenness of his comment to Synge that the shopkeepers prey on the impoverished. Having seen more of the world, he appears more able to understand it. Neither text nor illustration glorifies the peasant. Each insists that we consider the men realistically amid their surroundings, which are accorded as much significance as the two men.

Everywhere, mounds and walls of stones surround the clustered cottages. In the left rear, we see the little harbor with a few sailboats in it, and, on the horizon, we can just make out young men taunting a donkey. Yeats's illustration *Outside Belmullet* (plate 44) also emphasizes the desolation of the terrain by delineating the "waste of turf in the North Mayo country [that] takes the place of the waste of stones that is the chief feature of the coast of Galway." The forbidding setting provides a contextual narrative for the figures of woman, donkey, and two walking men in *Outside Belmullet*.

In the essay "Among the Relief Works," Synge, at first, lauds the relief projects of earlier years. But as he moves along, the mood changes, and the scene he next describes is the one Yeats illustrates:

We drove many miles, with Costello and Carraroe behind us, along a bog-road of curious formation built up on a turf embankment, with broad grassy sods at either side—perhaps to make a possible way for the barefooted people—then two spaces of rough broken stones where the wheel ruts are usually worn and in the center a track of gritty earth for the horses. Then, at a turn, of the road, we came in sight of a dozen or more men and women working hurriedly and doggedly improving a further portion of this road, with a ganger swaggering among them and directing their work. Some of the people were cutting out sods from grassy patches near the road, others were carrying down bags of earth in slow, inert procession, a few were breaking stones, and three or four women were scraping out a sort of sandpit at a little distance. As we drove quickly by we could see that every man and woman was working with a sort of hang-dog dejection that would be enough to make any casual passer mistake them for a band of convicts.

OUTSIDE BELMULLET

44. Jack Butler Yeats (1871–1957), *Outside Belmullet*, 1905, after Synge 1892

The wages given on these works are usually a shilling a day, and as a rule, one person only, generally the head of the family, is taken from each house. Sometimes the best worker in a family is thus forced away from his ordinary work of farming, or fishing, or kelp-making for this wretched remuneration at a time when his private industry is most needed. (*Prose* 296–98)

Synge then editorializes:

If this system of relief has some things in its favour, it is far from satisfactory in other ways, and is not always economical. I have been told of a district not very far from here where there is a ganger, an overseer, an inspector, a paymaster, and an engineer superintending the work of two paupers only. This is probably an exaggerated account of what is really taking place, yet it probably shows, not too inexactly, a state of things that is not rare in Ireland. (*Prose* 298)

Yeats's group scene (plate 45) depicts the same hopelessness; only the swaggering ganger (a figure we see again in his *Life in the West of Ireland*) looms large. He is dressed better than the peasants who, with lowered heads and bent backs, recall members of black slave gangs in the antebellum American South. Drawings and text both censure current relief methods for overworking and underpaying the very constituency they were designed to relieve.

"Among the Relief Works" and its illustrations can be usefully compared with "The Kelp Makers" and its accompanying drawings to demonstrate both artists' belief that Ireland's most needy would benefit psychologically and economically from indigenous industry rather than imposed relief work. Yeats's drawing *Gathering Seaweed for Kelp* (plate 46) shows upright women with straight backs holding baskets of seaweed more than half their size, and men in curraghs coming ashore. It implies not only the peasants' pride in their labors, but also Yeats's own conclusion that kelp gathering was worthy of the support that the Congested Districts Board had withheld. Despite its vivifying potential, the people had all but abandoned this work rather than subject themselves to the manipulation of gombeen men, who set the prices for the kelp they bought from the peasants and for the provisions they sold them. Synge's account courts encouragement for this native occupation:

All along the coast, a little above the high-water mark, we could see a number of tall, reddish stacks of dried sea weed, which had probably been standing for weeks, while others were in various unfinished stages, or had only just been begun. A number of men and women and boys were hard at work in every direction, gathering fresh weed and spreading it out to dry on the rocks. In some places the weed is mostly gathered from the foreshore; but in this neighbourhood, at least in the early summer, it is pulled up from rocks under the sea at low water, by men working from a boat or curagh with a long pole furnished with a short crossbar nailed to the top, which they entangle in the weeds. Just as we came down, a curagh, lightly loaded by two boys, was coming in over a low bar into the cove I have spoken of, and both of them were slipping over the side every moment or two to push their canoe from behind. Several bare-legged girls, crooning merry songs in Gaelic, were passing backwards and forwards over the sand, carrying heavy loads of weed on their backs. Further out many other curaghs more heavily laden were coming slowly in, waiting for the tide; and some old men on the shore were calling out directions to the crews in the high-pitched tone that is so remarkable in this Connaght Irish. The whole scene, with the fresh smell of the sea and the blueness of the shallow waves made a curious con-

RELIEF WORKS
45. Jack Butler Yeats (1871–1957), *Relief Works,* 1905, after Synge 1892

trast with the dismal spectacle of the relief workers we had just passed, for here the people seemed as light-hearted as a party of schoolboys. (*Prose* 308)

While most of Yeats's illustrations for the *Manchester Guardian* essays portray group activities or communal scenes, a number of individual portraits emphasize the oppression of the peasants' lives. Consider *A Man of Carraroe* (plate 47) from the article "Between the Bays of Carraroe." The man is seated on a rock, his shoulders rounded, fists tightly clenched on his knees above the patch in his trousers. He seems weary and resigned. The downward tilt of his head confirms his sadness and resignation. He is surrounded by more rocks, a few cottages and a single cow. Synge has recorded the man's lament over the misery in "the poorest parish in the country":

no one can live . . . but by cutting turf in the mountains and sailing out to sell it in Clare or Aran, for you see yourselves, there's no good in the land that has little in it but bare rocks and stone. Two years ago there came a wet summer, and the people were worse off then than they are now maybe with

GATHERING SEAWEED FOR KELP

46. Jack Butler Yeats (1871–1957), *Gathering Seaweed for Kelp,* 1905, after Synge 1892

A MAN OF CARRAROE

47. Jack Butler Yeats
(1871–1957), *A Man of Carraroe,*
1905, after Synge 1892

their bad potatoes and all for they couldn't cut or dry a load of turf to sell
across the bay, and there was many a woman hadn't a dry sod itself to put
under a pot, and she shivering with cold and hunger. (*Prose* 292)

When Synge asks if many of the peasants were often in real want of food,
the old man replies:

There are a few, maybe, have enough at all times . . . but the most are in
want one time or another, when the potatoes are bad or few, and their
whole store is eaten; and there are some who are near starving all times, like
a widow woman beyond who has seven children with hardly a shirt on their
skins, and they with nothing to eat but the milk from one cow, an a handful
of meal they will get from one neighbour or another. (*Prose* 292)

Was life in Carraroe as wretched when he was a young man as now? The
old man answers:

It wasn't as bad, or a half as bad . . . for there were fewer people in it and
more land to each, and the land itself was better at the time, for now it is
drying up or something and not giving its fruits and increase as it did.
(*Prose* 292)

We can hear the melancholy in the man's response when Synge asks if
there is much dancing and singing thereabouts:

No . . . this while back you'll never see a piper coming this way at all,
though in the old times it's many a piper would be moving around through
those houses for a whole quarter together, playing his pipes and drinking
poteen and the people dancing round him; but now there is no dancing or
singing in this place at all, and most of the young people is growing up and
going to America. (*Prose* 294)

In the Congested Districts was included in *In Wicklow, West Kerry and
Connemara,* published in 1911. Yeats added three drawings to those that
had accompanied the essays in the *Manchester Guardian,* all very different
from the original fifteen. The later drawings owe much to the twelve illus-
trations Yeats completed in the intervening years for Synge's *The Aran
Islands,*[12] when he worked from the text and from Synge's photographs. In
a letter thanking Synge for the use of the photographs, which he found
especially helpful, Yeats reveals how he intuitively understood the utopian
spirit of the essays: "I have done several particularly Bully ones! I think
though I say it that shouldn't [*sic*]. When I finished reading your manu-
script—I was bothered to understand how you could leave such

people"(Pyle 92). Yeats, too, had visited Aran, but he knew that Synge's empathy for the islanders was greater than his. There is a difference between Yeats's view of the men he encountered on Aran and those who come to life on Synge's pages. Synge's peasant is not necessarily Yeats's.

Most critics have asserted that the peasant was as crucial to Yeats's vision as he was to Synge's. Only Marilyn Gaddis Rose argues compellingly that the

> Humble folk who really imposed upon [Yeats's] artistic consciousness were either small-town or urban or marginal. . . . He incorporated sailor, jockey, circus entertainer, and tinker into his own consciousness; they figured in his fantasy life and were stored away in his memory pool. For the peasant, he was a kindly reporter, a sympathetic journalist-illustrator, when called upon. . . . His farmers and farm women are not, like his jockeys and tinkers, larger-than-life, they are people. (Rose 192–93)

In a remembrance published shortly after Synge's death, Yeats validates Rose's assertion, suggesting again the difference between his view of the countryfolk and Synge's:

> I had often spent a day walking with John Synge, but a year or two ago I travelled for a month along through the west of Ireland with him. . . . I think the Irish peasant had all his heart. He loved them in the east as well as he loved them in the west, but the western men on the Aran Islands and in the Blaskets fitted in with his humour more than any—the wild things they did and said were a joy to him. (*Prose* 402)

The Aran Islands illustrations imply that Yeats understood Synge's belief in the islanders' "rural-to-universal" significance (Knapp 59). They capture the idealization, the larger-than-life quality that marked Synge's descriptions of Aran.

Of the three newer illustrations, two are subjects that Yeats had portrayed in the original newspaper series: *The Ferryman of Dinish Island* and *Boat-building at Carna*. A comparison of the earlier and later drawings confirms Yeats's initially straightforward treatment of his subjects; he applied the enhanced style of *The Aran Islands* illustrations only to the later three.

Synge had found the Dinish ferryman remarkable, devoting a whole essay to this single figure. He describes meeting him at the channel between Dinish and Furnace islands:

> As we went to this channel across a strip of sandhill a wild-looking old man appeared at the other side, and began making signs to us and pushing off a

heavy boat from the shore. Before he was half-way across we could hear him
calling out to us in a state of almost incoherent excitement, and directing us
to a ledge of rock where he could take us off. A moment later we scrambled
into his boat upon a mass of seaweed that he had been collecting for kelp,
and he poled us across. (*Prose* 302)

Yeats's drawings show the ferryman poling in one and rowing in the
other, but each emphasizes his ferocious individuality, as Synge does in his
description. In the earlier drawing (plate 48), a very human boatman rows
furiously, pulling on his oars and bracing his left foot awkwardly against
the crosspiece for leverage. He and his boat form a triangle in the fore-
ground that takes up three-fourths the height of the picture. They appear
against a background of tiny cottages surrounded by stone walls and barren
countryside, with yet more sea beyond. The boatman seems to gaze direct-
ly into the viewer's eye. A strong man, he shares the page only with the des-
olate island he inhabits. The later portrait (plate 49) shows him again,
active and in control, his boat laden with seaweed that hangs over the side.
The ferryman and his boat once more occupy three-fourths of the drawing,
but now the perspective has changed; he seems to stand above the viewer in
front of an expanse of stone relieved only by a narrow glimpse of cottage
and hillside beyond. In this second drawing, the boatman seems like some
invincible deity facing the sea. Synge's ferryman has become, in this second
drawing, a Charon-like figure, ferrying the souls of the dead to Hades.

The two portraits of the boat builder also rely on a single scene—a shed
with open door, tools lying about, a hooker plying out to sea—but the rep-
resentations differ. In the earlier drawing (plate 50), the chief builder is
rendered tall, powerful, and hairy-chested, in strong, simple strokes. His
hard-working fellow laborers convey cooperation and unity. Engaged in an
endeavor that promises movement, change, and indeed, life, they contrast
markedly with the dispirited laborers of the relief crew and visually reiter-
ate Synge's text:

Not long afterwards we made our way to see the old carpenter . . . and
found him busy with two or three other men caulking the bottom of a boat
that was propped up on one side. As we came towards them along the low
island shore the scene reminded one curiously of some old picture of Noah
building the Ark. The old man himself was rather remarkable in appearance
with strongly formed features, and an extraordinarily hairy chest showing
through the open neck of his shirt. . . . From where we stood we could see
another island across the narrow sound studded with the new cottages that

48. Jack Butler Yeats (1871–1957), *The Dinish Ferryman*, 1905, after Synge 1892

THE DINISH FERRYMAN

49. Jack Butler Yeats (1871–1957), *The Ferryman of Dinish Island*, 1911, after Synge 1892

THE FERRYMAN OF DINISH ISLAND

BOAT-BUILDING AT CARNA

50. Jack Butler Yeats (1871–1957), *Boat-Building at Carna*, 1905, after Synge 1892

51. Jack Butler Yeats (1871–1957), *The Boat-Builder*, 1911, after Synge 1892

THE BOAT BUILDER

are built in this neighbourhood by the Congested Districts Board. (*Prose* 312)

Yeats's second drawing, *The Boat Builder* (plate 51), however, contains only the single figure of the self-possessed chief carpenter, who stands proud, but relaxed, next to his completed boat, his tools and wood shavings around his feet. There is no suggestion that he has been aided in his labors by other men. He and his work fill most of the picture. Clouds on the horizon surround his head. Yeats has sketched the background landscape with just the suggestion of sea and boats, land and houses. Again, the artist has created a portrait of a singular man, larger than life, all tasks completed. He transcends his surroundings; he is a man alone, out of time, out of society.

The imposing figures in these later drawings suggest the magnitude of Yeats's response to Synge's camera and words. Three of Synge's photographs, in particular (plates 52–54), influenced Yeats's drawings. In these Synge silhouetted the islanders against the sea and sky, showing them dauntless against the elements. These images also informed Yeats's first illustration for *The Aran Islands*: a single strong man, posed with hands behind his back, standing on a rock, looking out to sea, he exemplifies the essential humanity that Synge ascribed to Aran (plate 55).

In illustrating Synge's writings, other than those for the *Manchester Guardian,* Yeats intuited the "ethnographic allegory" in his partner's work. He understood that as Synge described "real cultural events," he simultaneously made "moral, ideological, and even cosmological statements" (Clifford 98). He recognized that the essays participated in a "conventionalized pattern of retrospection that laments the loss of a 'good' country, a place where authentic social and natural contacts were once possible" (Clifford 113). In the pastoral allegory of *The Aran Islands* Aran had become Eden.

It is the absence of an allegorizing dimension that distinguishes both text and illustration in the *Manchester Guardian* series. This difference bespeaks the unity in Synge's and Yeats's interpretation of C. P. Scott's assignment, and suggests the degree to which Synge's allegorical text and photographs of *The Aran Islands* influenced Yeats's later illustrations. Critics, like Hilary Pyle, may demean the aesthetic value of the *Guardian* drawings, but when we compare these sketches to photographs of the time, we see how realistically they capture the life of the Congested Districts. Yeats, like Synge, dispensed the required doses of objectivity and dispassion to

52. J. M. Synge (1871–1909), *Watching the Curragh on its Way to Collect Turf from a Galway Hooker*, ca. 1898–1902, photograph, Trinity College Dublin. (Courtesy of the Board of Trinity College Dublin and the J. M. Synge Trustees)

53. J. M. Synge (1871–1909), *The Islanders*, ca. 1898–1902, photograph, Trinity College Dublin. (Courtesy of the Board of Trinity College Dublin and the J. M. Synge Trustees)

54. J. M. Synge (1871–1909), *Islanders on Inishere,* ca. 1898–1902, photograph, Trinity College Dublin. (Courtesy of the Board of Trinity College Dublin and the J. M. Synge Trustees)

AN ISLAND MAN

55. Jack Butler Yeats (1871–1957), *An Island Man,* 1907, after Synge 1892

the paper's liberal readership, who were certain to help their neighbors across the Irish sea—if they appeared needy and receptive to help. To Scott's demand for particulars Yeats and Synge had responded accordingly. The editor was pleased with the results, writing to Synge, "You have done capitally for us, and with Mr. Yeats have helped to bring home to people here the life of those remote districts as it can hardly have been done before" (Greene 199). The later drawings were a different matter. Drawn to illustrate Synge's text, as Hilary Pyle has stated, they "express a general view of what Synge described in particular incidents, his figures convey[ing] the spirit of generations leading an unchanged life, rather than describing given people at a definite time" (Pyle 113).

So, now let us return to that powerful peasant figure in *The Country Shop*, the enigmatic eavesdropper. Placing him in a scene that Yeats drew from his travels with Synge, Yeats captures the range of statement and style of their collaboration. In contrast to the two women, the countryman's demeanor suggests that he belongs to Synge's idealized world of the peasant. He is the Natural Man who disdains involvement in the unfortunate particularities of a mercantile scene. *The Country Shop* is not only Yeats's rendering of an experience he shared with Synge; it is his tribute to Synge's unique perspective. If, for practical and political reasons, Synge omitted his "strange and marvelous" countryman from the *Manchester Guardian* articles, Yeats saw no need to omit him from the watercolor he completed from memory after Synge's death. That proud observer is Yeats's memorial to Synge's vision.

NOTES

1. In her discussion of this watercolor in *Jack B. Yeats in the National Gallery of Ireland*, Hilary Pyle identifies the scales (partially hidden by the figure of the peasant woman) as a "model hooker" (28).

2. In his catalogue note on the watercolor, Brian Kennedy claims that the "shop owner dominates the scene" (158). While the shopkeeper is clearly in control of the action, the onlooker seems to me to be the scene's most compelling figure.

3. Hilary Pyle includes *The Country Shop* with *The Man from Aranmore*, *The Ganger*, *The Causeway of Lettermore*, *Bonfire Night*, and several other of Yeats's works which, she has demonstrated, derive from this tour (*Eire-Ireland* 30).

4. In a letter to W. B. Yeats, Synge refers to these qualities in Western life in a similar fashion and compares them to the characterizations in William Boyle's play *The Eloquent Dempsey* (1, 126).

5. Tim Robinson sees Synge's remark not as an example of Ascendancy bias but as simply "impercipient" (xxxii).

6. He remarks in his catalogue entry to *The Country Shop*, "This introspective observer appears in many of [Yeats's] later oil paintings" (158). Similarly Hilary Pyle writes of *Gathering Seaweed*, another work that had its sources in Yeats's tour with Synge, "Yeats places one of his typical westerners, with wide brimmed hat, in the left foreground, surveying the busy scene . . . " (*Jack B. Yeats in the NGI* 30).

7. T. P. O'Neill indicates that the total spent in the government's relief efforts was lower in 1897–98 than in 1890–91 as a result of the well-marshaled private charities that year. He cites particularly the £20,000 raised by the Manchester Fund and, following the example of Manchester, the £11,155.2s.10d. raised by the Mansion House Fund in Dublin (185–86).

8. The pair traveled from June 3 until July 3, 1905.

9. Their route went from Galway along the coast to Spiddal and then on to Costellow, Carraroe, and to the islands of Annaghvaan, Lettermore, Gorumna, and Dinish. Before leaving Cois Fhairrge, they visited Trawbaun and Carna. On their way to North Mayo, they traveled through Recess, Ballina, Belmullet town and peninsula, Erris, Geesala, and finally Swinford (Pyle "Many Ferries" 27–28).

10. Synge visited Aran five times between 1898 and 1902. He visited West Kerry for the first time in 1903 and returned again early in 1904 and again in August 1905 after he left Connemara.

11. These essays indicate how wrong W. B. Yeats was when he commented that Synge was "unfitted to think a political thought" (*Prose* 283).

12. Yeats completed these drawings in 1907.

WORKS CITED

Bourgeois, Maurice. *John Millington Synge and the Irish Theatre*. London: Constable and Co., 1913.

Clifford, James. "On Ethnographic Allegory." *Writing Culture*. Ed. James Clifford and George E. Marcus. Berkeley: University of California Press, 1986. 98–121.

Croke, Fionnuala. *Irish Watercolours and Drawings*. Dublin: National Gallery of Ireland, 1991.

Greene, David H. and Edward M. Stephens, *J. M. Synge*. New York: New York University Press, 1989.

Jones, David S. "The Cleavage between Graziers and Peasants in the Land Struggle, 1890–1910." *Irish Peasants: Violence and Political Unrest 1780–1914*. Ed. Samuel Clark and James Donnelly, Jr. Dublin: Gill and Macmillan, 1983. 374–417.

Keogh, E. "In Gorumna Island." *The New Ireland Review*. 9 (June 1898): 193–200.

Knapp, James F. "Primitivism and Empire: John Synge and Paul Gauguin." *Comparative Literature* 18:2 (1983): 53–68.

O'Neill, T. P. "The Food Crises of the 1890s." *Famine: The Irish Experience: 900–1900*. Ed. E. Margaret Crawford. Edinburgh: John Donald Publishers, 1989. 176–97.

Partridge, A. C. *Language and Society in Anglo-Irish Literature.* Dublin: Gill and Macmillan, 1984.

Pyle, Hilary. *Jack B. Yeats.* London: Andre Deutsch, 1989.

———. *Jack B. Yeats in the National Gallery of Ireland.* Dublin: National Gallery of Ireland, 1986.

———. "Many Ferries: Jack B. Yeats and J.M. Synge." *Eire-Ireland* 18.2 (1983): 17–35.

Rose, Marilyn Gaddis. "Jack B. Yeats's Picture of the Peasant." *Views of the Irish Peasantry 1800-1916.* Ed. Daniel J. Casey and Robert E. Rhodes. Hamden: Archon Books, 1977. 192–201.

Synge, John M. *The Collected Letters of John Millington Synge.* Ed. Ann Saddlemyer. 2 vols. Oxford: Clarendon Press, 1983.

———. *Collected Works: Prose.* Ed. Alan Price. 2 vols. Gerrards Cross, England: Colin Smythe, 1982.

———. *The Aran Islands.* Ed. Tim Robinson. London: Penguin, 1992.

Thornton, Weldon. *J.M. Synge and the Western Mind.* Gerrards Cross, England: Colin Smythe, 1979.

Yeats, Jack B. *Life in the West of Ireland.* Dublin: Maunsel, 1915.

ACKNOWLEDGMENTS